ROUTE 66
GHOST TOWNS AND ROADSIDE RELICS

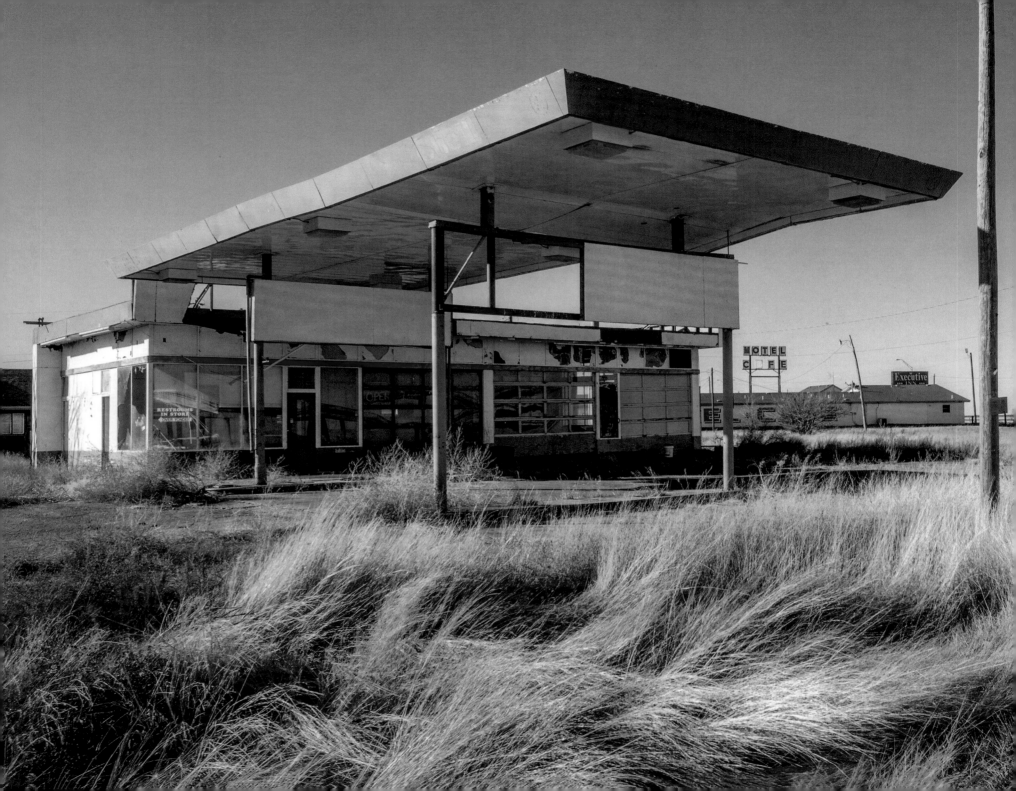

ROUTE 66
GHOST TOWNS
AND ROADSIDE RELICS

Skyhorse Publishing

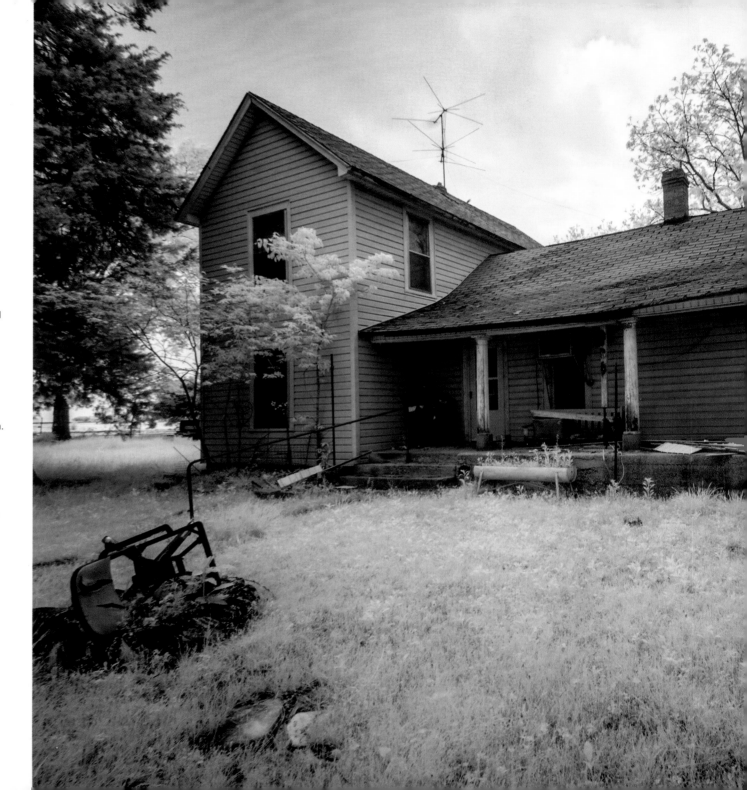

CONTENTS

ROUTE 66 IN ILLINOIS

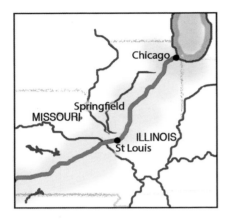

If ever you plan to motor west,
Travel my way, take the
highway that is best.

Bobby Troup, songwriter

THE ILLINOIS STRETCH OF ROUTE 66 had simple beginnings as the Pontiac Trail gravel track in 1915. Chicago, Illinois had been a focal point of many Native American trails, and was to pass through St. Louis, the jumping off point for Lewis and Clark's Expedition of Discovery that opened up the West through the newly acquired Louisiana Purchase. Fur traders gradually established a trail to the Mississippi road at Lake Michigan to take their goods south to New Orleans and thousands of others passed this way on their way to the West .

By amalgamating these existing tracks, Route 66 gradually emerged and a three-hundred mile long stretch of the route stretched through Illinois. The road should have been designated Route 60, but the road running between Kentucky and Virginia had already claimed this number. Cyrus Avery, who became known as the "Father of Route 66" agreed to the route name in 1926. Avery was an important member of the Joint Board of Interstate Highways and fully understood that the development of a modern highway network would have a huge impact on American prosperity. Route 66 became the most iconic road in the country, crossing the heart of America on its way to the Pacific. Under the direction of Avery's U.S. Highway 66 Association, the road was gradually paved. Paving began in the 1920s by road crews earning forty cents an hour for the back-breaking work. The Great Depression of the 1930s slowed its construction of the road, but the Illinois section was the first section to be

finished in 1927. It took until 1938 for the whole length of the route (all 2451 miles) to be covered by asphalt. Al Capone was one of the most prominent proponents of paving the road, which facilitated running bootleg liquor during the Prohibition era. By the time it was finished this iconic road crossed eight states from Chicago to the Pacific Coast of California. It wove through the center of countless villages and towns and brought prosperity to the heart of a nation, promoting travel and vacations around the country. Route 66 became the most important highway in America and helped to open up the West.

In 1939, novelist John Steinbeck dubbed Route 66 the Mother Road. It was used by hundreds of dust bowl farming families as they immigrated to California for better employment prospects. Steinbeck portrayed this westward migration in his novel *The Grapes of Wrath*. The road was also known as Main Street USA. It generated massive economic growth and opened up many American tourist attractions including the Grand Canyon, the Painted Desert, and the Meranec Caverns. These were promoted by countless Meranec Caverns barns.

The Illinois section of the road travelled across farmland, gliding diagonally across the state in a southwest-northeast direction. Beginning near the shore of Lake Michigan, the original route began at Jackson Boulevard and Michigan Avenue. In 1933 this was moved to reclaimed land at Jackson Boulevard and Lakeshore Drive. The current road moves west from the intersection of Lakeshore Drive and

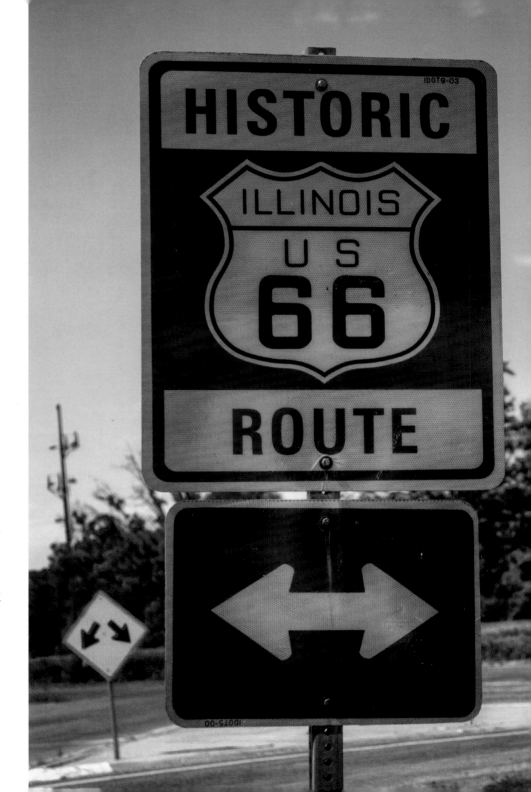

Jackson Boulevard. It then weaves a succession of iconic Illinois towns including Joliet, Odell, Bloomington, Lincoln, Springfield, and Edwardsville. President Lincoln himself walked the streets of Illinois's state capital, Springfield. He practiced law in the town and spoke in the capital building, returning to the town as a fallen hero.

In the 1930s the road carried a huge volume of traffic. The cars of the time had top speeds of sixty to eighty miles per hour, but had minimal safety equipment. This toxic cocktail resulted in a plethora of fatal accidents and the road became known as the "Bloody Highway" or "Death Alley." The stretch of Route 66 in Towanda, Illinois was a terrible accident black spot and became known as the "Dead Man's Curve." Underpasses were built to prevent pedestrian casualties, but these also became common.

The Mother Road also played its part in World War II, carrying personnel, equipment, and munitions across the country. In the Post-War years, thousands of de-mobbed GIs travelled West along the road to new lives in California. In the 1960s, Route 66 became a route to the counterculture of the West Coast and hundreds of hippies and young people used it to make their way West.

In the 1950s, Route 66 became most important as a vacation route for thousands of American families, serviced by thousands of roadside attractions of every kind from motels, to drive-ins, diners, shops, and gas stations. The iconic Muffler Men dated from this time and became emblematic of the route. These iconic statues were giant

fiberglass advertising characters that promoted many businesses along the road. The first of these, Tall Paul appeared in 1940, advertising a hotdog stand in Cicero. Following restoration, Tall Paul was moved along the route to Atlanta, Illinois. The state's surviving Muffler Men are known as the "Three Gentle Giants of Illinois." Tall Paul has two giant companions along the Illinois stretch. The green "Gemini Giant" of Wilmington, Illinois advertises the Launching Pad restaurant, while the third is the Lauterbach Tire Man. There are two other Route 66 muffler men located in Flagstaff, Arizona and Gallup, New Mexico.

The road became an icon of popular American folklore; it became the most famous road in America and has come to symbolize freedom, adventure, and mobility. It became a year-round route between the American Midwest and the West Coast. It also helped to draw the West into the economic life of the nation and mirrored the up-beat mood of the nation. The road was celebrated by books, movies, songs, and television shows. These cultural celebrations include the movies *Easy Rider*, *Thelma and Louise*, *The Bagdad Café*, *Disney's Cars*, *Paris Texas*, *Little Miss Sunshine*, and the television series *Route 66*. This was aired between 1960 and 1964 and focused on the mythical characters Todd and Buzz who drove their Corvette Sport along the route. But the most famous embodiment of the excitement of Route 66 is undoubtedly Bobby Troup's famous song, *Get Your Kicks on Route 66*. First recorded by the Nat King Cole Trio in 1946, the song has been covered

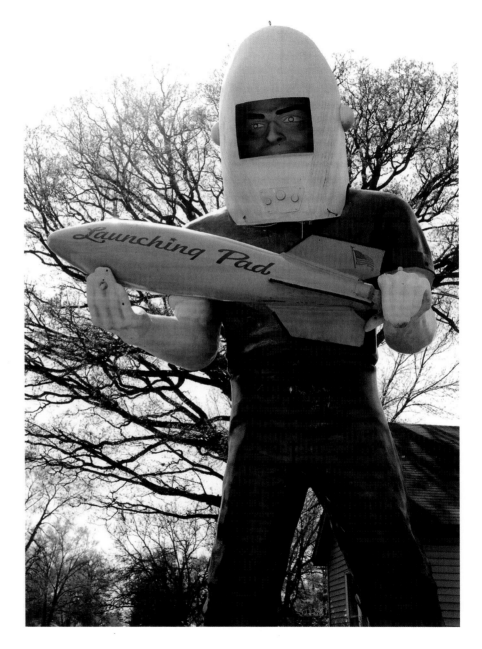

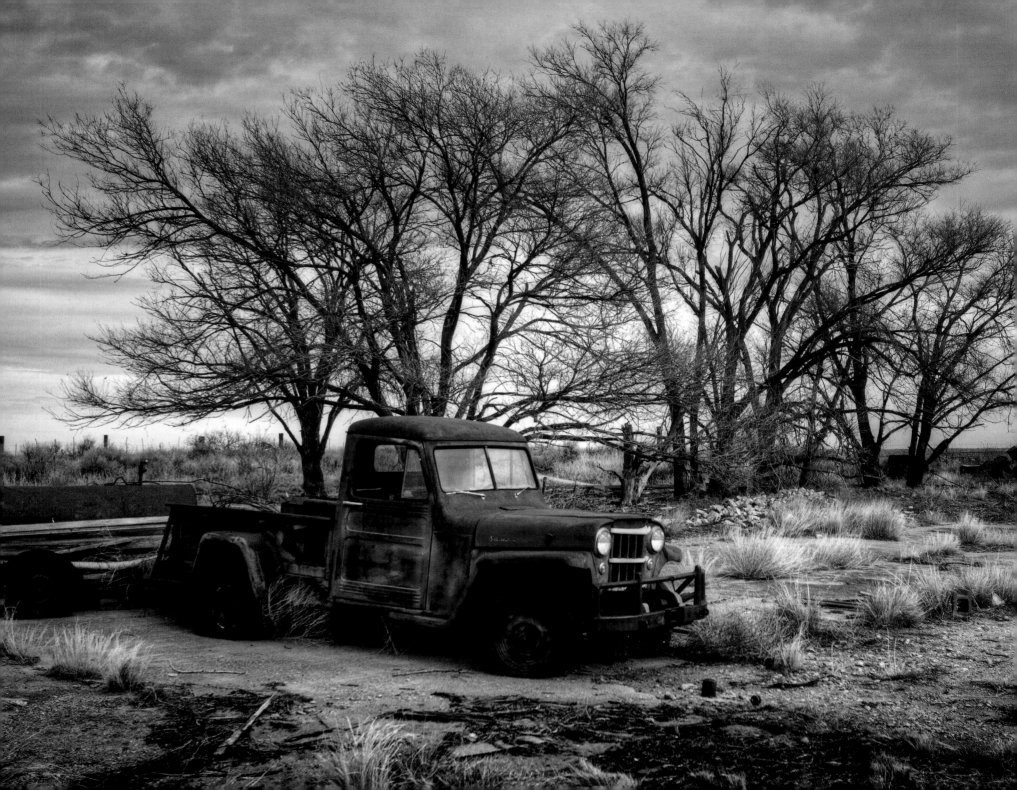

by hundreds of artists over the decades, including Chuck Berry, The Rolling Stones and Dépêche Mode.

Sadly, having been the initiator of the road, Illinois was also the first state to start decommissioning Route 66 and replace it with Interstate I-55. The iconic signs started to come down in January 1977. The road had become overcrowded and dangerous with its many distractions and roadside attractions.

As the road became disused, by-passed towns along its route became ghostly shadows of their former selves as thousands of travelers switched to the Interstate. Route 66 is haunted by deserted ruins and abandoned motels, gas stations, diners, drive-ins, and road signs. It is estimated that there are over three-thousand abandoned motels line the old road, and innumerable crumbling buildings. Ironically these ghost towns have now become the focus of the thousands of travelers from all around the world who make the road trip along this historic route every year. The first Route 66 Association was formed in 1989 by Angel Delgadillo to "preserve, promote and enjoy the past and present of U.S. Highway 66." In the 1990s, the route was designated a "state heritage tourism project" in the late 1990s and was named a National Scenic Byway in 2005. There are now Route 66 Associations in all eight Route 66 states: Illinois, Missouri, Kansas, Oklahoma, Texas, New Mexico, Arizona, and California. In Illinois, the Illinois Route 66 association conserves the route for today's tourists and the Route 66 Museum in Pontiac, Illinois preserves nostalgic relics from the Mother Road.

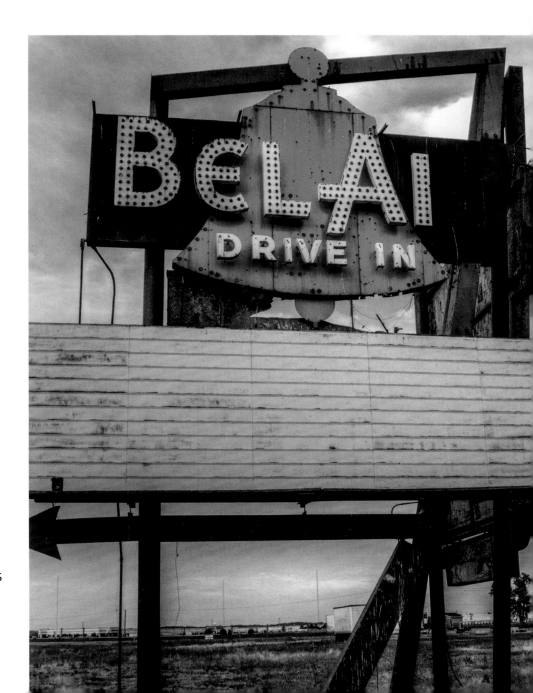

SHADES OF DECAY IN WILMINGTON, ILLINOIS

WILMINGTON (ORIGINALLY WINCHESTER) WAS BORN IN 1834, when Thomas Cox acquired four-hundred acres of land from the government and built a sawmill. Another building built in 1836, the Eagle Hotel, became a stage stop. The hotel is of no particular style, but is most strongly influenced by the Greek Revival movement. An addition was added to the hotel in the 1840s, which connected the hotel to an adjacent warehouse. This addition featured a storefront where independent businesses could rent space to sell their goods.

When Route 66 was built in the early 1930s, the town of Wilmington received a much needed boost by providing services for the many travelers of the new route. The Eagle Hotel, having served the stagecoaches of the past, now served those traveling on the new trail to the west, managing to remain profitable by offering cheap rooms to families who recently moved to or were passing through the town. In 1937, there was further growth in the form of the five-hundred-seat Mar Theatre opened at 121 S. Main Street .The Dairy Delight would open in the late 1950s, and would later become the Launching Pad Drive-In, selling only hot dogs and ice cream, but has long since expanded to a full service menu. The drive-in is located on 810 East Baltimore Street and a 1960s vintage, large green Gemini Giant stands welcomes travelers to the restaurant.

With the demise of Route 66 the Eagle Hotel fell into

Opposite: The Eagle Hotel is the oldest on Route 66.

serious disrepair by the late 20th century and the City of Wilmington was considering demolition until it was purchased by Bill Scales, a man with a real estate and building background. This old hotel is the oldest on all of Route 66, first catering to riverboat and stagecoach travelers when it was built in 1836. Thanks to Scales, the Route 66 Corridor Preservation Program, and other preservationists, there are plans for the old hotel to be restored so that it can continue to cater to travelers for generations to come. The old hotel is listed on the *National Register of Historic Places* and is located at 100 Water Street.

Below: The rear of the Eagle Hotel.

THE AMBLER-BECKER GAS STATION IN DWIGHT, ILLINOIS

THE ICONIC AMBLER-BECKER GAS STATION in Dwight, Illinois operated for longer than any other gas station along the route of the Mother Road. The building was constructed in 1933 by local builder Jack Schore on just under an acre of land bought from a local man, Otto Strufe. The single storey building has asphalt shingles and three gas pumps, It was constructed in the classic "house and canopy" style that typified the genre. Located at the junction of Route 66 and Illinois Route 17, the business operated for sixty-six years. It was originally known as Becker's Marathon Gas Station. In 1936 it was leased by Vernon Von Qualen who bought the premises over the next couple of years. He sold the business on to Basil "Tubby" Ambler in 1938, who owned and operated it until 1966. The gas station then changed hands twice more before being bought by Phil Becker in 1970. Becker ran the station with his wife Debbie until 1996. Becker had hung around Ambler's from the age of nine and started work there in 1964. As the owner, Becker contracted with Marathon Oil and named his business Becker's Marathon Gas Station. Becker's fell in to disuse after the business ceased trading, but it retained a hold on the imagination of the people of Dwight. The building was added to the National Register of Historic places in 2001, and the Register contributed $10,400 to its restoration. This took place between 2005 and 2007 before Becker's was re-opened as a visitor center

for Dwight. The interior of the building now evokes the spirit of the 1940s, with its pot belly stove, old-style Coke bottles, antique cash register and vintage advertising. It looks as though Tubby Ambler has just stepped out to pump gas for a weary traveler pulling off from Route 66...

The station sold gasoline until the 1960s and then became an auto body shop until the late 1970s, when it closed its doors for good. It fell into disrepair and would have been destroyed had it not been for the town of Odell and the people who loved their gas station. In 1997, the station was listed in the National Register of Historic Places. Then, thanks to a collaborative effort, the Illinois Route 66 Association, the Village of Odell, Illinois State Historic Preservation Office, the National Park Service Route 66 Corridor Preservation Program, and Hampton Inn Landmarks restored the station to its former glory. A Standard Oil sign hanging from the roof swings gently in the warm breeze and an old-fashioned gas pump looks ready to serve the next customer. Although Odell's Standard Oil Gas Station no longer sells gasoline, it has become a welcome center for the Village of Odell. The station won the National Historic Route 66 Federation Cyrus Avery Award in 2002 for the year's most outstanding Route 66 preservation project.

Opposite: Ambler-Beck gas station, Dwight, Illinois

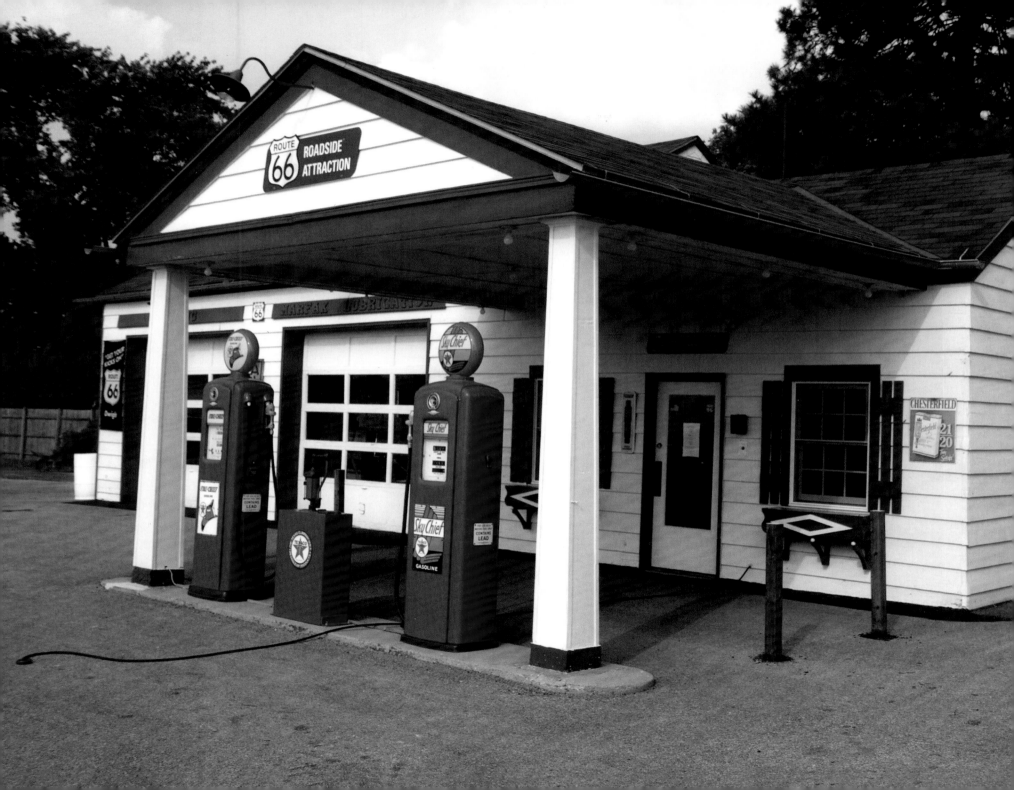

FUNKS GROVE: THE WALKER STORE, RITTENHOUSE GAS STATION AND MAPLE SYRUP ANTIQUE STORE, ILLINOIS

THE WALKER STORE WAS A GROCERY STORE and gas station until the late 1970s, when it became an antique store. The storefront is not being used at this time. Named after the Funk family, Funks Grove, Illinois is home to the original "Maple Syrup." Upon nearing this old community, a rustic sign stands on a grassy embankment with the simple words "Maple Sirup." Here, amongst the prairie, sits a natural maple grove dominating the landscape and filled with sugar and black maples of record size. The actual site of the syrup operation is about a quarter mile to the south.

At the sign, situated at Funks Grove Road, turn west to the sleepy little hamlet of Funk's Grove. Here sits the old Walker Store which once operated as a grocery store and gas station. Later, it was utilized as an antique store, and though still filled with dusty relics, it is closed today. The historic depot that stands in the middle of the clearing was actually the passenger depot in nearby Shirley before it was moved to Funk's Grove. The original Funk's Grove Depot is located at the Funk's Grove Camp to the south.

Passing by still utilized grain silos, the road continues westward about a mile to the old cemetery and Funk's Grove Church which dates back to 1845. Adam Funk, Isaac's father, chose the location of the cemetery and in 1830, he was the first to be buried there.

When the Funk and Stubblefield families first came to

Opposite: Funk's Grove Maple Syrup Antiques, Illinois.

Left: An old gas pump stands guard.

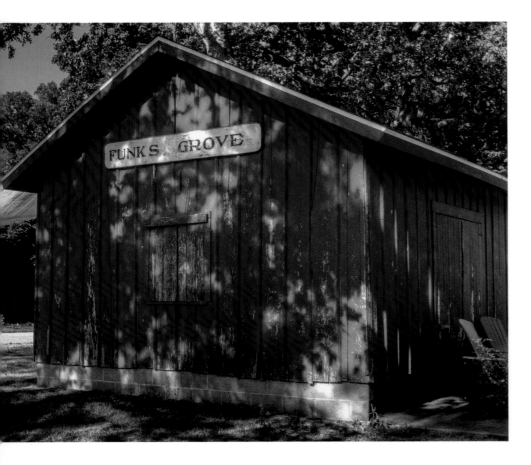

Above: The Funks Grove Camp.

the area church services were first held in their private homes before a log school building was constructed in 1827, at which time they were held there. Though the building is gone, it is marked with a large stone just west of the still standing church building. However, Robert Stubblefield would later insist on building a "real" church building and he, along with Isaac and their sons erected the building in 1864-65. The church, an outdoor "chapel," and the cemetery are now owned and managed by the Funks Grove Cemetery Association. The church, which still features its original walnut pulpit and altar rail, white pine pews, and original glass is open year round and can be rented for weddings.

On down the road about another mile is the original homestead site of Robert Stubblefield. All that's left today is a rustic barn sitting in the middle of a field. Near here also was once the Burger Sawmill and Farm. There is nothing left of the sawmill, but a sign marks the spot.

The Sugar Grove Nature Center, which protects over 1,000 acres of the largest remaining intact prairie grove in Illinois, is just south of the old town site of Funks Grove. It includes over five miles of trails and hosts various events throughout the year.

After having visited the sites of Funks Grove, return to Route 66 and continue a quarter mile south to Funks Grove Camp, the site where maple syrup is made. For generations the Funk family used the many maple trees to make syrup and maple sugar for their personal use. Years later, Arthur Funk, Isaac's grandson, capitalized on this when he opened the first commercial syrup camp in 1891. In 1896 Arthur's brother, Lawrence, took over the operation and in the 1920's the syrup operation was passed to Hazel Funk Holmes.

THE ODELL SERVICE STATION, ILLINOIS

IN 1868, JOHN D. ROCKEFELLER FORMED the Standard Oil Company in Pittsburgh, Pennsylvania. This was the beginning of the Standard Oil Trust Company that would soon dominate oil refineries and gas stations around America. In 1890, the Standard Oil Company set up its first company in Illinois.

In 1932, a contractor, Patrick O'Donnell, purchased a small parcel of land along Route 66 in Odell, Illinois. There he built a gas station based on a 1916 Standard Oil of Ohio design, commonly known as a domestic style gas station. This "house with canopy" style of gas station gave customers a comfortable feeling they could associate with home. This association created an atmosphere of trust for commercial and recreational travelers of the day. The station originally sold Standard Oil products, but after O'Donnell leased the property to others, the station began selling Sinclair and the now famous Phillips 66. In the late 1940s, O'Donnell added a two-bay garage to the building to accommodate garage and repair services, which were necessary in order to stay competitive with the nine other stations that occupied the short stretch of Route 66 through Odell. The gas station was in constant use during the heyday of travel on Route 66. It was a welcomed rest stop for weary travelers and a place for the kids to get out and stretch their legs.

Right: The original workshop at the Odell Service Station.

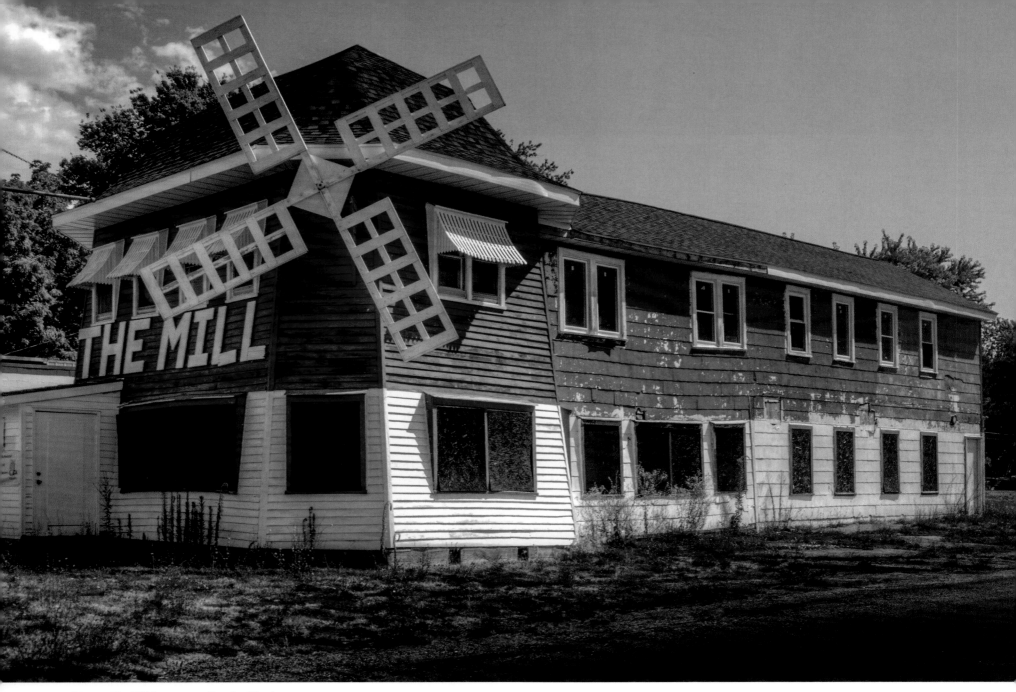

Above: The Mill Restaurant, Lincoln, Illinois.

LINCOLN, ILLINOIS

ROUTE 66 IN LINCOLN FOLLOWED TWO DIRECTIONS: Business 66, the original route, went through residential neighborhoods and ran adjacent to the downtown business district. The "bypass" or "beltline" branch of Route 66 (now part of Business 55), which was completed by the start of World War II, ran along the western and northern perimeters of the city.

Paul Coddington of Lincoln formally opened his restaurant at the corner of Washington St. and Stringer Ave. on June 25, 1929, under the name of the Blue Mill. As a special treat that night, his children dressed in Dutch costumes with wooden shoes and passed out roses to all of the patrons. The eatery was constructed by local contractors in the shape of a small Dutch windmill with sails on the front. The building had blue trim and the continuously turning sails were decorated with lights. Waitresses, dressed in blue with white aprons, served food on plates from the Illinois China Company that were emblazoned with a "Blue Mill" design. One of the opening day specials was fried ham with peanut butter on toast with mayonnaise and head lettuce – three high. Soon, the Blue Mill became known for serving patrons grilled sandwiches at any time of the day or night. The establishment served meats from Eckert's Market, locally made Marcucci ice cream and soft drinks from the Chero-Cola Bottling Company in Springfield, Illinois. On September 9, 1936, Raymond Hickman purchased the property, His wife, Fern, who had formerly operated a private catering service, took over supervision of the kitchen. Hickman enjoyed squirrel hunting and he liked to share his bounty with his customers. On at least one occasion in the 1930s, he was said to have served a squirrel dinner at The Mill. In 1945, Blossom Huffman purchased The Mill, unbeknownst to her husband, Albert. He, nevertheless, ended up helping to run the establishment.

By the mid-1980s the Mill had lost most of the Dutch-themed interior and along with its food offered a museum of strange objects. A mechanical leg appeared to have just kicked its way through a hole in the ceiling. Additional oddities included four life-sized figures, a suit of armor and a 20-pound stuffed catfish.

There was also a "jack-in-the-box toilet" that made noise when one raised the lid. Albert once explained, "I had to keep changing things so people would come down here and see what the crazy nut was doing now." The Mill closed in 1996, and stood deteriorating for many years, the subject of increasing neighborhood complaints about unsafe conditions. Ernie Edwards, owner of the famous Pig Hip restaurant on Route 66 in Broadwell, pleaded for the building to be saved for use as a museum, especially after his own Pig Hip Museum burned.

In 2005, The Mill was sold for taxes, but a year later, then Logan County Tourism Director Geoff Ladd stepped up to work with Edwards and other supporters in an effort to save the building. In 2006, The Route 66 Heritage Foundation of Logan County was created to promote and preserve Route 66 sites in Logan County.

CAYUGA, ILLINOIS

THE SECTION OF ROUTE 66 BETWEEN CAYUGA to Chenoa was first constructed in the 1920s. At the time, it was state-of-the-art pavement that boasted a width of eighteen feet and a Portland cement slab six inches deep. Like the Route 66 Alternate between Wilmington and Joliet, this 18.2-mile segment stretching from Cayuga to Chenoa proved woefully inadequate to carry the burden of Route 66's World War II mission. The excessive weight and volume of wartime traffic wreaked havoc on the thin roadbed, necessitating a serious upgrade. A 1943-44 wartime makeover included two lanes of twenty-four feet wide and ten-inch thick concrete. The sections were generally striped for eleven feet driving lanes (an extension of two feet over the older pavement). The southbound lanes, constructed directly over the older roadbed, were finished in 1944, and the northbound lanes were completed in 1954-55, together creating a four-lane highway with a center median. Today the northbound lanes have a new macadam overlay, but the southbound lanes retain, for the most part, their original concrete surface. The segment retains six historic bridges. The cracked and crumbling blacktop seems to echo the deserted feel of the road.

Left: The old roadbed in Cayuga, Illinois.

SHEA'S GAS STATION, SPRINGFIELD, ILLINOIS

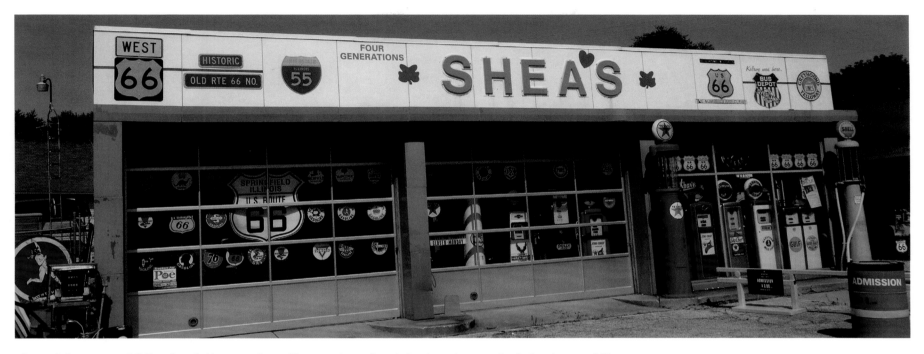

Above: D-Day veteran Bill Shea founded his iconic Route 66 gas station and ran it for sixty-six years. He died at the age of 91.

SHEA'S GAS STATION MUSEUM LOCATED on Route 66 in Springfield, Illinois was transformed from a working Texaco, and later Marathon, station into a world renowned museum by owner Bill Shea and his wife Helen. The museum contains an eclectic mix of vintage gas station memorabilia collected over the last fifty years including the original gas pumps, wooden phone booths, signs, photos, and other mementos reminiscent of old Route 66 service stations. In February 2000, the former Mahan's Station, rumored to be the oldest filling station in Illinois, was moved 21 miles to its current location within the museum compound. It has since been fully restored. The museum's guestbook boasts visitors from all over Europe and Asia and has become a destination for international travelers exploring the Mother Road. Due to his commitment to preserving Route 66 history and gas station memorabilia, plus his many years of quality service to his customers, Bill Shea and his shop were inducted into the Route 66 Hall of Fame in 1993. The entire Shea family was inducted in 2002. Bill Shea died in December 2013.

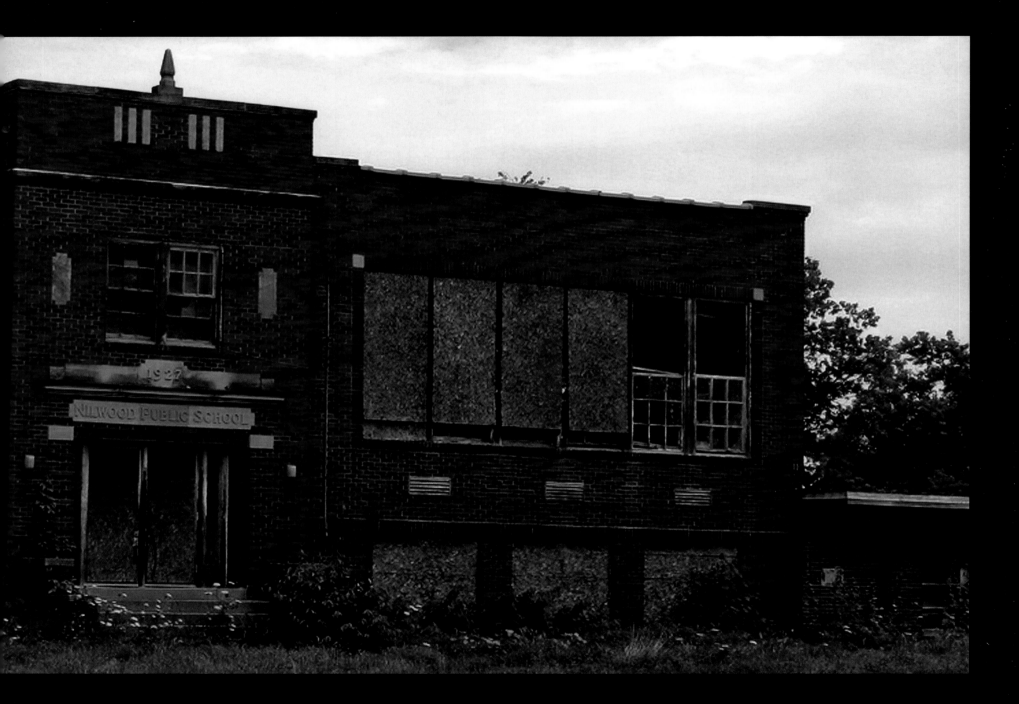

NILWOOD, ILLINOIS

The Nilwood Public School has been abandoned for decades, and the structure has been left to deteriorate. The original school building was constructed in 1927, and a small addition was added in the 1950s or 1960s. Unfortunately, vandalism has contributed to the structure's decline. It is a real shame this building could not have been saved for some useful purpose. Nilwood is located on Route 66 and is a town in Macoupin County. The city is located about thirty miles to the south west of Springfield. The population of Nilwood was 284 at the 2000 census.

The school now has a ghostly and abandoned feel. Nilwood itself is famous for the "turkey tracks."

Opposite: Ruins of Nilwood School.

Right: Nilwood Public School yearbook photographs.

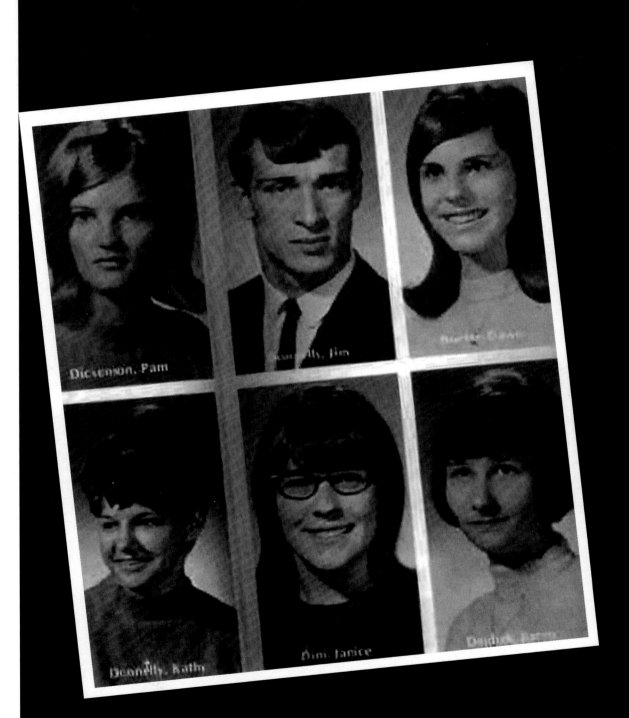

LITCHFIELD, ILLINOIS

THE FORMER BELEVIDERE MOTEL, CAFE, AND GAS STATION is located at Litchfield, Illinois, on the original Route 66. Originally opened as a one room gas station in 1929, Albin and Vencenzo Cerolla, had expanded the Belevidere business into a full service complex with gas station, cafe, and motel by 1936. The business closed when route 66 was bypassed by Interstate 55 in the 1970s.

Right: A Route 66 Shield, Litchfield, Illinois.

Below: The Belevidere Motel, Litchfield, Illinois.

Opposite above: Old Gas Station sign at the Litchfield Museum, Litchfield, Illinois.

Opposite right, above and below: Route 66 Café, Litchfield, Illinois.

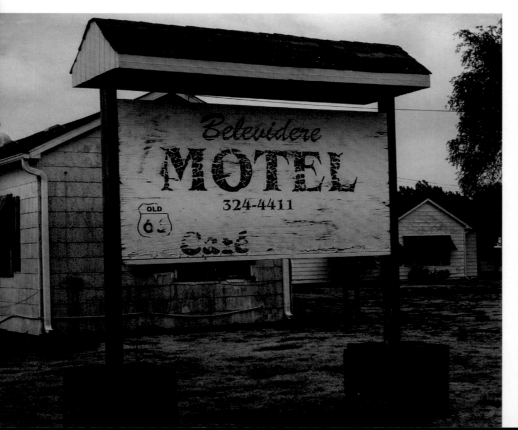

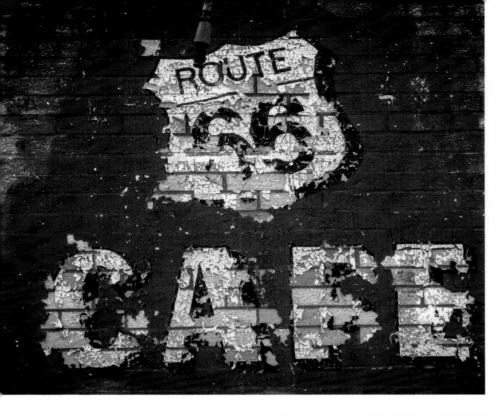

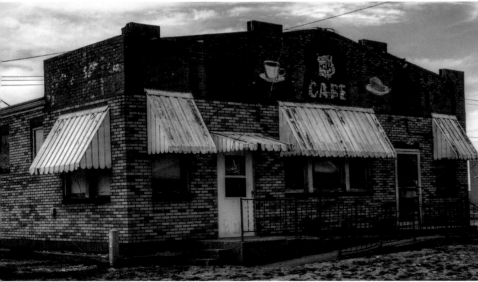

ROUTE 66 IN MISSOURI

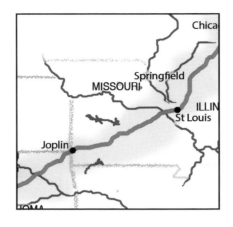

ROUTE 66 HAD AN EXCITING HISTORY IN MISSOURI, and Missouri was the first state to erect a historic marker on the road, located at the corner of Kearney Street and Glenstone Avenue in northeast Springfield. The Missouri stretch of the road was built in 1922 and began in downtown St. Louis at the Mississippi River and ran to the Kansas state line west of Joplin, but it followed a much older route, that of the Osage Indian Trail. Settlers laid a telegraph line along this Native American trail in the nineteenth century, all the way to Fort Smith, Arkansas and the road became known as the Wire Road. Route 66 followed the path of the later roads, Route 14 from St. Louis to Joplin and Route 1F from Joplin to Kansas. The road was designated Route 66 in 1926. Missouri was the third state along the length of route 66 to completely pave the surface of the road. The final section, near Arlington, Missouri was finished on January 5 1931. During its lifetime, Route 66 underwent two major realignments in St. Louis and Joplin and several lesser re-directions in St. Louis, Springfield, and Joplin. The Joplin stretch zigzagged due to the collapse of several mines that the road had been built over. Several stretches of the road have now been absorbed into today's Route 100, Route 366, Route 266, and Route 96. Interstate I-44 approximates many miles of the Missouri stretch of Route 66 that ran between St. Louis and Springfield.

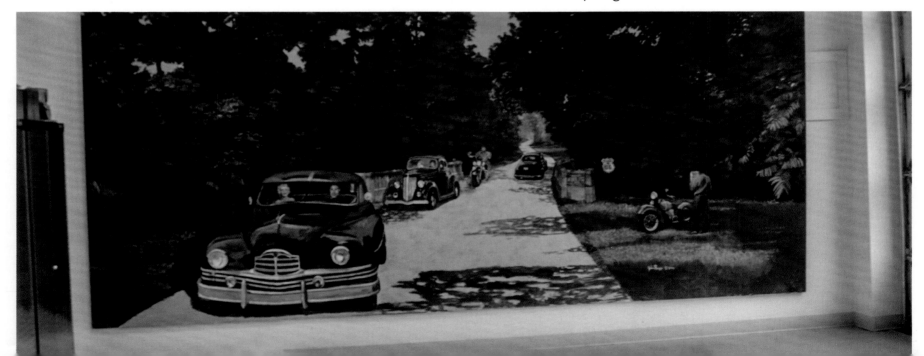

THE CHAIN OF ROCKS BRIDGE, MISSOURI

WHEN ROUTE 66 WAS DE-COMMISSIONED, a new marker, designating the Missouri part of the highway as a National Scenic Byway was erected on May 5, 2006.

THE ABANDONED CHAIN OF ROCKS BRIDGE originally took the Route 66 Traveler from Madison, Illinois to the north east of St Louis, Missouri across the mighty Mississippi. Constructed in 1927 and completed 1929, the mile long steel cantilever bridge is one of the longest of its type in the country and is twenty-eight meters high. It spans the most scenic part of the river. Its name is taken from the seventeen mile stretch of treacherous rocks protruding from the Mississippi river bed which were a serious hazard to river traffic. The bridge had to be designed with a thirty percent bend midway, to allow boat traffic to navigate two massive and ornate water intake towers that had been constructed on the riverbed by the St. Louis Waterworks in the early twentieth century, when Henry Kiel was the city's mayor. Water workers camped out in the towers until the 1920s to ensure that the intake tubes were working properly. The bridge foundations also had to follow the shape of the available bedrock for its foundations. The Chain of Rocks Bridge spanned the river from the north east of St. Louis. It took on the brunt of the Route 66 traffic in 1936 and served for more than three decades as a major landmark and an inspiration to travelers along the route, symbolizing the passage from East to West. There was a toll to cross, which stood at 35 cents (plus 5 cents for every extra passenger) during World War II.

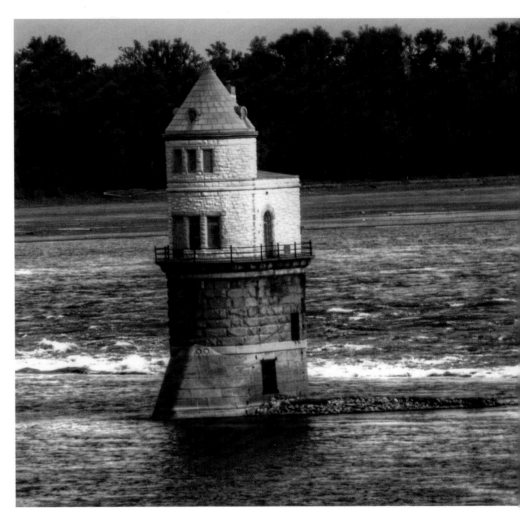

Above: Two massive and ornate water intake towers were constructed on the riverbed.

Opposite: A mural at the Route 66 Visitor Center and Chamber of Commerce in Webb City, Missouri. The mural was painted by Mayor John Biggs in 2010.

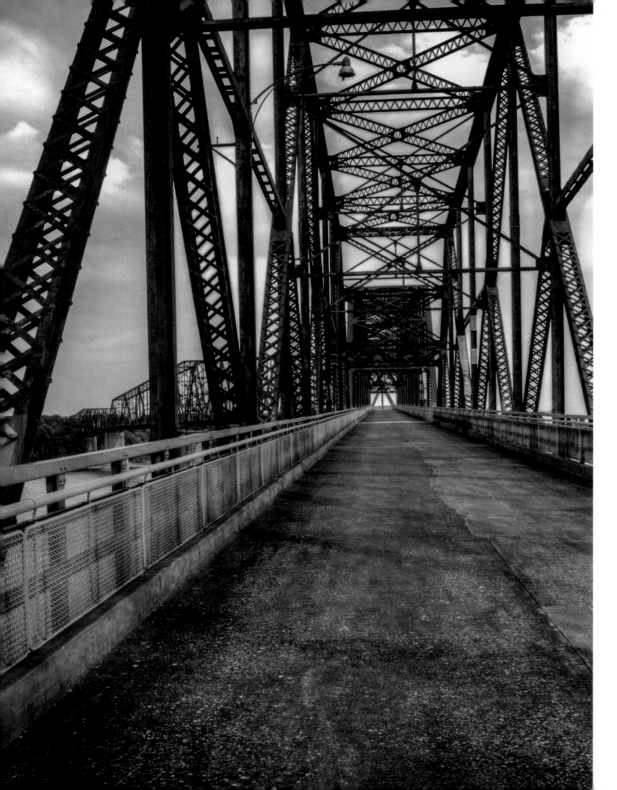

In 1966 a new bridge was built immediately upstream from the Chain of Rocks Bridge. It was designed to carry I-270. Gradually, the old bridge fell into disrepair and was closed to motor traffic on February 25, 1970.

The Chain of Rocks Bridge was threatened with demolition in the 1970s but the low cost of recycled steel made this uneconomical, and the bridge was allowed to gently rust away. During this time the bridge gained a reputation for crime and violence, culminating in the tragic murders of Julie and Robin Kerry in 1991. This tragedy unfolded on the night of April 4 to 5 1991, when Julie and Robin took their cousin, nineteen year-old Thomas Cummins to see a graffiti poem, "Do The Right Thing." The sisters and their friend Holly McClain had written Julie's poem in large white paint letters over a twenty meter span of the bridge. The nineteen- and twenty-year-old Kerry sisters were students of the University of Missouri St Louis and were anti-racist activists and members of Amnesty International who campaigned for social justice and against the death penalty. English Literature major, and Julie's poem reflects their beliefs:

United We Stand
Divided We Fall
It's Not a Black-White Thing
We as a New Generation
Have Got to Take a Stand
Unite as One
We've got II
STOP
Killing One Another

On that fatal night, the sisters and their cousin were attacked on the bridge by a gang of four men led by Marlin A. Gray. The sisters were raped and were then murdered by being thrown from the bridge by Gray into the river far below, where they drowned. The gang also forced Thomas Cummins to jump fifteen meters into the swirling river water, but he miraculously survived and was able to swim to his escape. Convicted of two first degree murders, Gray was executed by lethal injection on October 26, 2005, maintaining his innocence until the very end.

The 2015 movie, *A Fall from Grace* was loosely based on the murders and drew on the sad and desolate resonance of the location.

The bridge is currently in use as a cycleway but still retains a sinister atmosphere.

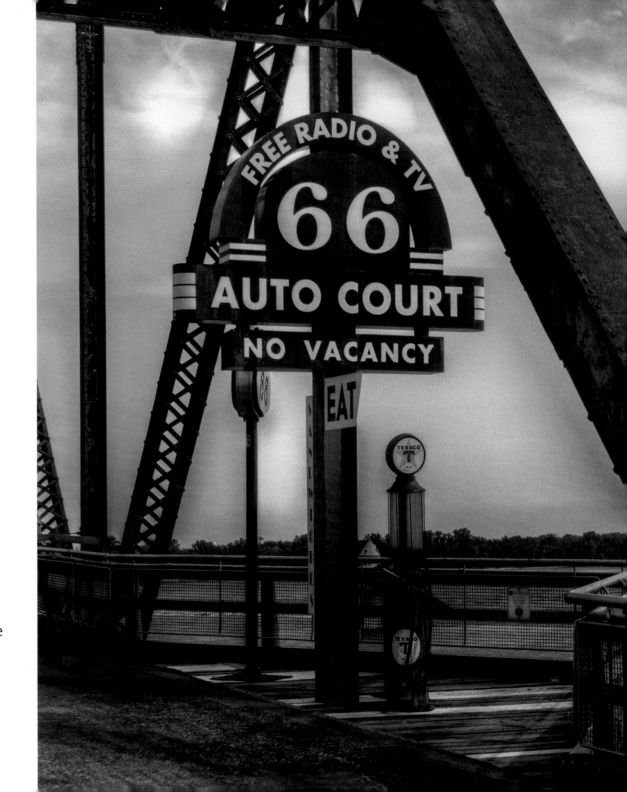

JOHN'S MODERN CABINS, NEWBURG, MISSOURI

THE CRUMBLING SITE OF JOHN'S MODERN CABINS is one of the most iconic ruins along the Missouri stretch of the old Route 66. Located on a dead-end stretch of the road, to the west of Rolla, Beatrice and Bill Bayliss opened the business as Bill and Bessie's Place in 1931, constructing a dance hall and six rustic lodging cabins. This form of inexpensive campground lodging became particularly popular in the Depression years, but it was pretty basic. The cabins were constructed from logs cut from the slopes of the Ozark Hills and had no bathroom facilities. Guests had to use a couple of outhouses. The place soon got a reputation for being seedy, but much worse was to come. On Halloween night in 1935, a young couple's life fell apart. Twenty-two-year-old Eugene Duncan shot and killed his estranged wife, Billie who was just eighteen. Billie had left her young husband and gone home to her mother ten days previously and Duncan hadn't taken it too well. Two other merrymakers were injured in the shooting in the site's dance hall. Eugene pleaded guilty to second-degree murder and served thirteen years of a fifty-year sentence.

In 1951, the Baylisses sold out and the business finally passed to a childless couple from Chicago, John and Lillian Dausch, for the princely sum of $5,000. The Dauschs optimistically re-named the site "John's Modern Cabins" and developed it with three more lodging cabins constructed from a concrete-asbestos material, a large log cabin for the couple themselves, a laundry room, and a beer and snack bar. The business soon gained a reputation for flouting the law as John Dausch sold beer on Sundays in defiance of Missouri state law. This led to him becoming notorious as "Sunday John."

Route 66 was widened in 1957 and the cabins had to be moved back from the enhanced road. The Bayliss's original dance hall was demolished and not rebuilt. In 1965 more of the site was lost when it was sold to the Missouri state Highway Commission and was lost under the newly constructed freeway, Interstate 44. But the new highway provided no easy access to the cabin court and the business began to wither. John Dausch finally closed it down when his wife died later that same year. He continued to live in the large log cabin he had built for Lillian and himself, but died of a stroke in 1971. Since that time, John's Modern Cabins have been unused and unmaintained. The road has now completely by-passed the site and it is no longer visible from the highway, screened as it is by a canopy of trees. The "Modern" cabins now decay slowly, in peace. The shingle roofs gradually fall in, and the business's red sign becomes increasingly faint and difficult to read.

Opposite: The "Modern" cabins now decay slowly, in peace.

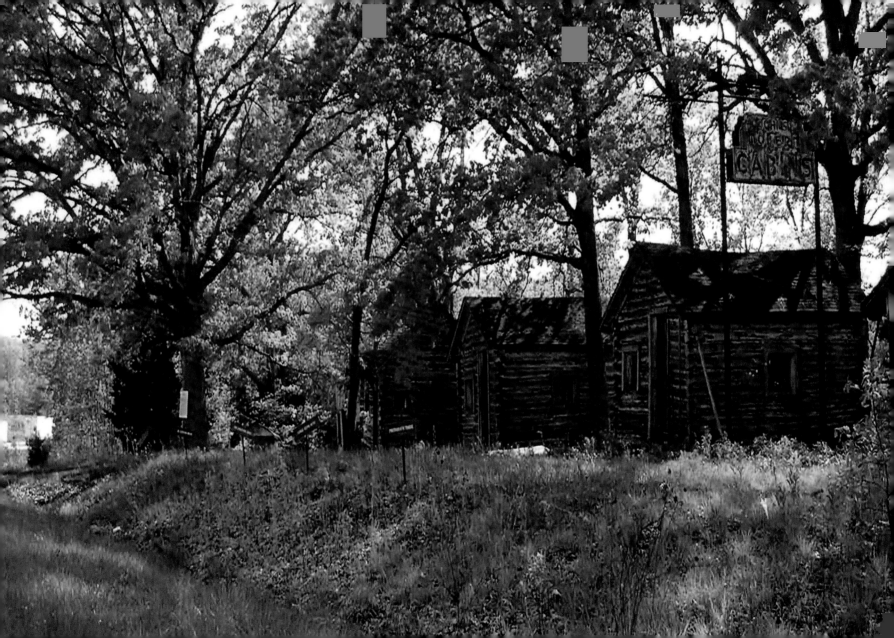

SPENCER, MISSOURI

THE TINY UNINCORPORATED OZARK HAMLET of Spencer, Missouri is one of the thousands of ghost towns on the old Route 66. Six miles west of Halltown, Spencer was founded in the late 1860s on Missouri's Carthage Road. Decades later, this road was to become the 1928 alignment of Route 66. When Route 66 was opened, several businesses sprang up virtually overnight to service the many travelers along the road, including a service station (initially a Tydol station, later a Phillips 66 garage), church, post office, grocery store, barbershop, and a cabin motor lodge. The Casey family was responsible for opening several of these enterprises.

Tydol was the East Coast brand name of the Tide Water Oil Company, founded in New York City in 1887. The company entered the gasoline market just before World War I and sold gas, oil and other products under the Tydol brand. But by the 1950s the brand gradually fell into disuse. By contrast, the Phillips 66 logo owes its very existence to the Mother Road. In 1927, the Phillips Petroleum Company was testing its gasoline on the Oklahoma stretch of Route 66. When it turned out that the test car was also travelling at 66 miles per hour, the company decided to name the new fuel Phillips 66. The first Phillips 66 service station opened on November 19, 1927 in Wichita, Kansas. The famous Phillips 66 shield logo, created to reflect the gasoline's link with the famous road, was introduced in 1930. The logo's original black and orange color scheme would last for nearly thirty years.

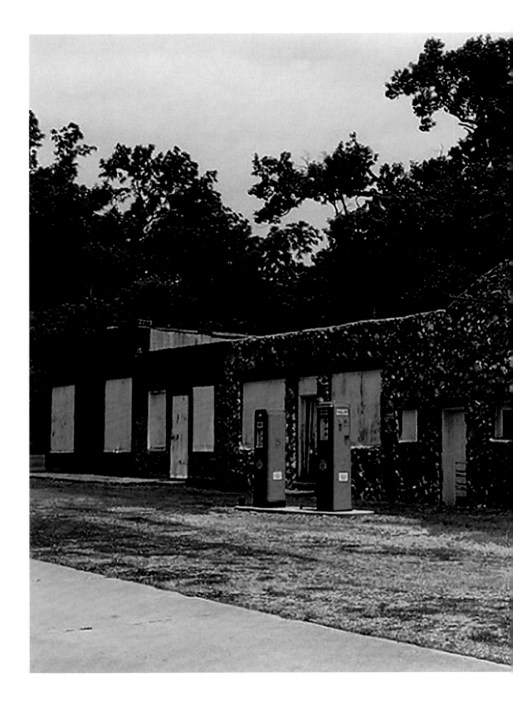

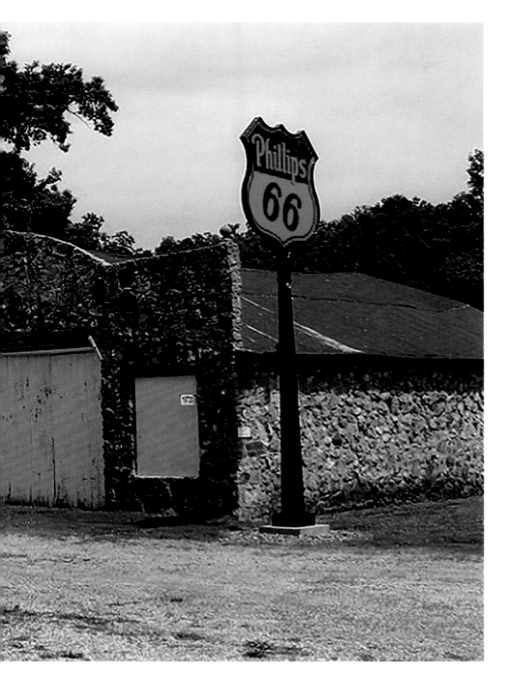

In 1959, Phillips introduced a revised version of the shield in red, white and black, which is still in use today.

Once Route 66 was de-commissioned, and Interstate 44 bypassed the settlement, Spencer faded into history. Today, Spencer is just a wide spot in Lawrence County's Farm Road 2062, but it is also one of the few places left where the original Route 66 highway still exists intact. It has never been paved over, widened, or changed and the concrete road surface is completely original.

If you approach Spencer from the west, you will cross the one-lane Johnson Creek Bridge. Built in 1926 this Pratt truss bridge crosses the same small waterway that flows through Paris Springs Junction.

As the road became obsolete, Spencer was completely abandoned and became a true ghost town. But in recent times, the town's gas station has been restored by Francis and Marie Lynn Ryan, complete with vintage Phillips 66 gasoline pumps. The business now serves a new generation of leisure travelers along Route 66. No longer pumping gas for people on their way to new lives, the garage now serves travelers that are in love with nostalgia and vintage charm. It is a flawless time capsule of years gone by.

Left: The D.L. Morris Garage and Station was built in 1936 on the site of the Heatonville Post Office. It was one of many Phillips 66 gas stations.

RED OAK II, MISSOURI

Above: Artist Lowell Davis pioneered the town of Red Oak II.

LOCATED A COUPLE OF MILES to the northeast of Carthage, Missouri, the ghost town of Red Oak II is now one of the most-visited icons on Route 66. Back in 1987, the site

of was just a cornfield but the famous artist Lowell Davis recreated the town by buying up iconic buildings from the ghost towns of Missouri and re-erecting them on land at his Fox Fire Farm, right next to the Mother Road. The inspiration behind this massive and expensive project was Davis's nostalgia for the simpler times of the 1930s. He has now recreated a complete facsimile of the original Red Oak, Missouri where he grew up. This extraordinary living art work now includes a Phillips 66 station, schoolhouse, marshal's office, general store, blacksmith's shop, town hall, feed and seed store, and several homes.

Red Oak is also home to the famous Belle Starr House that Lowell Davis moved from Carthage, Missouri to its current location. Known at the Queen of the Oklahoma Outlaws, Myra Maybelle Shirley Reed or "Belle" Starr was born in Carthage in 1848. Belle's father was a Kentuckian, Judge John Shirley who operated several businesses in his adopted Missourian home, including a hotel and tavern, blacksmith, and livery stables. Belle's mother was Eliza Hatfield, a daughter of the famous feuding family. The judge and his wife were both hot-blooded Southerners and their daughter certainly inherited their fiery natures. Belle learned to shoot at an early age and as she grew up, she associated with many notorious outlaws including the James-Younger Gang. She was convicted of horse theft in 1883. Ultimately, Belle was fatally shot just outside her Missouri home in 1889. Her murder was never solved and the perpetrator was not brought to justice.

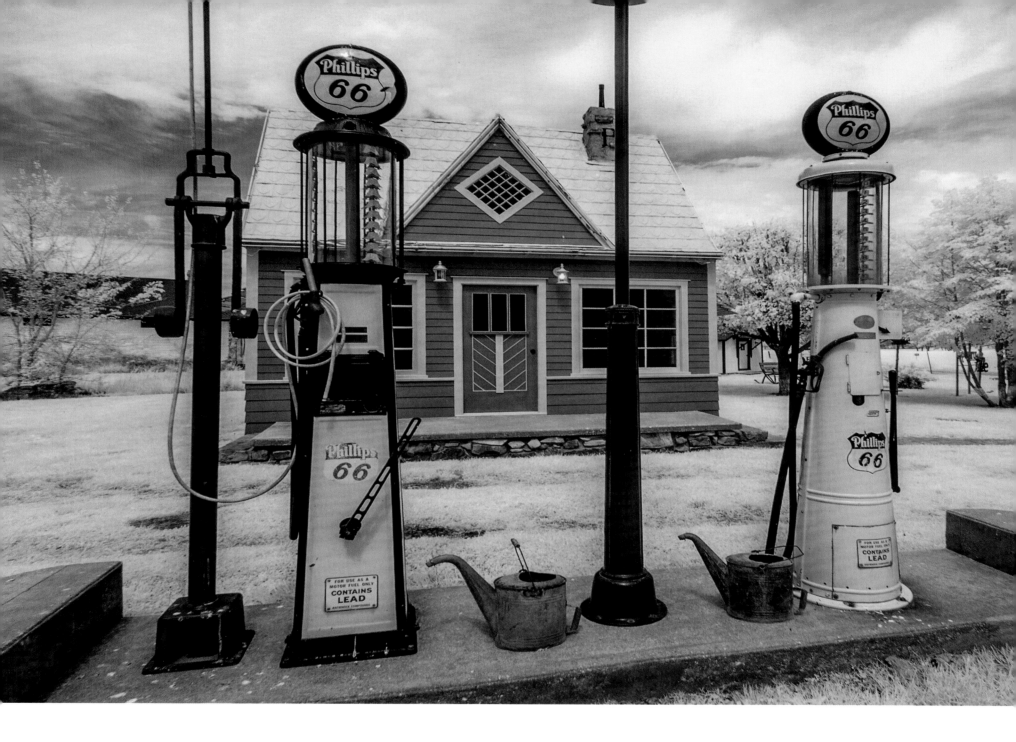

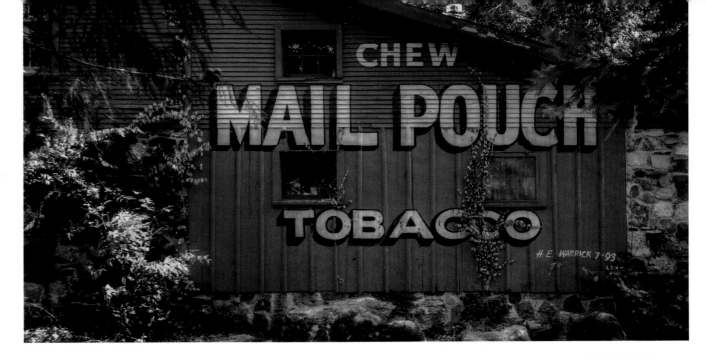

Right: Harley Warrick, the nationally known "Mail Pouch" barn painter, who painted over 20,000 barns, chose the Birdsong to be his last barn to paint before retiring, and is the only one west of the Mississippi river.

Below: Red Oak General Store.

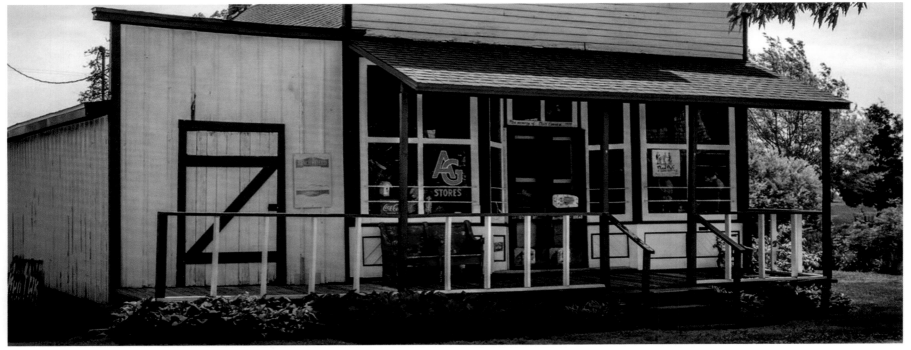

AVILLA, MISSOURI

PIONEERS WHO CAME TO AVILLA in the 1830s and 1840s would have seen beautiful prairie land interspersed with belts of timber and winding rivers, located on the edge of the Ozarks. The town itself was founded in 1858 by D.S. Holman and A.L. Love and is the fourth oldest settlement in Jasper County, Missouri. Avilla was on the Union side during the Civil War and a Union army garrison was established there in 1863. This pro-Union stance resulted in the town being attacked by a group of Confederate raiders headed by Bloody Bill Anderson. Several Avilla men were murdered in the raid. By 1874, Avilla was calm once more and had two churches, a one-room school house, several flour mills, and a post office.

Route 66 came to the town in the 1920s. In 1932, the Irish O'Malley Gang drove along the road to rob the Bank of Avilla, which had been founded in 1915. The gang kidnapped cashier Mr. Ivy E. Russell and sped off west along the Mother Road in a 1929 Model A Ford sedan. Unharmed, Mr. Russell was pushed out of the car into a corn field located outside of Carthage. The road stimulated several new businesses in the town including the Log City Camp, which consisted of several cabins, a gas station, a dining room, and a coffee shop. In 1940, it cost between $1.50 and $3.00 for two people to stay the night there. The town also had a barbershop, beauty salon, Old Flo's Tavern, The Avilla Café, several auto service stations, a seed mill, a Boy Scout meeting hall, and an arena for the local rodeo, the Avilla Saddle Club. In 1946, Jack Rittenhouse

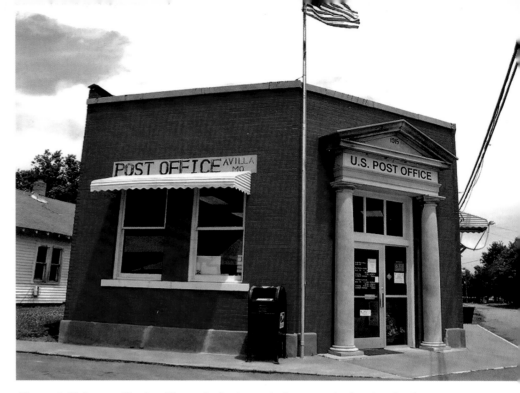

Above: Avilla's post office is still open for business six days a week, closed on Sundays. It is located at 205 Greenfield Street.

counted a population of 176, and noted that the town also had a lumber yard (owned by Raymond Ziler and burned out in 1971) and the Chapman-Follmers farm implement store.

Since Route 66 was bypassed, Avilla has become a ghost town and the population has dwindled to 120. The town still boasts many historic buildings including the red brick Bank of Avilla (now a post office), three churches, a school, and the cemetery. Avilla also has its share of crumbling ruins and abandoned homes and garages, including the Twin Oaks Gas Station just outside the town. A few businesses remain open, including Bernie's Route 66 Café.

THE CENTER OF CARTHAGE BOASTS a beautiful courthouse and a picturesque plaza, but the part of the town next to Route 66 has a more nostalgic feel. The town has a very interesting history. Founded in 1842, it was sandwiched between the Union and Confederate forces during the Civil War and most of the town was burned down in 1864. By the 1890s, Carthage was known as both the "Queen City of the Southwest" and the "Open Gate to the Ozarks." Local deposits of lead, zinc, and marble meant that Carthage had more millionaires living there than any other town in America. The splendid courthouse building was erected in 1894, and cost a massive $100,000. The court presided over many public hangings.

When the Mother Road came to the town a whole new generation of iconic buildings sprang up. Located at "The Crossroads of America" the Boots Motel dates from 1939. Built by Arthur Boots, it is a great example of 1930s streamlined "Modern" architecture. It was built to have every up-to-the-minute convenience including radios in every room, tiled shower cubicles, thermostat climate control, and even air conditioning. Clark Gable was reputed to have once stayed in Room 6. Opposite the Boots Motel, a drive-in restaurant offered travelers a food and fountain service. This closed down in 1971, but the Boots Motel has been restored and re-opened for a new generation of travelers.

The golden age of the road really began after 1945, when the war and gas rationing had ended. A new wave

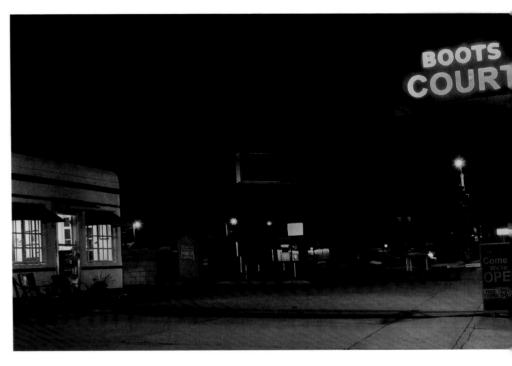

Above: The Boots Court Motel in Carthage, Missouri opened in 1939.

of businesses sprang up at this time to accommodate the leisure tourists that flocked to Route 66. Carthage still has a working drive-in cinema that dates from 1949, The 66 Drive-In Theatre. It is one of the countless drive-ins that used to line the road. Nearly all of these have now fallen into disuse and decay so the Carthage theatre is a rare survivor. Its screen was adapted to Cinemascope in 1953 and the theatre still shows movies today. Other ghostly remnants from this era include the Dazy Apartments and Sleeping Rooms tourist court, and the abandoned C & W Café in Northside Square. This used to be a popular roadside diner for travelers along Main Street USA.

ROUTE 66 IN KANSAS

Opposite: The 1951 International "Tow Tater" truck sits at the Historic Kan-O-Tex service station in Galena, Kansas.

HISTORIC ROUTE 66 PASSES THROUGH the southeastern corner of Kansas for just over thirteen miles. It winds through the Kansas Hills and the Ozark Plateau. It is the shortest state stretch of the road, running along Galena high street in the east to the town of Baxter Springs in the west. The Sunflower State section of the Mother Road was first opened in 1926, and it was the first state-long part of the road to be paved. This was completed in 1929. Although the entire Kansas section of the road was bypassed by Interstate 44 in 1961, it retains much of its original character. It is also the home of several important Route 66 sites including the Steffleback House, Galena's Old Depot, the Galena Motel, the Palace Drug, Murphy's Restaurant, and the Spring River Inn. It also has the last Marsh Rainbow-arched bridge of the hundreds that were built along the route, just a few miles to the west of Riverton. Although it is the shortest section of Route 66, it is also the best signed.

In its heyday, the Kansas section of the road hosted five large trucking companies together with a plethora of businesses that were established to cater to travelers along the road. These included restaurants, roadhouses, filling stations, and stores. By 2002, most of these had closed and fallen into disrepair. Some are now being restored.

The Kansas miles of the Mother Road acted as the entry point to the American Midwest and this has given the area an influential role in history. The area was preyed on by William Quantrill's rebels during the Civil War.

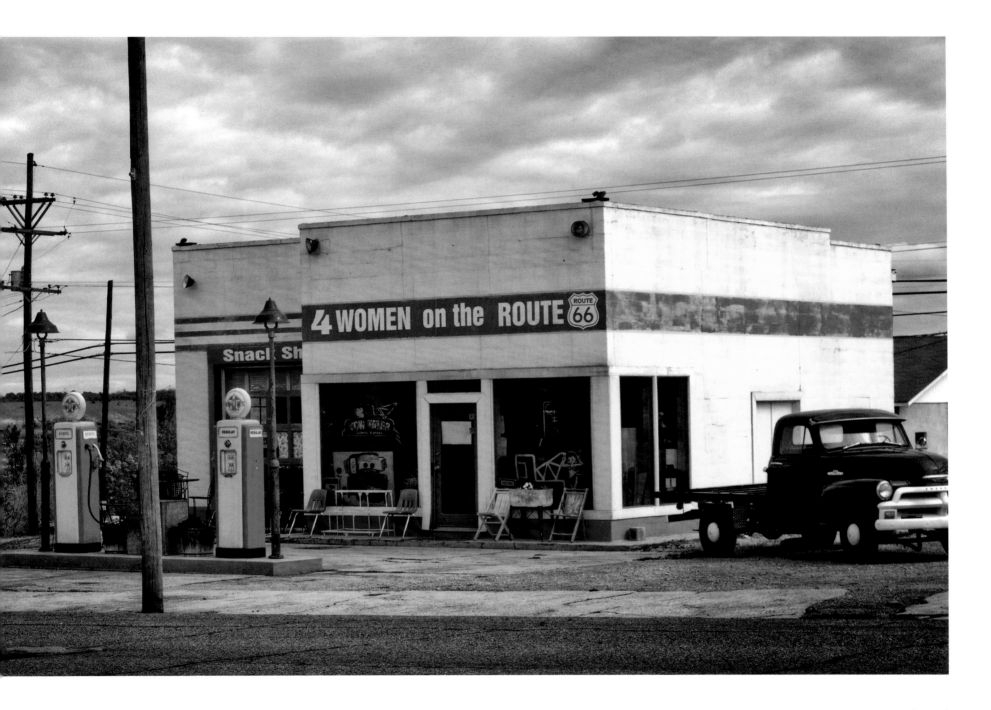

GALENA, KANSAS

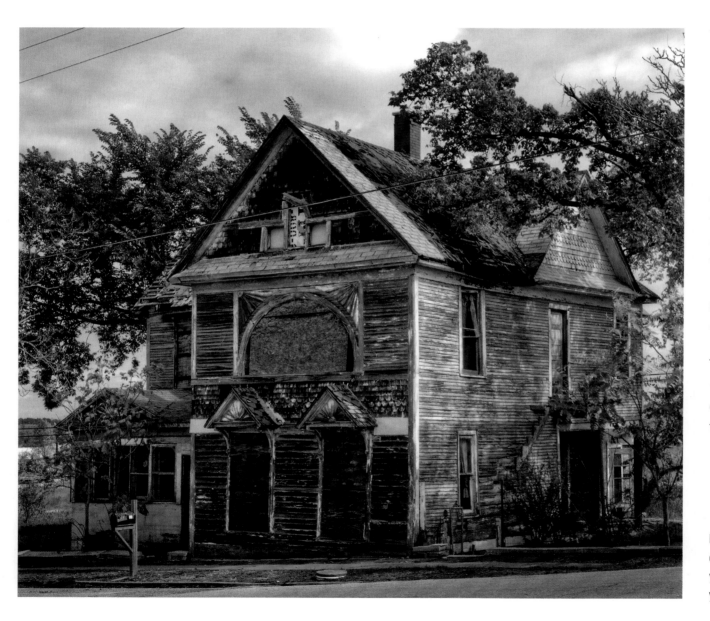

THE DERELICT AND SINISTER looking Steffleback House received national attention in 1897 during the trial of the then owner Mrs. Charles Steffleback and her sons for killing an unknown number of lodgers in her 'bordello' and disposed of the bodies in a mine shaft outside of the home. The victims were lured into the house by the promise of a good time and then robbed and murdered for their money and possessions. The house stands on Route 66 on the mere 16 miles of the road that passes through Kansas.

Left: The Steffleback House stood in this dilapidated and sinister state for many years before being renovated in recent years.

RIVERTON, KANSAS

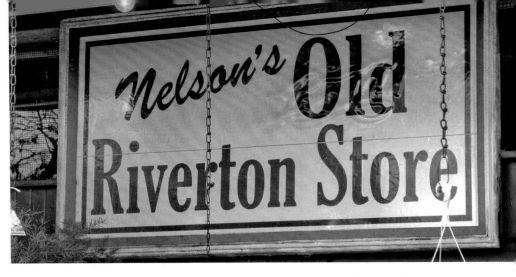

In continuous operation since before U.S. 66 became the official cross-country highway from Chicago to Los Angeles. Still operating as it did "back then," it serves as a stopping, shopping place for the small community of Riverton, as well as for travelers on Route 66. It was nationally familiar in its early days, because this Southeast corner of Kansas literally tied 66 together, and today it is internationally known as one of the most authentic, still working 75-year-old stores of its kind on all of Route 66. It has groceries, produce, flowers, an old time Deli serving excellent sandwiches; gifts (including area handcrafts), lots of Route 66 memorabilia and the friendliness of Yesterday.

It's become a meeting place for those who have grown up on or near Route 66 as well as travelers from New York, Utah, Canada, or even Germany, Japan, and France. It's a fun place where you can relax over coffee at a table on the Produce Porch and perhaps make new friends while you experience and enjoy a glimpse into the past.

Once known as the "Williams Store", Eisler Brothers Old Riverton Store, located on HWY 66 in Riverton, Kansas, received the honor of placement on the National Register of Historic Places. The store at Riverton was also called the Lora Williams AG Food Market for some years. It was built by Leo Williams, owner, in 1925 and has retained "a very high degree of integrity" according to the write-up that came with the information and pictures.

The current building replaced one destroyed by a tornado in 1923, where Lora had served lunches and sold groceries

Above: The Eisler Brothers Old Riverton store retains its original tin ceiling from 1925.

while Leo worked at the Empire District Electric Co.

The existing building originally had an open front porch, but the present closed in porch replaced that in 1933. It is one story, built of hollow, dark red bricks on a concrete slab foundation.

The interior of the Williams' Store in the 1930's. The tables and chairs at the front show where customers enjoyed their barbecue sandwiches and home made chili.

The interior has changed little since 1925. It is divided into two primary spaces, the east section which was, and is, used as the commercial area and the west section consisting of three rooms in a linear arrangement with a small bath, (added later) which was the residence of Leo and Lora Williams and their daughter, Jane Marie. The kitchen was in the commercial part just west of the meat lockers. A pressed metal ceiling is used throughout the building.

In the 1940s the Williams family moved their residence to the house next door to the store. Today the front part

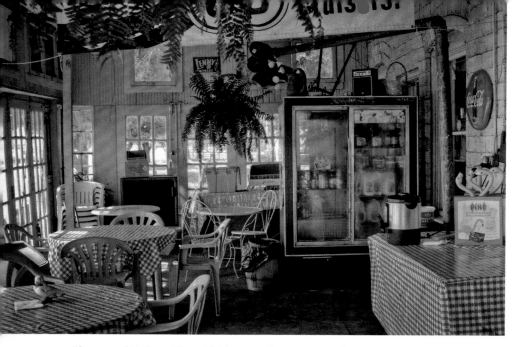

Above and Below: The old Riverton Store is now known as Nelson's Old Riverton Store. It remains a Route 66 landmark and gift shop.

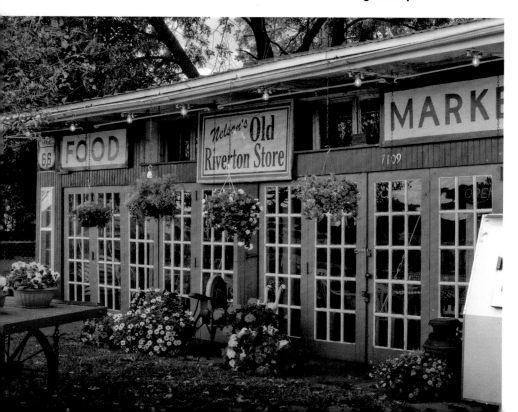

which was originally the living room, houses Route 66 merchandise and souvenirs.

There were gasoline pumps in front of the store for many years, leased first to Texaco and later to Standard Oil. The store itself carried everything from groceries to general merchandise-shoes, clothes, milk, fresh meat, a wide variety of goods. Leo also barbecued beef and venison in a pit behind the store and served sandwiches to customers. Lora served her special recipe of chili.

Customers were mostly local people, but the store also played an important role on Route 66 as the traffic increased through the late 20s, 30s, 40s and 50s.

There were originally two outhouses back of the store. One now remains, painted white and a thin moon silhouette cut into the door. The papers concerning the property say, "..this resource is contributing to the nomination."

Leo and Lora Williams ran the store until 1945 when they leased the grocery to Lloyd Paxson. Leo died in 1948, so when the Paxson lease expired, Lora returned to the store and operated it until about 1970.

Joe and Isabell Eisler of Allen, Texas, purchased the business in 1973. It has continued to operate as a grocery and deli, just as it had, with very little changes in its decor. The store was managed for the Eisler's by their nephew, Scott Nelson. Scott purchased the store March 31, 2011 from the estate of the Eisler's. Scott is the President of the Route 66 Association of Kansas.

BAXTER SPRINGS, KANSAS

BAXTER SPRINGS IS A FEW MILES FURTHER DOWN THE ROAD. In 1926, its downtown main street became part of Route 66. The town was first settled by John J. Baxter in 1849 on a hundred and sixty acres of land but the area was known to Native Americans for the healing properties of its waters. He started an inn and general store known as Baxter's Place near what is now known as Military Road. Baxter himself was killed in a gunfight and never saw the town develop.

During the Kansas cattle drives, Baxter Springs became a wild cow town. Cattle were brought up from Texas to be shipped East by railroad. At one time up to 20,000 head of cattle would pass through the town at a time, but as the railroad extended into Texas the cattle trade dried up.

Baxter Springs saw action during the Civil War when William Quantrill's Confederate Raiders massacred General James Blunt's men in The Baxter springs Massacre, a surprise attack that happened just outside the town. Some of Quantrill's victims are laid to rest in the National Cemetery to the east of Baxter Springs.

The town is also famous for the number of robberies it has sustained. Notable perpetrators include Bonnie & Clyde (twice), the James-Younger Gang, and the Starr Gang. The town's proximity to the Missouri and Oklahoma borders made escape across the state lines very easy.

This old cottage style Phillips Filling Station along Route 66 in Baxter Springs has an attached garage. It was run by Burl Chubb in the 1940s and 1950s. It is now the Route 66 Visitors Center.

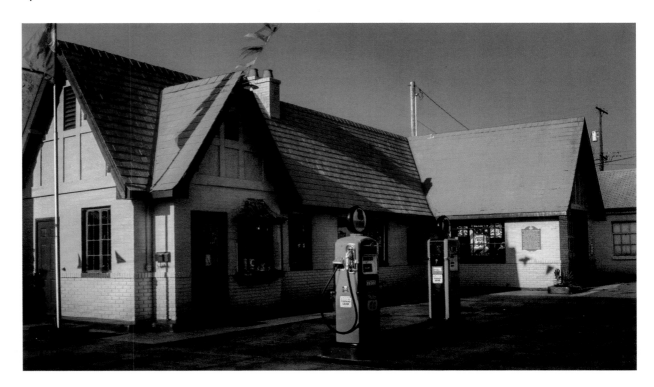

Right: A typical cottage-style gas station.

ROUTE 66 IN OKLAHOMA

THE 375 MILES OF ROUTE 66 that passes through Oklahoma is the longest drivable stretch of the road. Over half a million people live along the Oklahoma portion of Route 66, which passes through Oklahoma City and Tulsa. The road once gauged the success of the US economy and carried millions of American families on the road to riches. In Oklahoma, 200,000 "Okies" used the road to flee from the 1930s dust bowl and Depression to California. It now meanders past charming small towns, roadside diners, shops, theaters, museums, and wide open plains. These include the Route 66 Museum in Clinton. The Vintage route is also home to several Historic Places

that appear on the National Register of Historic Places and many quirky attractions. These include the blue whale, Foyil's Totem Pole Park, Pop's Soda Ranch (home to 600 crazy flavors) and a unique style of motels and roadside diners.

The road crosses the state in a great arc that runs from Quapaw in the east of Oklahoma to the town of Texola in the west. It was opened on December 7, 1926 (when Oklahoma had only been a state for twenty years) and was de-commissioned on April 1, 1985. Cyrus Avery's influence ensured that by 1937, the Oklahoma stretch of Route 66 had a good driving surface. The road consolidated a series of unpaved state roads that had first been built in 1916. The road was gradually straightened and resurfaced between 1926 and 1951, and was shortened by forty-seven miles. The road was widened between 1955 and 1961 and the new road by-passed several towns. The Father of Route 66, the famous Cyrus Avery, was a businessman from Tulsa, Oklahoma and was certainly familiar with the original route.

Oklahoma has preserved more miles of the original vintage pavement of Route 66 than any other state. It was the first state to sponsor a Route 66 museum and was the first to install historic markers along the route. It is also home to many buildings on the National Register of Historic Places. Oklahoma was the final haven of several Native American tribes and promotes their heritage along the route.

Opposite: The faded Quapaw murals celebrate the area's long-gone mining industry.

QUAPAW, OKLAHOMA

IN THE FAR NORTHEASTERN CORNER of Oklahoma, the abandoned Mother Road runs through relics of a former lead and zinc mining region. Quapaw is the first Oklahoma town that the traveler comes across. It is still pretty and charming, although many of its buildings are boarded up and deserted. Several of the buildings have beautiful murals painted on them. Several of these celebrate the defunct mining industry that was once central to the community.

COMMERCE, OKLAHOMA

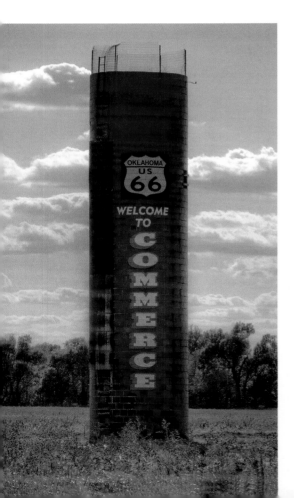

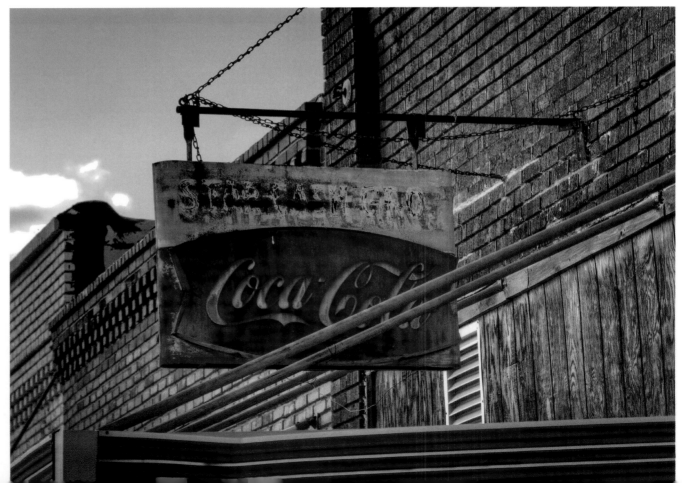

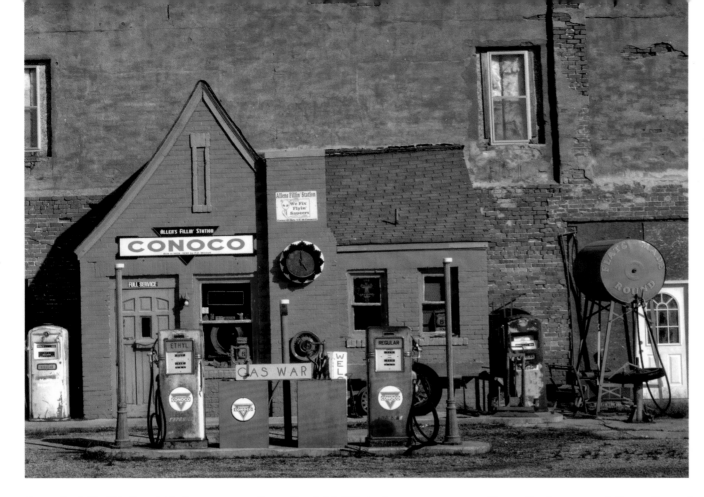

Opposite left: Old silo outside Commerce Oklahoma on Route 66, welcoming visitors.

Opposite right: Old sign hangs on a shop in downtown Commerce.

Above: The Conoco gas station on the west end of main street in Commerce, Oklahoma was first operated around 1930. It was built onto the side of the last building on Main Street and resembles a French cottage-style building.

COMMERCE IS SIX MILES on from Quapaw, past several large chat heaps that are the remains of the Oklahoma lead and zinc mines. In 1914, the town was named for the Commerce Mining and Royalty Company. In 1934, Bonnie and Clyde blew into town on Route 66 for an ill-fated visit that began their final downfall. They murdered one local policeman, Constable William Calvin Campbell and kidnapped the Chief of Police Percy Boyd. Route 66 gradually became overcrowded and dangerous. It was by-passed by the multi-lane Turner and Will Rogers Turnpikes in 1957. As the road travel dwindled and the local mines closed in the 1960s, many local people returned to agriculture and ranching.

AFTON, OKLAHOMA

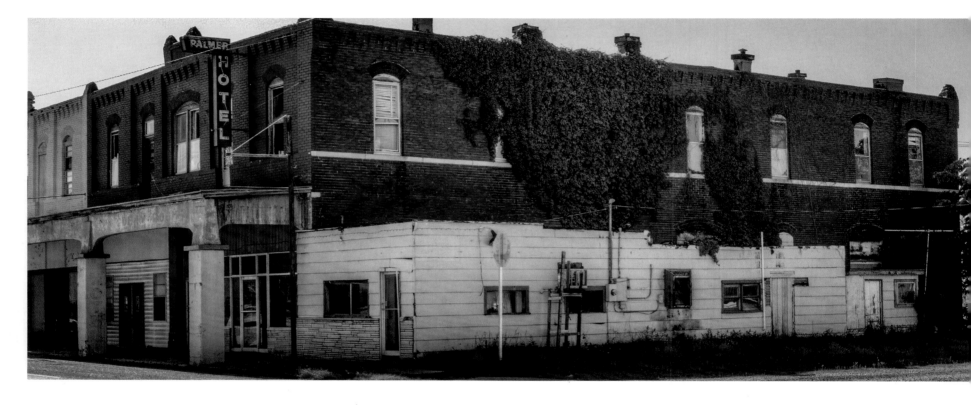

AFTON WAS ESTABLISHED IN 1886 as an agricultural community and grew prosperous on the area's rich black soil. During the Route 66 years, many businesses sprang up to service travelers along the road. The town was at the southern tip of the 1926 alignment of the road. This old section of the road included the so-called "nine-foot section," where cars travelling in opposite directions had to veer into the gravel at the sides of the road to pass. This section was also known as the "sidewalk highway" or "ribbon road." It crossed the town from east to west. The new businesses included several motels (including the Avon Motel, Palmer Hotel, Rogers' Motel, Green Acres Motel, and the Rest Haven Motel), tourist courts, eating houses (including the 1932 Baker's Café), shops (including Bassett's Food Store) and filling stations. The most famous roadside attraction at Afton was the now defunct Buffalo Ranch, opened in 1953. Many of these businesses failed when the town was by-passed by Interstate 44.

Opposite: Closed down in 1991, the Palmer Hotel has nothing but a faded sign to recall busier times along the Mother Road.

Right: The faint and rusty sign outside the remains of the Rest Haven Motel recalls a time when it offered welcome repose to Route 66 travelers.

The faded and lonely remains of the 1930s Avon Motel eerily haunt the roadside. John Foley opened the business in 1936, and ran it with seven units that each had a covered carport. It was then operated by W.R. Trebilcock between 1951 and 1955, and by Harry Glover between 1955 and 1958.

The Palmer Hotel was a prominent local business, opened before the motor era in 1911. Its brick structure was built to replace an earlier wooden building that burned down, positioned next to Palmer and Shelton Furniture. A café was added to the hotel in 1940. Between 1952 and 1991 the hotel was run by Alvin and Lulu Malone. It then closed down, leaving nothing but a faded sign, a brick façade, and a lonely covered sidewalk out front.

Very little survives of Afton's Rest Haven Motel except the rusty sign. It has now been closed to guests for many years and very little is left of the original structure. What there is has been re-purposed as cheap housing. The Motel was located to the east of Afton station on the north side of Route 66.

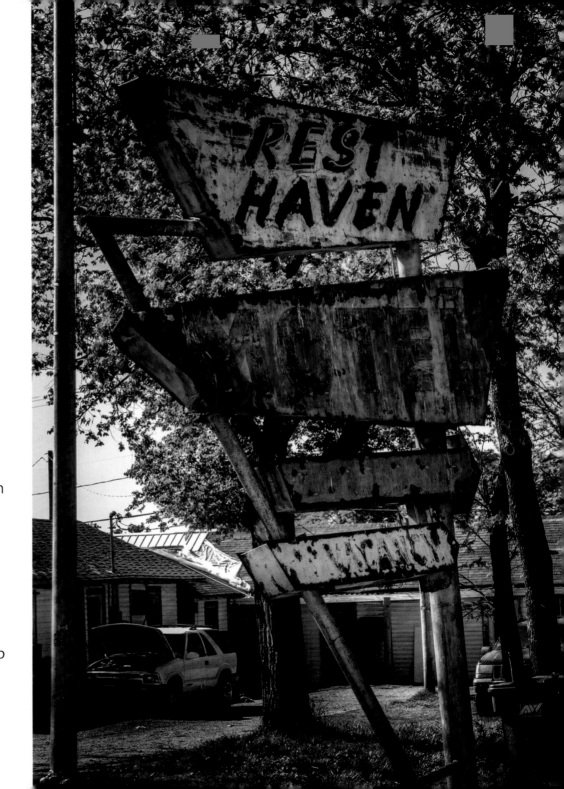

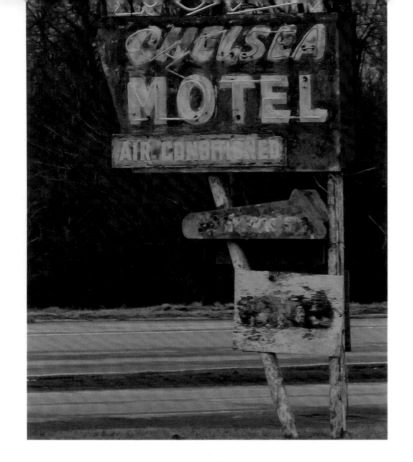

CHELSEA, OKLAHOMA

CHELSEA WAS THE SITE OF OKLAHOMA'S first oil well, on land once owned by the Cherokee tribe. Edward Byrd discovered the oil and organized the United States Oil and Gas Company. The first oil well was dug there in 1889. It produced about one half barrel per day which was used as "dip oil" to remove ticks from cattle. The oil well is located one mile south of highway 66. The remains of the Chelsea Motel is one of three buildings in Chelsea that are listed on the National Register of Historic Places. The motel was once one of the most prominent businesses on Chelsea's Walnut Avenue. Its elaborate neon sign remains as a reminder of the glory days of Route 66.

Left: The Chelsea Motel is a simple stucco building with six sleeping units.

CATOOSA, OKLAHOMA

THE TULSA PORT OF CATOOSA is the furthest inland seaport in the United States. It is also the home of one of Oklahoma's most famous Route 66 sights, the giant blue whale. The whale was built as the centerpiece in an animal-themed

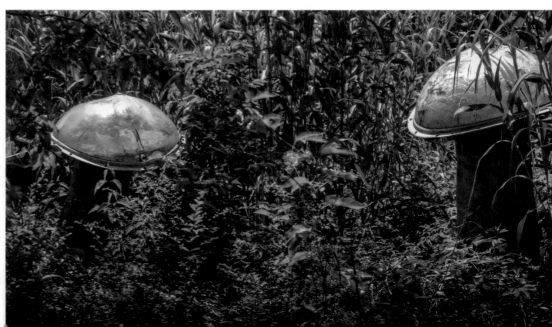

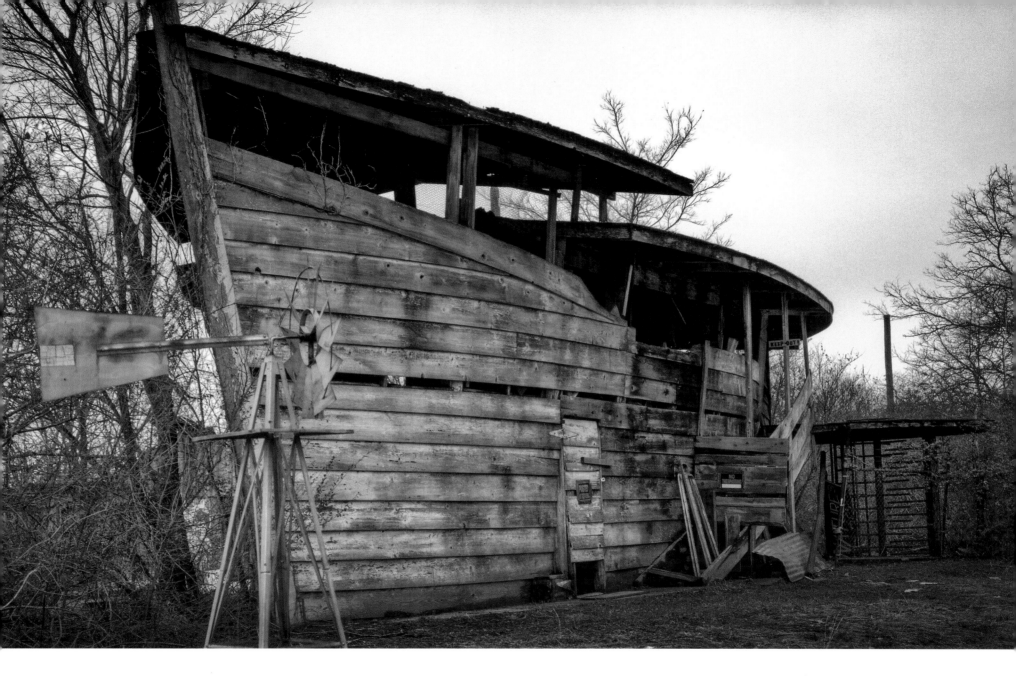

Opposite right: The ARK's (Animal Reptile Kingdom) man-sized wooden mushrooms nestle into the undergrowth.

Above: The ARK was built by retired zoologist Hugh Davis for his wife Zelta and their family. It soon became an iconic Route 66 attraction. It closed down in 1988.

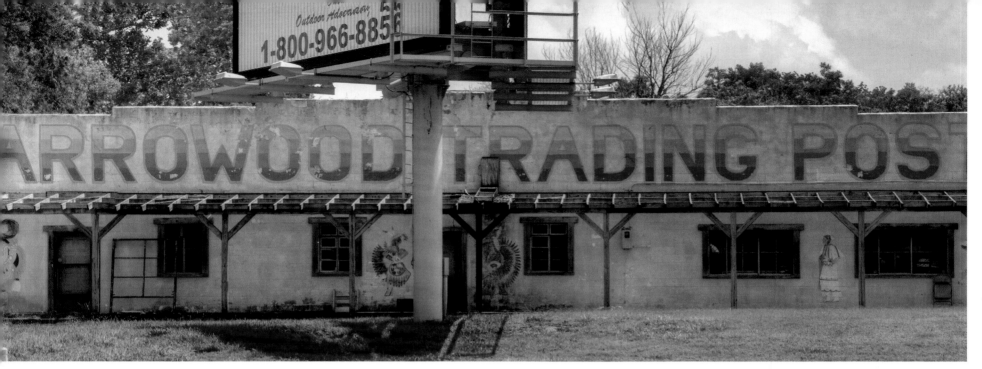

Above: Chief Wolf-Robe once ran the Arrowood Trading Post.

amusement park. This eccentric park was the creation of Hugh and Zelta Davis. Hugh was the curator of Tulsa's Mowhawk Zoo and was also a renowned wildlife photographer. The blue whale was built between 1970 and 1972. You can still walk into the whale's mouth, but the park's man-sized wooden mushrooms are even more weird, nestled into the woodland floor.

The Arrowood Trading Post is located just across the highway from Catoosa's blue whale. Formerly a trading post, the Trading Post now serves as a performance car shop.

Opposite: The sun sets behind the Rock Creek Bridge in Sapulpa, Oklahoma. The bridge is one of the best examples of steel-truss bridges in Oklahoma. It was constructed in 1924 as part of the route 66 Ozark Trail. It served the route until 1952.

Right: Catoosa's Blue Whale is surrounded by a stream-fed pond.

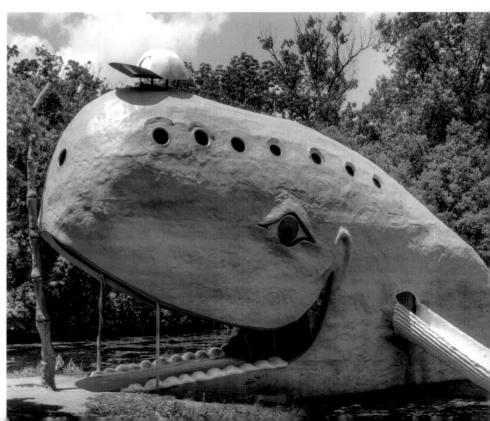

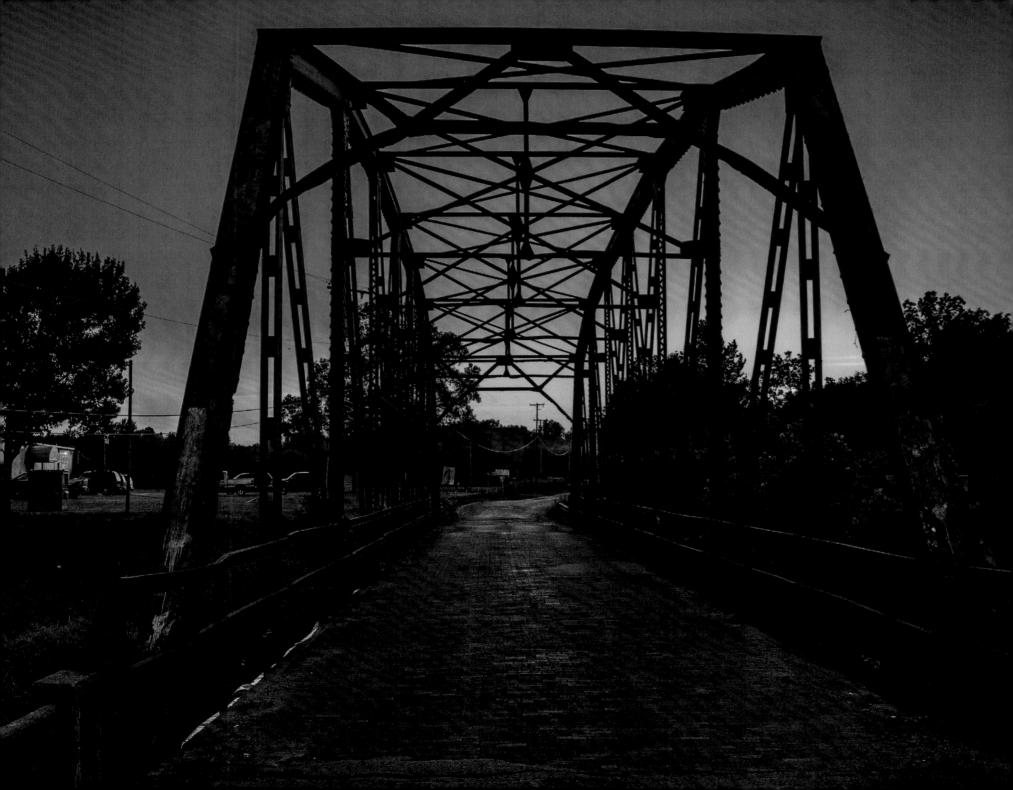

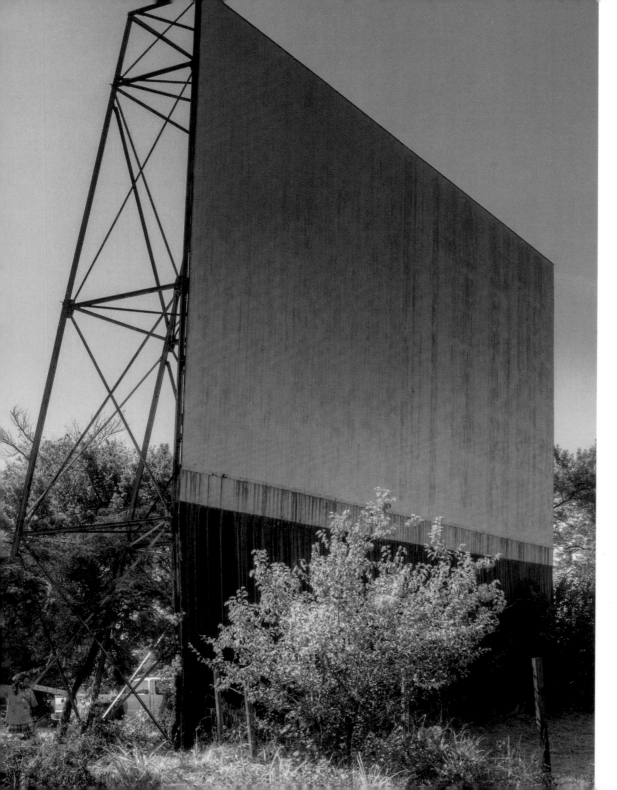

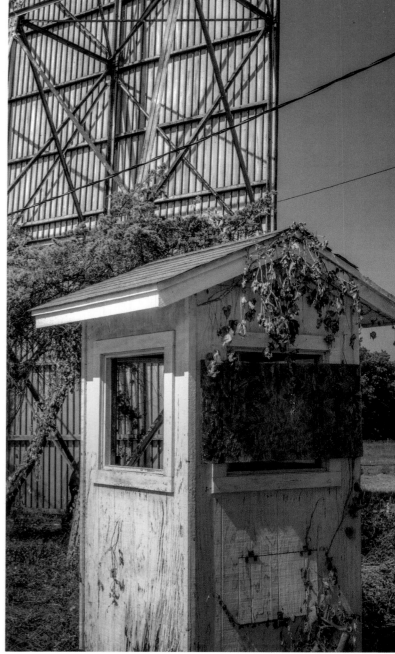

Left, above and opposite: The old drive in movie theater is now abandoned with its giant screen stranded in the middle of a field.

DRIVE-IN MEMORIES OF ROUTE 66

THE GOLDEN AGE OF ROUTE 66 coincided with that of the drive-in movie theater. Drive-in Theaters became icons of the road and American culture itself, combining the movies with car culture. Over four thousand were constructed in the 1950s. They were promoted as a great family night out, but their real market came from young people who could escape their parents' watchful eyes for a few hours. Drive-ins blossomed along the route from Chicago to Los Angeles in the 1950s. They had a ready market from entertainment-hungry travelers. Television started to rival the cinema in the 1950s, and movie studios moved to widescreen format to differentiate their product from broadcast television. From 1953 onwards, many drive-in screens were widened to reflect this.

The Tee Pee Drive-In was built in 1950, just west of Sapulpa in the outskirts of Tulsa. It had a capacity of four hundred cars. Passing through the hands of numerous owners, the theater operated until 2000. It is now abandoned and overgrown with its giant screen stranded in the middle of a field. The Tee Pee reflects the fate of many other movie theaters, with only 366 operational drive-ins in operation in the United States.

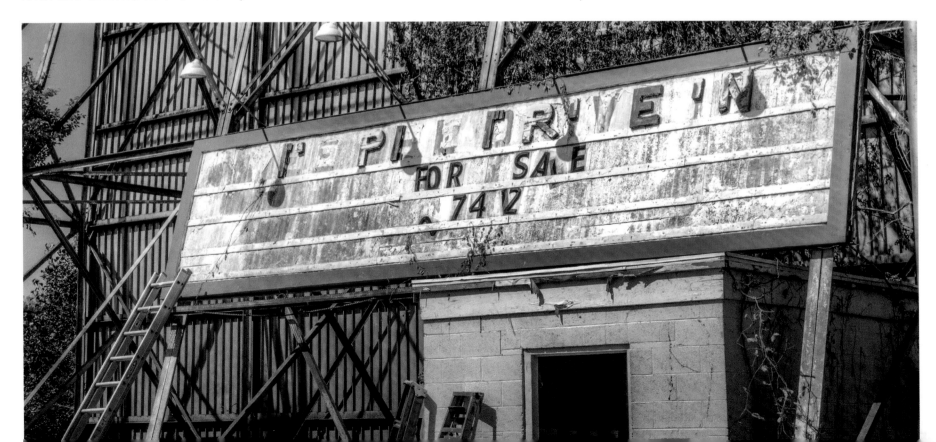

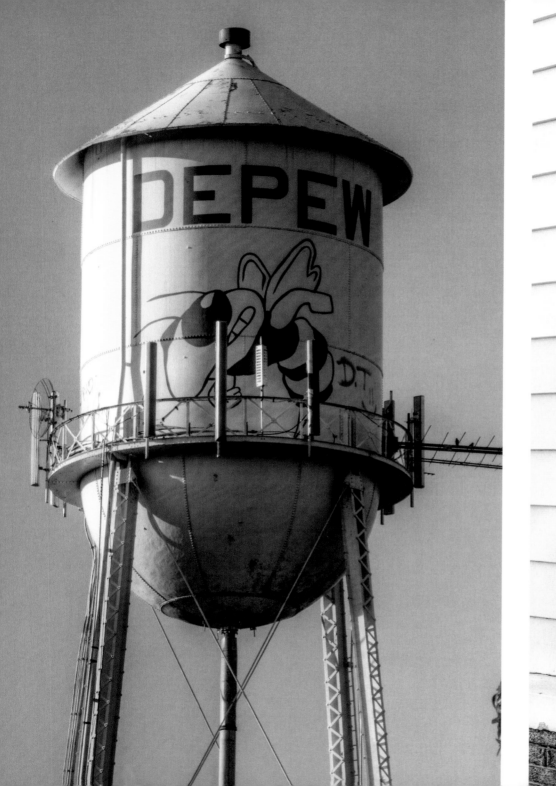
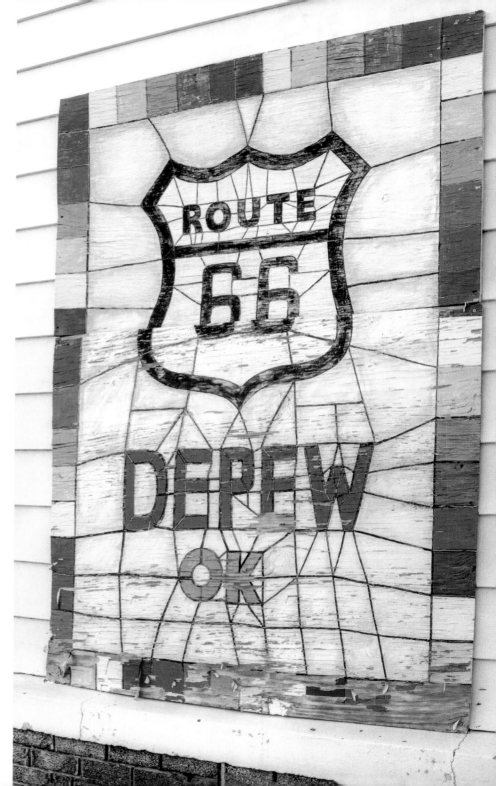

DEPEW, OKLAHOMA

DEPEW WAS FOUNDED IN 1901 AND NAMED FOR Senator Chauncey Depew. In 1909 the town was devastated by a double twister. But the town was rebuilt and the local dirt road was consolidated into the paved highway of Route 66. The first alignment passed through the town, and the concrete road surface is still in use. The current 1928 route of the

Opposite Left: The Depew Bumblebees water tower was manufactured by the Chicago Bridge and Iron Works in 1923.

Opposite Right: Depew has several faded street murals that recall its colorful past.

Right: Spangler's Grocery store was one of the businesses that closed down when the road was by-passed.

Below: Depew's Sinclair Gas Station was owned by the Gimmel family. It is now abandoned.

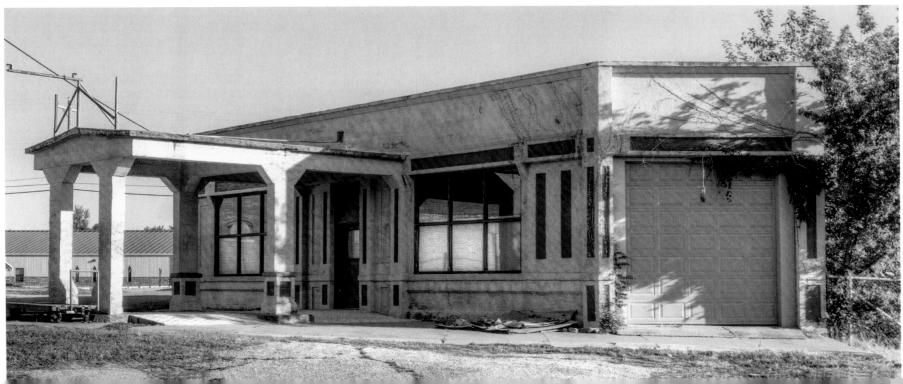

Mother Road by-passes the town to the north. Several businesses sprang up along the road. A derelict gas station stands at one end of Main Street. During its working life, this was a Sinclair Gas Station and owned by the Gimmel family. Main Street is now flanked by a host of abandoned and shuttered businesses, including the Coppedge Drug Store and Spangler's Grocery.

The Depew Bumblebees water tower was finished in 1923. The 60,000 gallon tank was built by the Chicago Bridge and Iron Works. It rests on ninety-seven feet tall steel supports, which are eight feet wide at the base.

Right: Depew was an oil boom town before it dwindled to a shadow. Its main street is lined with derelict buildings from the early statehood era.

STROUD, OKLAHOMA

STROUD'S ROCK CAFÉ WAS FIRST OPENED in 1939 as the local stretch of Route 66 was being paved. It was built in the craftsman bungalow style by Roy Rieves. It was named for the sandstone used in its construction. Rieves paid $100 for the land and the stone cost a further $5. The café has been remodeled many times since then. Between 1959 and 1983 it was operated by Mamie Mayfield, who became a legendary hostess among long-haul truckers and road trippers on the old Mother Road. The current proprietor is Dawn Welch, a prodigious cook who credits the goodness of her food to the vintage griddle in the kitchen, which she describes as having been "seasoned for eternity." Dawn is reputed to be the basis of the animated character Sally Carrera in the Pixar film *Cars*.

The Rock Cafe survived a devastating fire in 2008 and was repaired with a bigger dining room, but with the same cozy local-cafe spirit. Stroud bills itself as the heart of the heartland and has now pretty much gone to sleep.

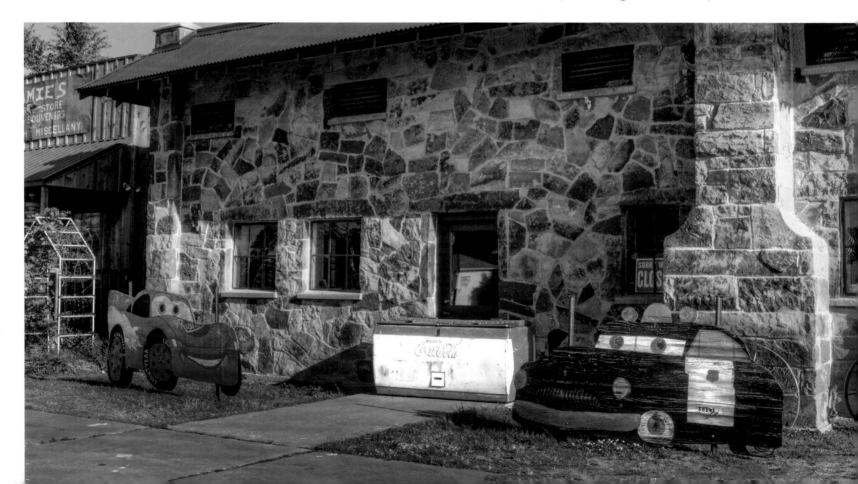

Right: Stroud's Rock cafe became legendary among Route 66 truckers for its great home-cooked food.

CHANDLER, OKLAHOMA

ROUTE 66 PASSES THROUGH HISTORIC downtown Chandler, Oklahoma. The town was established by a land run on September 28, 1891. In the twentieth century, Route 66 brought a wave of commercial business to Chandler, but when the Turner Turnpike (Interstate 44) by-passed the town, the town settled into a steady decline.

Built in 1903 and opened in 1904, the St. Cloud Hotel is located at 1216 Manvel Avenue. This area is known as "Gormley's Block" and was the property of local pioneer John Edward Gormley. It was placed on the National Register of Historic Places in 1984. The brick, two-storey building is now deserted and in a state of disrepair. It has some very nice vintage advertising signs painted on the south-facing wall of the building. When the hotel business failed, the building was used as a warehouse, cabinet makers, and a garment factory.

Today, rows of deserted shops and abandoned businesses line Chandler's empty streets, sadly recalling the busier times of years gone by.

Right: Chandler's abandoned St. Cloud Hotel has been on the NRHP since 1984.

WARWICK, OKLAHOMA

fide ghost town, with abandoned businesses and houses.

Warwick's first school was held in a log cabin that was also used as a church. A solid block building was constructed in 1909, to be replaced by a solid stone school in 1940. As the town shrank, the school was finally closed down in 1968.

Left: John Seaba opened the Seaba Service Station in 1921.
Below: The Seaba Station is now a motor cycle museum.

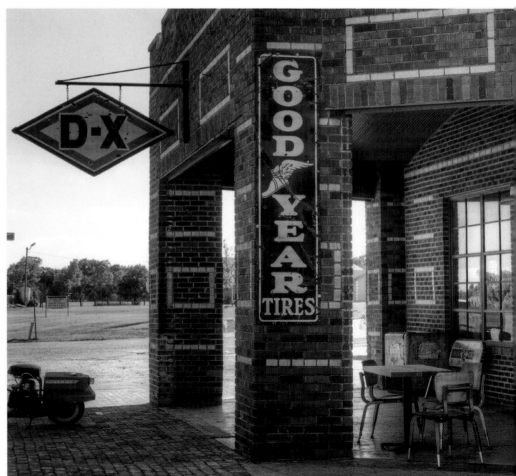

WARWICK WAS ONCE A THRIVING TOWN replete with stores, filling stations, hotels, a cotton gin, bank, post office, saloon, blacksmith, drug store, saw mill, veterinarian, and a newspaper. The town was first settled by David and Nora High in 1891 as the centre of an agricultural community. But once the town's St. Louis & San Francisco Railway depot shut down Warwick slowly died and is now a bona

ARCADIA, OKLAHOMA

THE GHOST TOWN OF ARCADIA was established soon after the Land Rush of 1889 and became home to both white and African American cotton farmers. The Missouri, Kansas and Texas Railroad constructed a line between Bartlesville and Oklahoma City between 1902 and 1903 which passed immediately south of Arcadia.

The arrival of Route 66 stimulated the establishment of many local businesses, including the Rock Gas Station. Located just east of Arcadia on Route 66 the business was a Conoco Station in the 1920s. It was constructed with two pumps, one for regular gas and one for higher-octane ethyl. Oil and kerosene were served from fifty-gallon drums. As there was no local electricity supply, kerosene was used for heating and lighting. The gas station also sold soda, candy, and chocolate. The Rock Gas Station is one of the last gas stations still standing in this part of the country.

Cold soda pop was sold only on days when the ice man made it by. The pop was put in a large metal box with chipped ice over it. Hard candy was sold most of the time; chocolate was sold only in the winter, because in the summer it would melt — since there were no refrigerators.

Even during the Route 66 years, it was difficult to make a living from these wayside gas stations, and there is a rumor that the owners counterfeited ten dollar bills to make ends meet.

Arcadia is now home to a sixty-six foot tall futuristic sculpture of a soda bottle, and the town's iconic Round Barn.

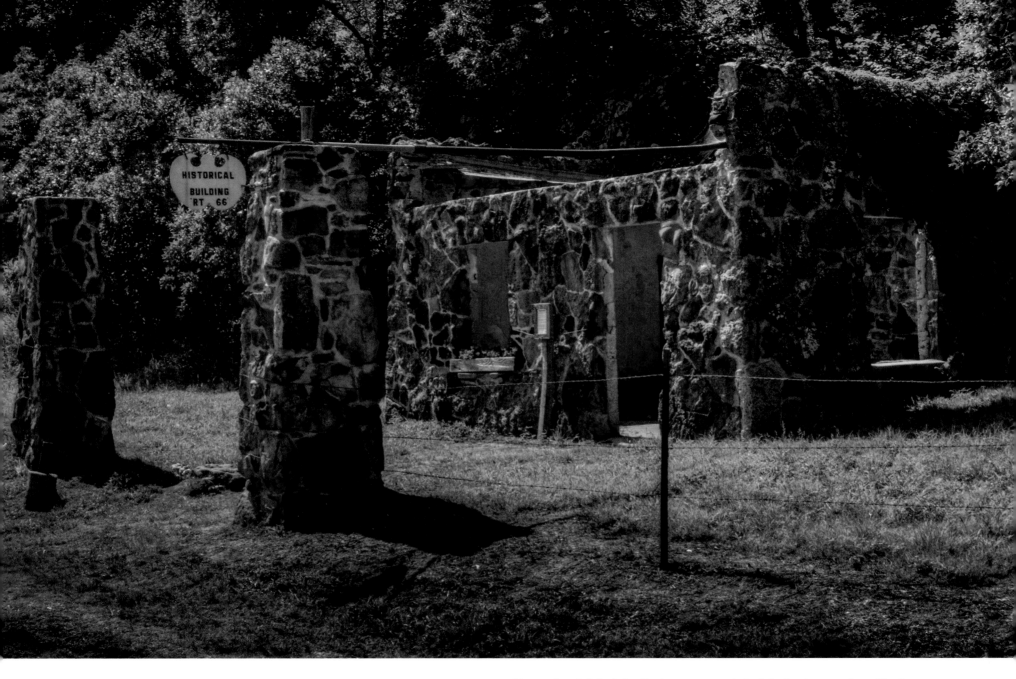

Opposite: The old alignment of Route 66 as it runs through Arcadia, Oklahoma.

Above: Arcadia's Rock Gas Station was once a hub of the local community, selling kerosene, candy, and chocolate.

EL RENO, OKLAHOMA

EL RENO WAS FOUNDED IN 1889 but is now most famous for its annual Fried Onion Burger Day Festival, held on the first Saturday in May and celebrates the cooking of the world's largest fried onion hamburger, weighing over 850 pounds. The giant burger consists of meat, fried onions, sliced pickles, and mustard all served between two huge buns.

Jobe's Drive In was opened alongside Route 66 in 1958. Robert Sanders bought the restaurant in 1969, serving Jobe's famous char burgers and hickory sauce. Sanders ran the restaurant until he and his wife Dorothy were involved in a very serious car accident in 2014. Very sadly, Dorothy died in the crash and Robert was left with serious injuries. In June 2015, about four-hundred people celebrated the closure of the Jobe's with a Last Cruise past the restaurant. Only the sign remains.

Right: Jobe's Drive-In finally shut its doors in 2015.

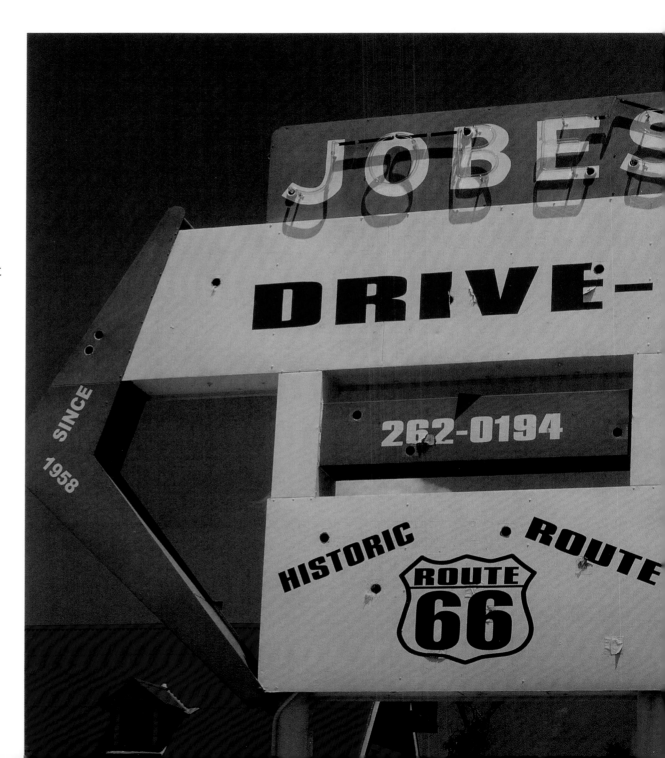

HYDRO, OKLAHOMA

HYDRO WAS FOUNDED IN 1901 and named for the sweet local well water. It was an agricultural community until the advent of Route 66 diversified the economy into the service sector. Lucille's was built by Carl Ditmore in 1927 and is an almost perfect example of a service station of the time. Located at the Provine Intersection of Route 66, the Provine Station became a magnet for other service businesses including the Hilltop Café, a Texaco service station, and Kirk's Court and Café. Carl and Lucille Hamons bought the business in 1941 and re-named it Hamons Court. Hydro was the scene of a nationally recognized tragedy in 1948 when a flash flood affected a five-mile stretch of Route 66. A Greyhound bus and over fifty cars and trucks were stranded by a twelve-foot wall of water. At least six travelers were killed and many more were listed as missing.

Although Hydro was by-passed by Interstate 40 in 1962, the restaurant survived. The original Hamons Court sign blew down in 1974 and the gas station was re-named Lucille's. It became one of the most-photographed icons along Route 66, which was de-certified in 1985. Lucille Hamons died in August 2000 and her gas station and motor court is now empty. Route 66 enthusiast Rick Koch opened a new Lucille's Roadhouse in Weatherford, Oklahoma.

Right: Carl Ditmore built Lucille's in 1927. It now stands as an empty but much-photographed icon of the Mother Road.

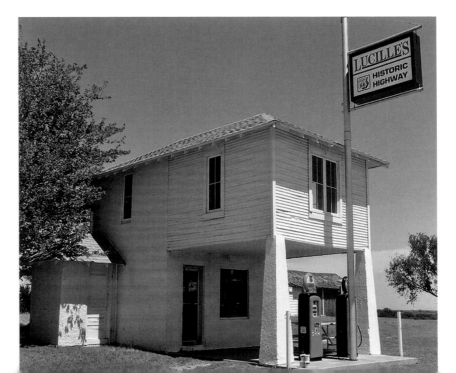

FOSS, OKLAHOMA

First settled during the 1892 Cheyenne and Arapaho Opening, Foss is a now a ghost town with just a smattering of inhabitants. It was named after J.M. Foss, the postmaster at nearby Cordell, Oklahoma. Kobel's was once a thriving gas station for travellers along Route 66. It also served as a café and bus station. But as the town was bi-passed by Route 66 in 1931 and was completely abandoned with the building of Interstate 40. Gradually, Kobel's business failed and was abandoned. The shell of the building is now filled with assorted trash and detritus and presents a sad and derelict appearance.

Right: Kobel's Place Gas Station is now just a few ruins at the intersection of former Route 66 and Broadway, half a mile south of Foss. The site now has cracked walls, peeling paint, and is overgrown with trees.

Opposite: The ruins of the vintage service station are at the south west corner of the intersection of Route 66 and Broadway.

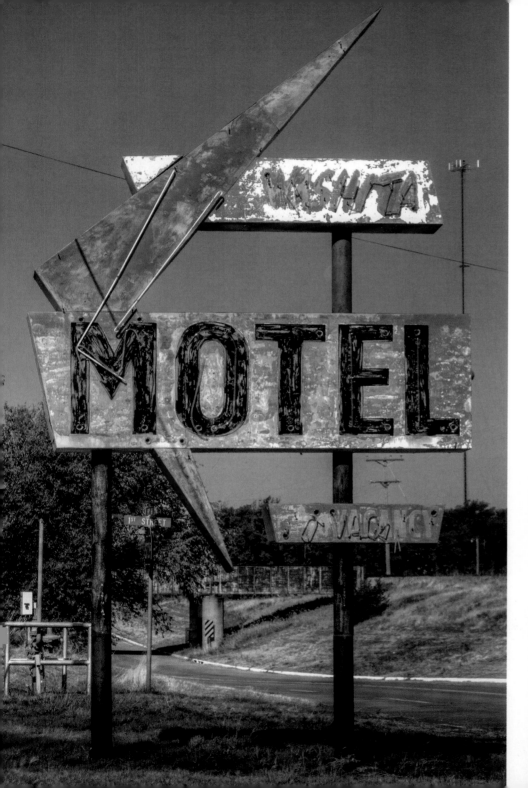

CANUTE, OKLAHOMA

CANUTE WAS ESTABLISHED IN 1899 as a stop on the now defunct Rock Island Railway. The small town then became a popular stop on Route 66, with many gas stations, motels, night clubs, soda shops, and restaurants. In 1970, Canute was bi-passed to the north by Interstate 40 and the town began to wither and die. Its end was hastened by the closure of the nearby Clinton-Sherman Air Force base. David Lee Walters, the twenty-fourth Governor of Oklahoma was born in the town in 1951 and raised on a nearby farm.

Woodrow and Viola Peck, former cotton farmers, opened the Cotton Boll Motel in Canute in 1960. But the business plummeted when the town was bi-passed and the Cotton Boll finally closed in 1979. Only the nostalgic motel sign has survived.

The now-abandoned Canute Service Station opened as

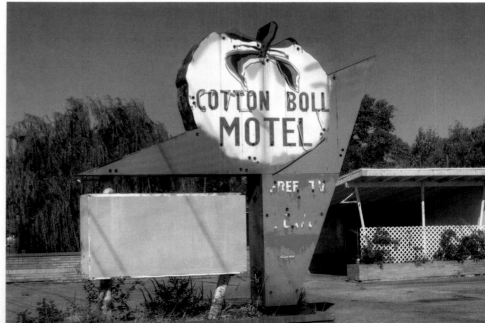

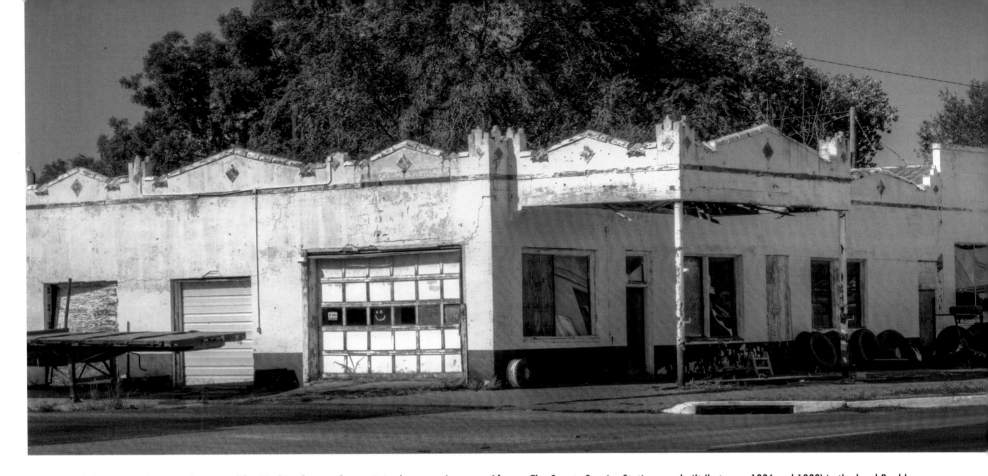

Opposite left: The Washita Motel is named for Washita County. Canute is in the county's northwest corner.

Opposite right: The iconic neon sign of the Cotton Boll Motel stands alongside the Mother Road in Canute. The motel now stands derelict and weeds have strangled the flowers that once grew beneath the angular sign.

Above: The Canute Service Station was built (between 1936 and 1939) in the local Pueblo deco style (popular along Route 66 in the southwestern states). It is a one-storey concrete block building with stuccoes walls. The canopy and corners are castellated with triangular pediments decorated with red tiles and diamond-shaped inserts.

a roadhouse in 1936 and the gas station was added in 1939. The former Sinclair station is located on Route 66 in Canute Oklahoma and was listed on the National Register of Historic Places in 1995. Its castle-like rooftop and canopy details are more elaborate than the standard gas station design. The Station is often referred to as Kupka's

Service Station, as various members of the Kupka family ran it for many years. It is said that Elvis Presley stopped here for gas on more than one occasion.

Canute's Washita motel is long-closed but its sign lingers on. Named after the county in which it stands, the motel was one of Canute's hospitable roadhouses.

SAYRE, OKLAHOMA

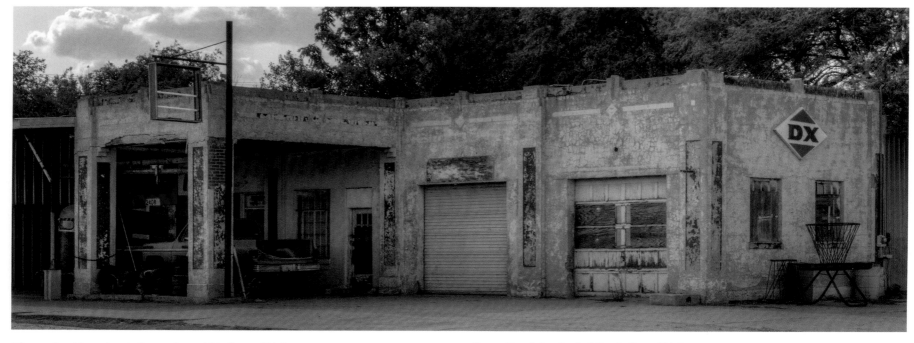

Above: An old service station on Route 66 in Sayre, Oklahoma.

Opposite: A derelict building in Hext, Oklahoma.

ALTHOUGH SAYRE IS THE LAST SUBSTANTIAL TOWN along the western Oklahoma stretch of Route 66, it was served by only a couple of motels. These were the Western Motel and the sixteen-room Sunset Motel. The latter was a collection of small ranch style buildings dwarfed by a huge neon sign. It is now one of many faded signs that adorn Sayre's quiet streets. The Sunset also offered individual garages for the guests' cars. Sayre is also home to the Beckham County Courthouse, with its massive Tuscan columns, which makes an appearance in Steinbeck's *The Grapes of Wrath*.

DX was a popular gas brand in Oklahoma. It merged with the Sun Oil Company (Sunoco) in the late 1960s, and the brand was retired in the late 1980s.

Before Route 66 came to Sayre in 1928, the town was a focus of agricultural processing. Sayre had four cotton gins, two grain elevators, and a flour mill. The Farmers Cooperative Gin Association was established on South 6th Street in 1922. By 1937, Route 66 was paved and servicing the road became the main business of the town.

HEXT, OKLAHOMA

HEXT WAS ONLY EVER A GLIMMER OF A PLACE, and it is now an archetypal Route 66 ghost town. Founded in 1901, Hext had only a single gas station (later converted into a home and the pumps removed) and a Work Progress Administration school built in the 1930s. The school is now crumbling and derelict and is virtually the only building still standing in Hext. This section of Route 66 was the last in Oklahoma to lose its designation to Interstate 40 in 1975. Abandoned stretches of the road remain. The original surface is cracked and weed-ridden, and has several "Road Closed" signs to warn travelers away.

Right: About the only building remaining in Hext, Oklahoma, a Route 66 ghost town, is the WPA school built in the 1930s.

Opposite: An abandoned section of old Route 66 near the Mother Road town of Erick, Oklahoma.

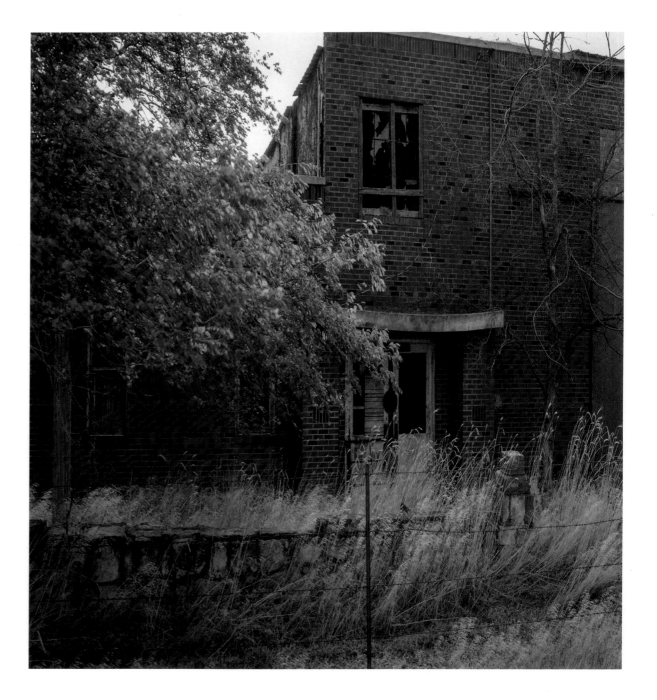

ERICK, OKLAHOMA

ERICK WAS ONCE THE WESTERNMOST TOWN in Oklahoma, and proclaims itself as the "Gateway to Oklahoma." But local celebrity Roger Miller described the town as "close to extinction." Miller wrote the song "King of the Road" and the local section of Route 66 is named the Roger Miller Memorial Highway in his honor. Erick was founded in 1900 and became prosperous when cattle drives used the sweet local springs to water the herds. The Dust Bowl of the 1930s hit the town hard, but the arrival of Route 66 re-vitalized the local economy. Businesses proliferated to service Mother Road travelers, including the West Winds Motel, DeLuxe Courts, the Erick Court and Trailer Park, Elms Garage, Carl's Country Kitchen, and the Cabana Motel. Like many of these establishments, the Cabana is now deserted, and just a few letters remain on its coronet-topped sign. Interstate 40 by-passed the town in 1975 and Route 66 crumbled into a strip of deserted and abandoned businesses.

Erick is home to the legend of the over-zealous Traffic

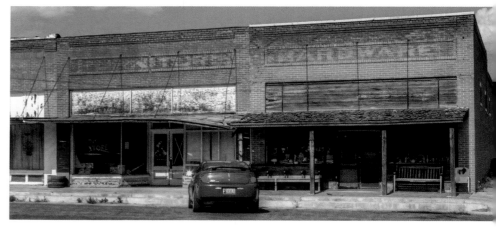

This page: When Interstate 40 by-passed Erick in 1975, the town's economy collapsed. It is now littered with crumbling and abandoned buildings.

Officer Elmer. The obsessive Elmer busted hundreds of drivers for driving just a couple of miles over the limit, including the famous entertainer Bob Hope. Local legend has it that Officer Elmer still patrols Route 66 in his black 1938 Ford V-8, hunting for speeding drivers.

TEXOLA, OKLAHOMA

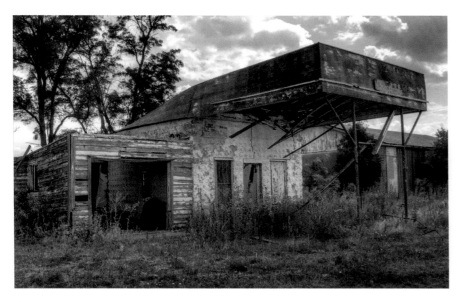

A SIGN ON THE OUTSKIRTS OF TEXOLA maintains that "There's no other place like this place anywhere near this place so this must be the place." Founded in 1901 on the windswept prairies of western Oklahoma, Texola became a cotton processing town. The arrival of Route 66 ushered in a brief period of prosperity in the 1930s, but decline soon set in during the Great Depression and the Dust Bowl. Texola is now a true ghost town — just a collection of ruined old buildings. These include an old jail, the Magnolia Gas Station, and the Texola Bar. Just beyond the bar, the road crosses into the Texas Panhandle. The local stretch of Route 66 remains a straight four-lane stretch of road. Very few cars now use the route and Texola is alive only with forty living souls and ghosts of the past.

This page: The ghost town of Texola is littered with abandoned buildings.

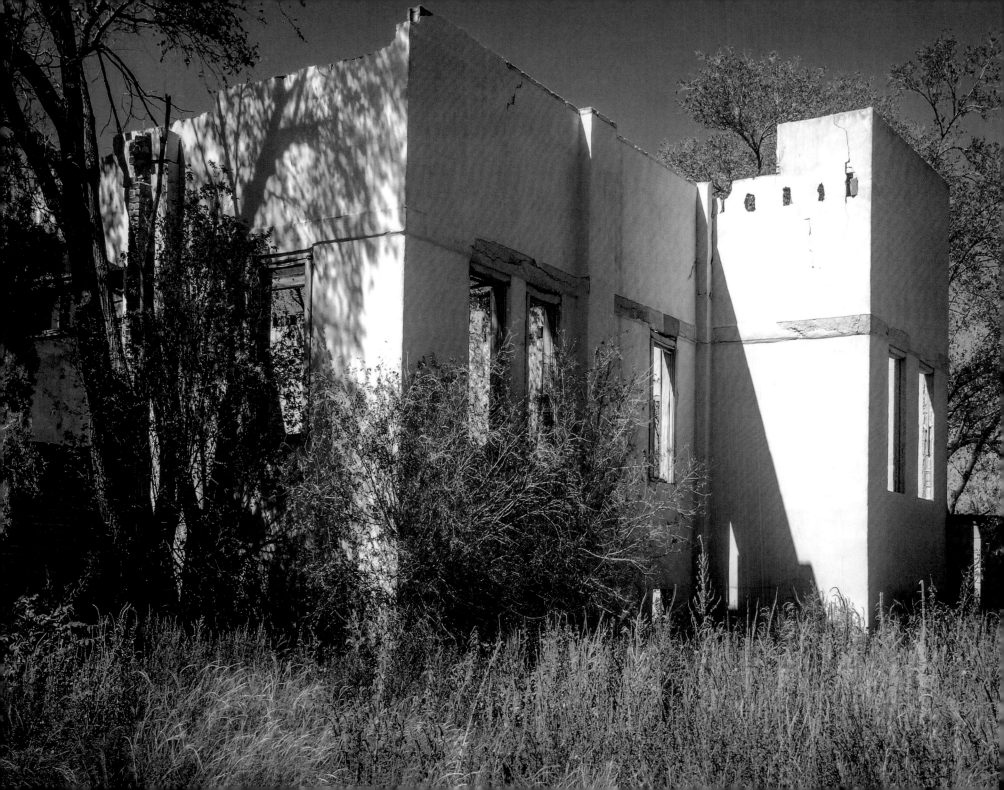

Right: The world famous Water Hole # 2 building is also home to Tumbleweeds Grill and Country Store. This is the only general store within ten miles of the ghost town of Texola.

Left: Another crumbling building in Texola.

Below: A rotting and abandoned car just outside Texalo recalls the better days enjoyed by the town in the 1950s.

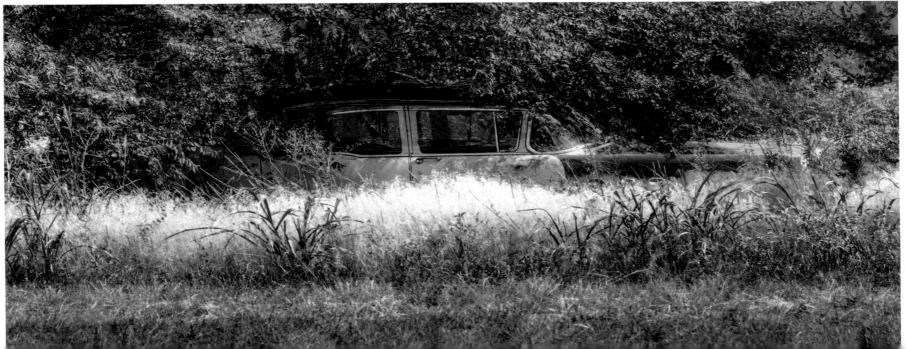

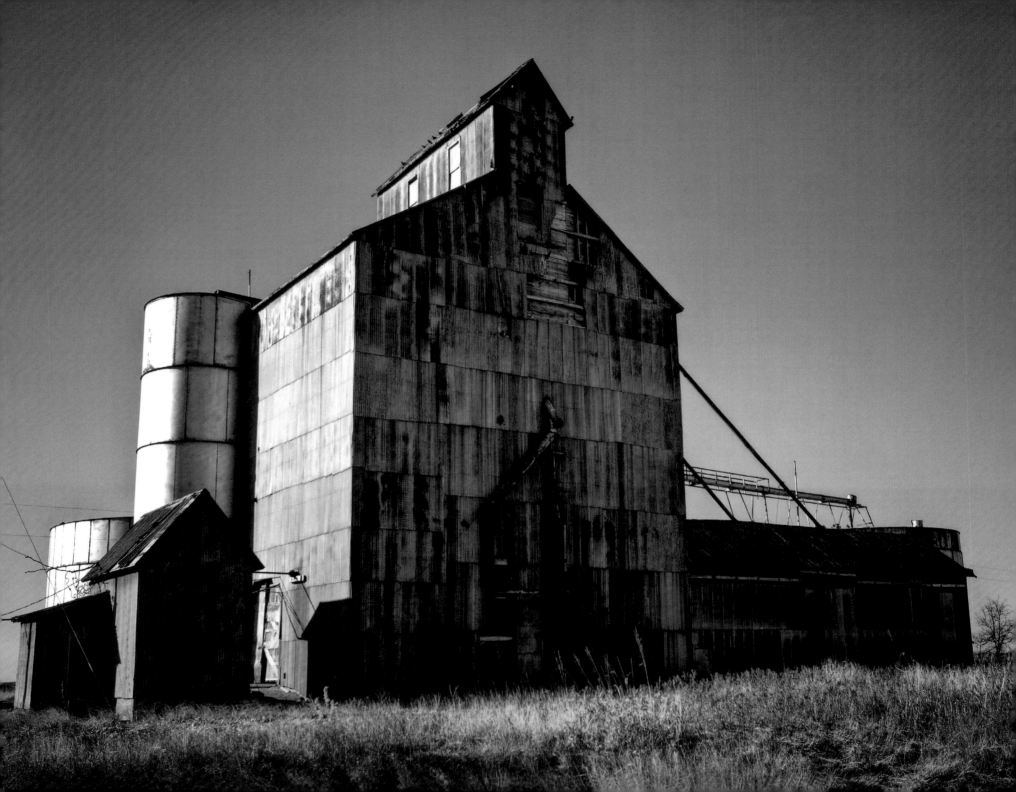

ROUTE 66 IN TEXAS

ONCE ROUTE 66 LEAVES THE ROLLING HILLS of Oklahoma, it crosses the wide open Staked Plains (the Llano Estacudo) of the Texas Panhandle. This Wild West landscape is the land of cattle drives and is peppered with fences, dirt farm roads, grain elevators, and windmills. The Panhandle's early roads were little more than dirt tracks. Route 66 arrived in 1926, following the path of the Rock Island & Pacific Railway in an east-west orientation. Stretching from Shamrock in the east to Adrian in the west, the straight highway was concrete paved in the 1930s. 150 of the road's original 178 Texan miles are still drivable, excluding the stretches between Jericho and Alanreed, and Adrian to Glenrio. The best preserved section of the original road in the Lone Star State runs between State Highway 207 and Interstate 40, which is designated Texas Farm Road 2161. In the time of the Great Depression and the Dust Bowl, Route 66 became an evacuation route to the west, but

by the boom times of the 1950s it was heavily used by tourist traffic.

Although the Texan stretch of the Mother Road isn't very long, Texas claims the road's halfway point at Adrian. This milestone is celebrated by the Midpoint Café, which was run by Fran Houser until 2012. Amarillo, with its livestock market and stockyards, is the only major town on the Texan portion of the highway, and is celebrated in Bobby Troup's famous song. To the east and west of the town, the two-lane highway passes through a string of mostly abandoned ghost towns.

The Texan section of Route 66 is lined with a unique blend of trading posts, rock shops, tourist stops, motels, and refreshment stands. It passes through a prosperous region that produces oil, gas, wheat, grain, and fine Hereford cattle. Over time, the road became a destination in itself, but the Texas stretch has been re-aligned several times so a map is required to follow the original route. The demise of Route 66 began in 1956 when President Dwight Eisenhower signed the Federal-Aid Highway Act. This action resulted in a flood of Interstate construction. The Texas section of the Mother Road was finally de-commissioned in 1985.

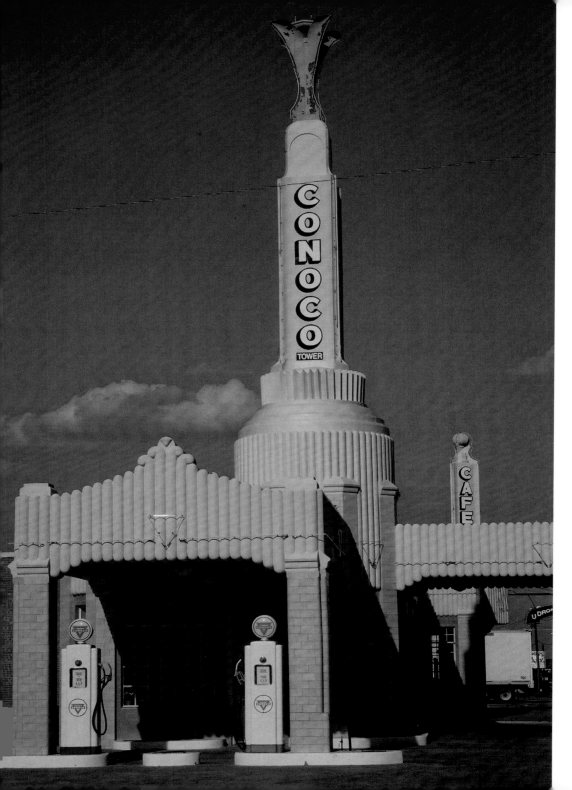

SHAMROCK, TEXAS

FIFTEEN MILES INTO TEXAS, Shamrock is proud to be the first Texas Route 66 city in the east. The town has several of the state's most famous Route 66 landmarks. The Art Deco styled Tower Station and U-Drop Inn café in Shamrock Texas, is one of the most extraordinary buildings on the Mother Road. It is said that the design was drawn in the dirt, and built in 1936 at the jaw-dropping cost of $23,000 by J.M. Tindall and R. C. Lewis. At the time, the U-Drop was the only café within a hundred miles of Shamrock. The facility has been restored by the city of Shamrock, and now houses the Chamber of Commerce. Shamrock also has a selection of spooky abandoned buildings including Lewis' Gift Shop and a classic deserted service station.

Shamrock was named by Irishman George Nickel, one of the town's first inhabitants. The shamrock is a traditional Irish symbol of good luck. The remainder of the town celebrates its Irish connections with an annual St Patrick's Day parade.

Left and Right: The Deco-styled U-Drop Inn was built in 1936 at the corner of US Route 66 and Route 83. At the time it was the only café within a hundred miles of Shamrock. It was an instant success but fell into disrepair when the road was de-commissioned. Later it was acquired by the Texas Historical Commission. It was then added to the National Register of Historical Places.

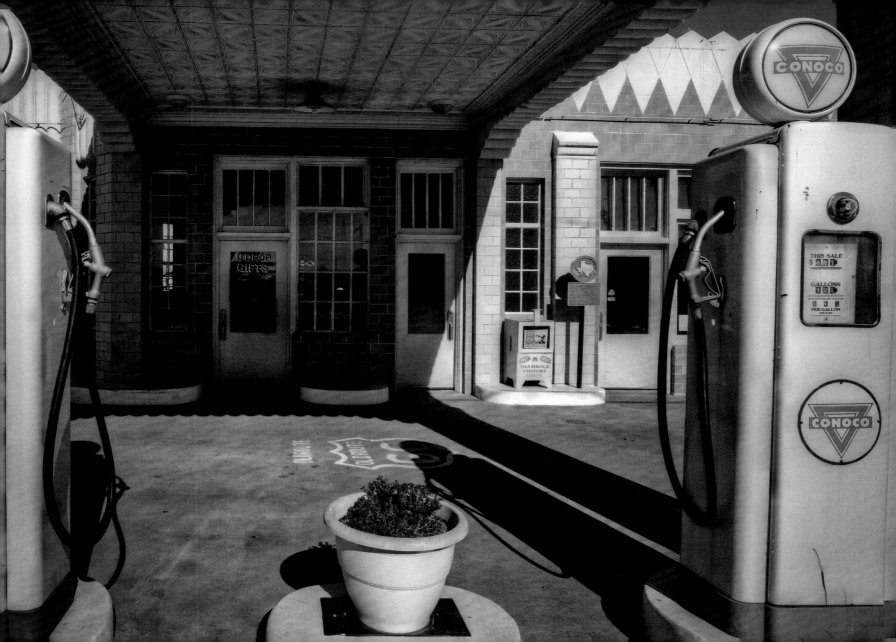

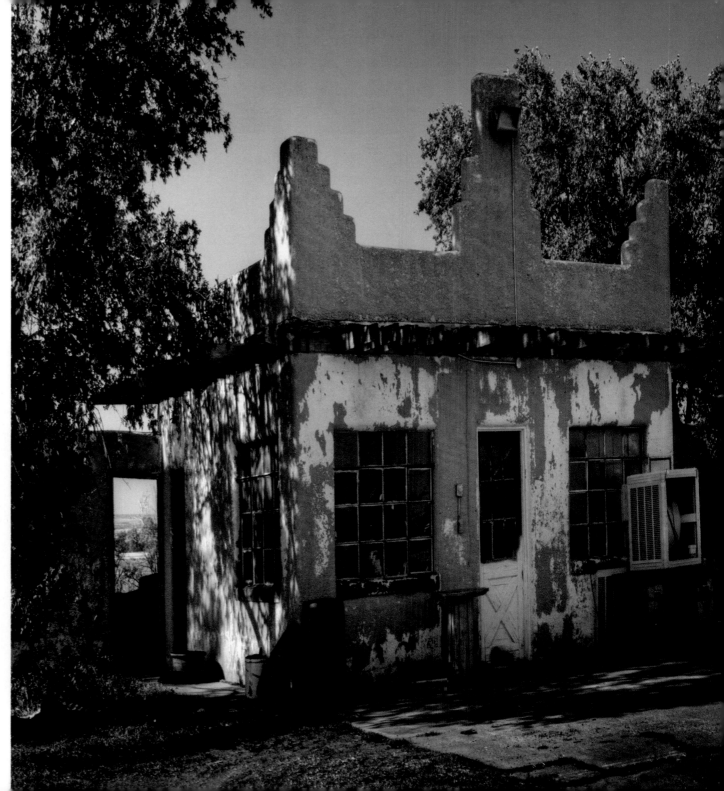

Opposite page, Left: A windmill east of Shamrock, Texas.

Opposite page, Right: An abandoned service station in Shamrock.

Left: Budget lodgings in Shamrock.

Right: An old restaurant sign in Shamrock.

Below: Lewis' Gift Shop in Shamrock is now abandoned and crumbling.

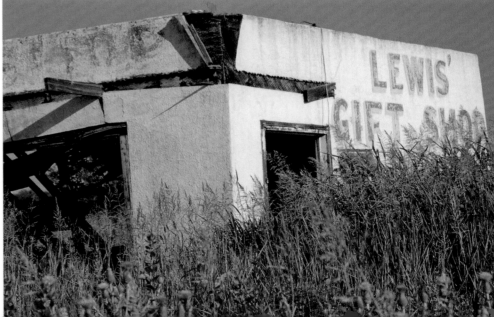

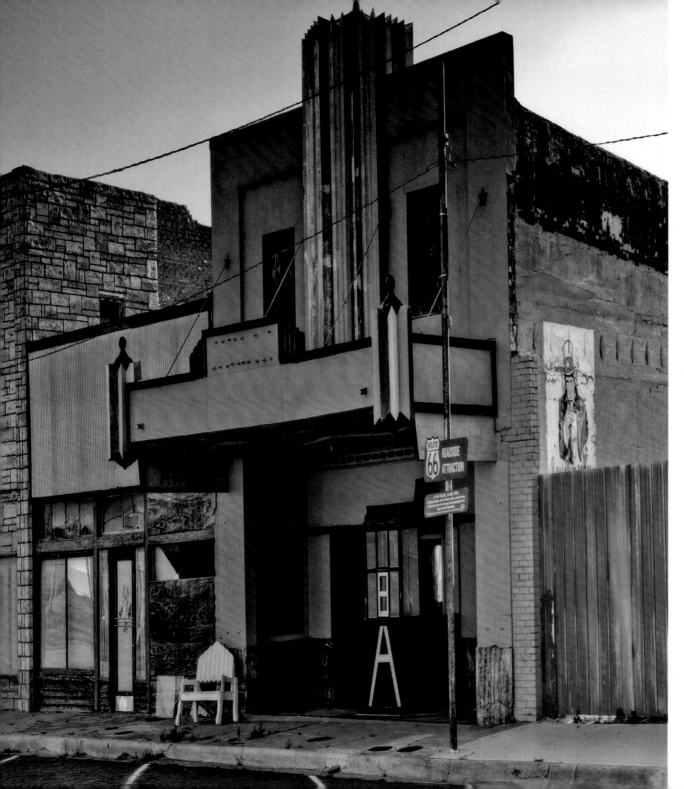

McLEAN, TEXAS

MᴄLᴇᴀɴ ɢʀᴇᴡ ғʀᴏᴍ ᴀ ʀᴀɪʟʀᴏᴀᴅ cattle loading stop into a small town in the early twentieth century. By 1904, the town had three general stores, a bank, two livery stables, a lumberyard, and a newspaper. In 1927 Route 66, was built through the town, and it became a stop for tourists as well as a center for oil, livestock, and agricultural processing. But as other Panhandle towns, such as Amarillo and Pampa grew, McLean gradually shrank. The town was by-passed in 1984, as part of the final phase of the construction of Interstate 40.

Left: The old Avalon Theater was built in the 1930s.

Right: Downtown McLean, Texas.

Opposite page, top: An abandoned service station in McLean.

Opposite page, below: An abandoned garage in McLean.

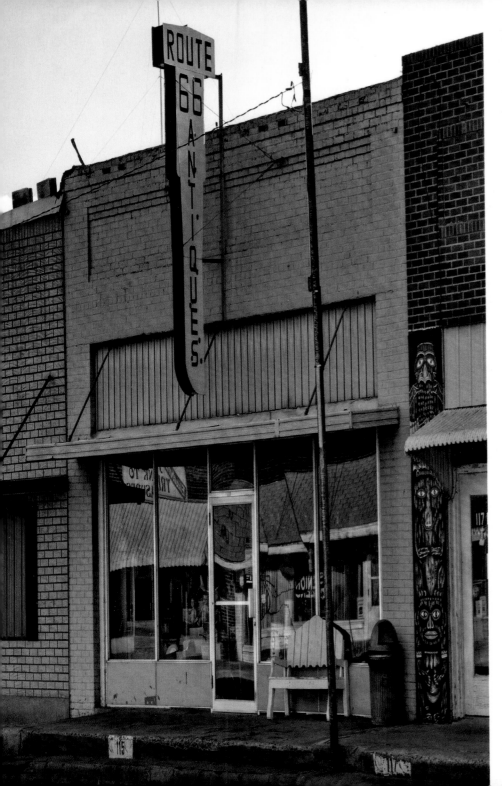

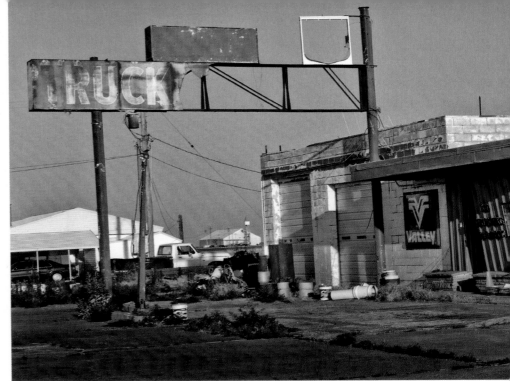

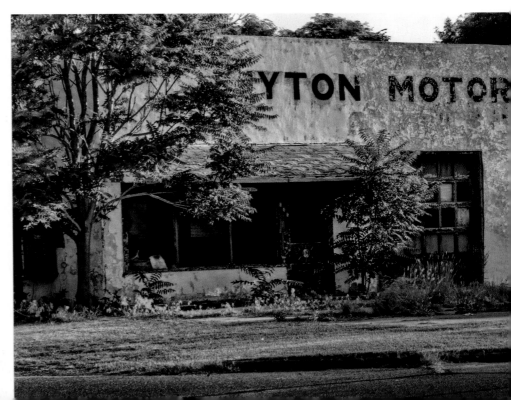

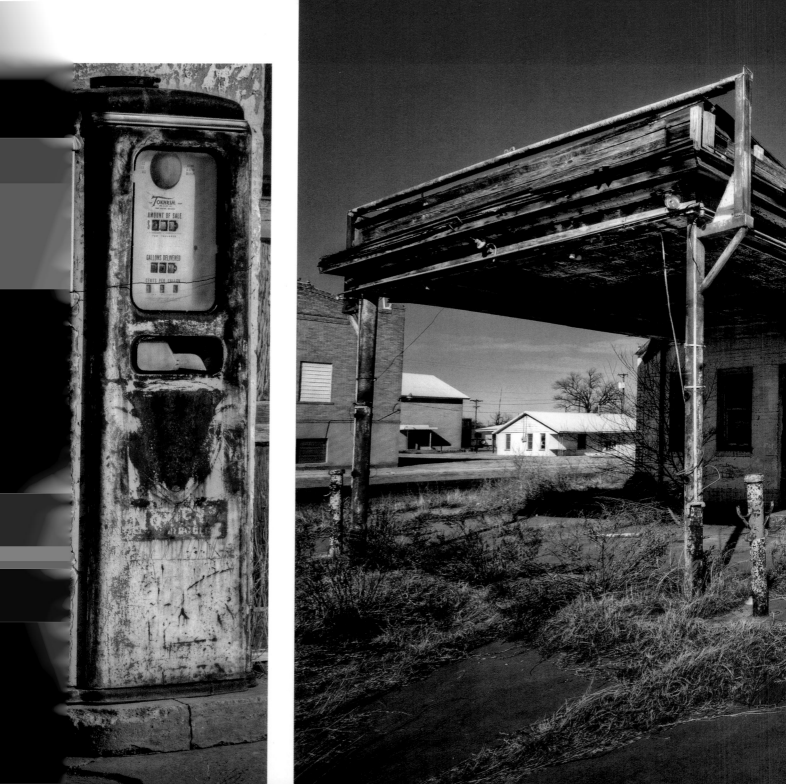
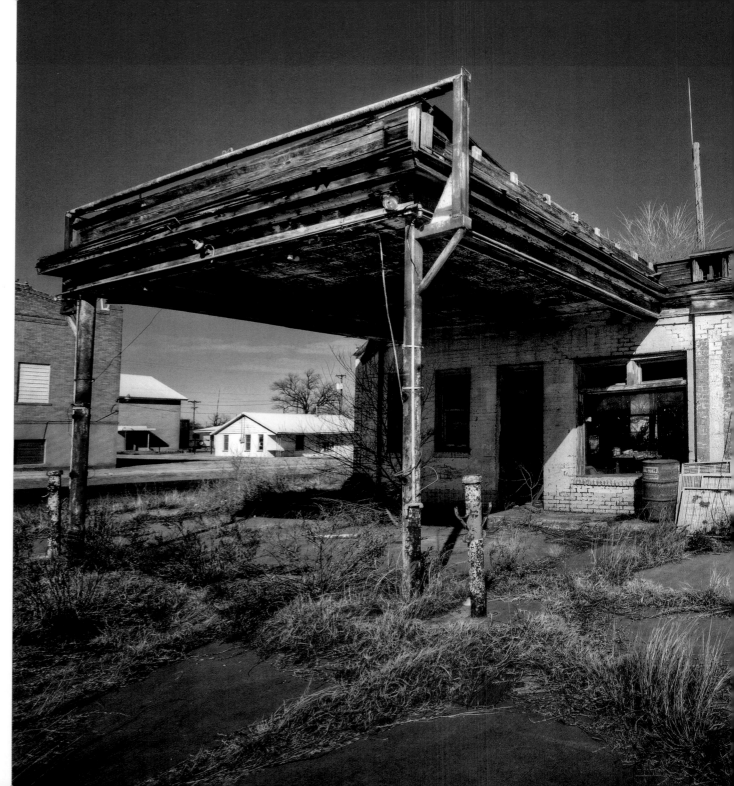

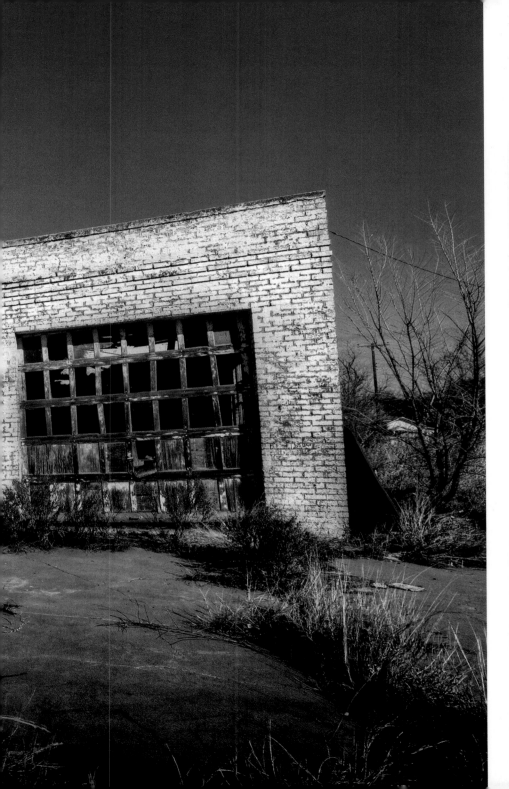

Opposite page: An abandoned gas pump in McLean.

Left: An abandoned service station on historic Route 66.

Above: The Phillips 66 gas station was built in 1928.

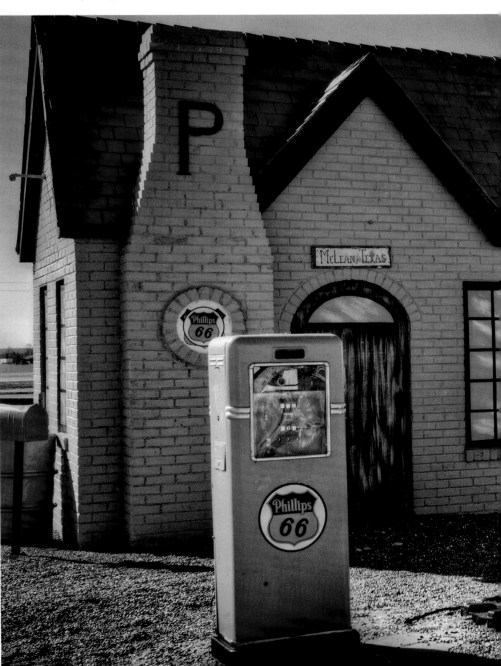

ALANREED, TEXAS

ALANREED IS LOCATED ON INTERSTATE Highway 40 and U.S. Highway 66 in southern Gray County. At various times the town has also been called Springtown, Prairie Dog Town, and Gouge Eye. Like many towns in the area, Alanreed started out as a cattle shipping point on the Rock Island railroad. But in 1927, Alanreed had two strokes of good fortune, a local oil boom and the arrival of Route 66. But after a few good years, the town shrank back into almost complete obscurity and became a route 66 ghost town. The town now mostly consists of abandoned homes and businesses.

Below: Bradley Kiser built this service station in 1930.
Opposite: An abandoned café in Alanreed, Texas.

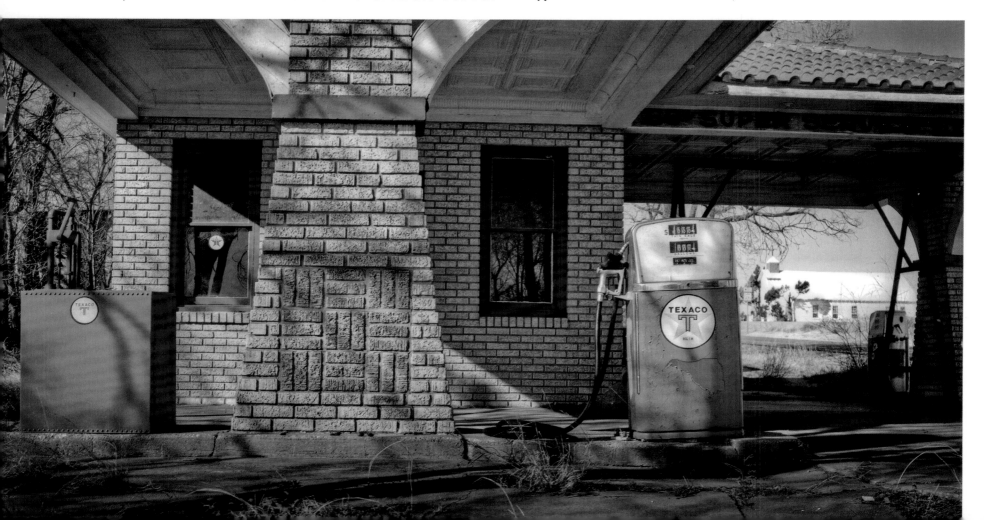

GROOM, TEXAS

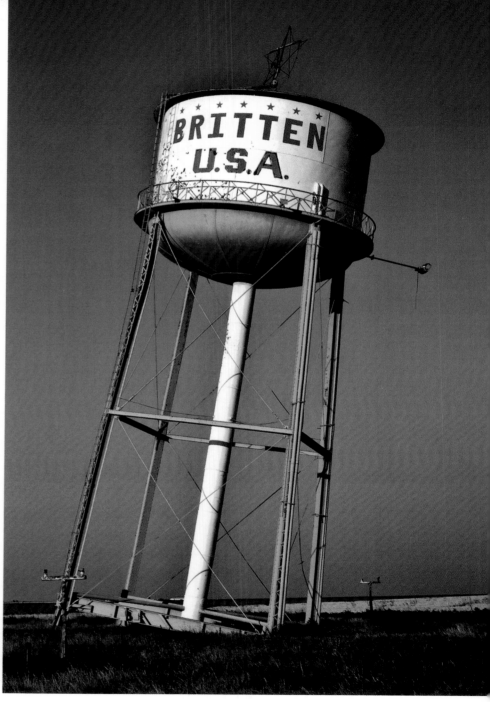

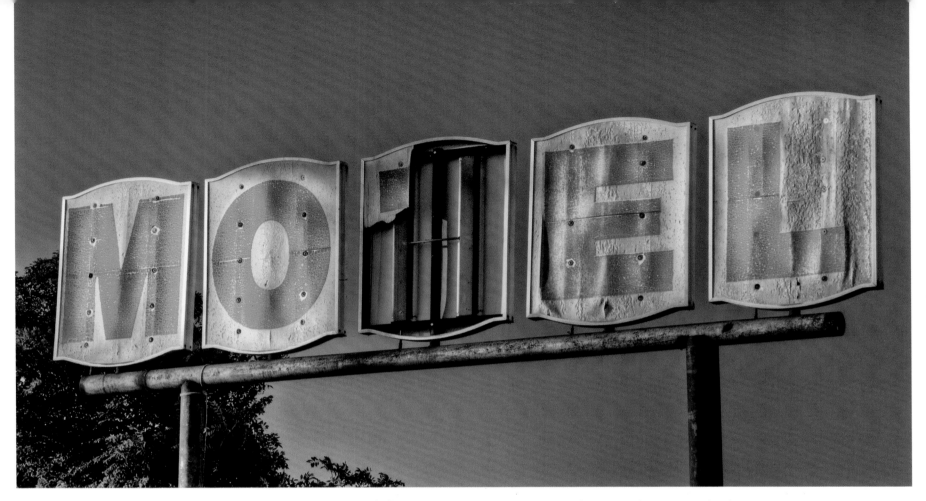

GROOM DATES BACK TO 1902, when its main commodities were cattle, wheat, and maize. Groom was named after a local rancher. When Route 66 arrived in the late 1920s it boosted the town's economy greatly. Westbound travelers were particularly pleased to have crossed the Jericho Gap and survived. This infamous stretch largely consists of dirt road and could turn into a muddy trench when it rains. As a result Route 66 was re routed to avoid the area.

In 1946 Groom had a small hotel, Wall's Café, and several gas stations and garages. The town is also home

Above: The sign marks the site of Groom's one hotel.

Opposite, right: The leaning Tower of Texas is in Groom.

to the famous Leaning Tower of Texas, which leans precariously to one side. Although this looks precarious, the water tower was deliberately constructed this way to attract passing tourists. The Tower Lounge and Restaurant was built to commemorate the water tower, but it burned down a few years ago and is now nothing more than a Route 66 memory.

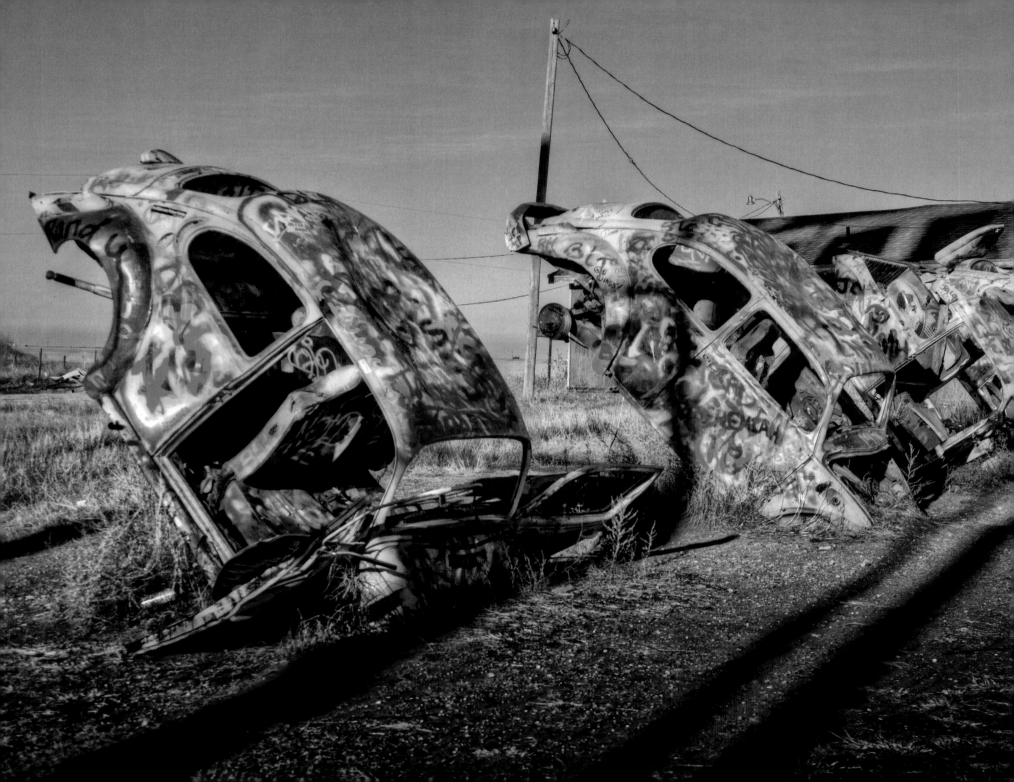

CONWAY, TEXAS

Conway was founded in 1905 and the Mother Road came to the town in 1926. Its arrival encouraged a brief period of activity but the Conway's population collapsed once the road was by-passed. Conway is however, home to most untouched and best preserved section of Route 66. Seven miles of this two-lane stretch have now been listed on the National Register of Historic Places. The road is surrounded by a wild grassland landscape dotted with dirt roads and windmills pumping fresh water for the cattle. Conway is also home to the famous Bug Ranch. Inspired by Amarillo's Cadillac Ranch, this consists of a single row of VW Beetles buried nose down in the ground.

Opposite: The Bug Ranch, Conway where VW Beetles are planted like gravestones.

Below: The vegetation starts to claim the abandoned buildings.

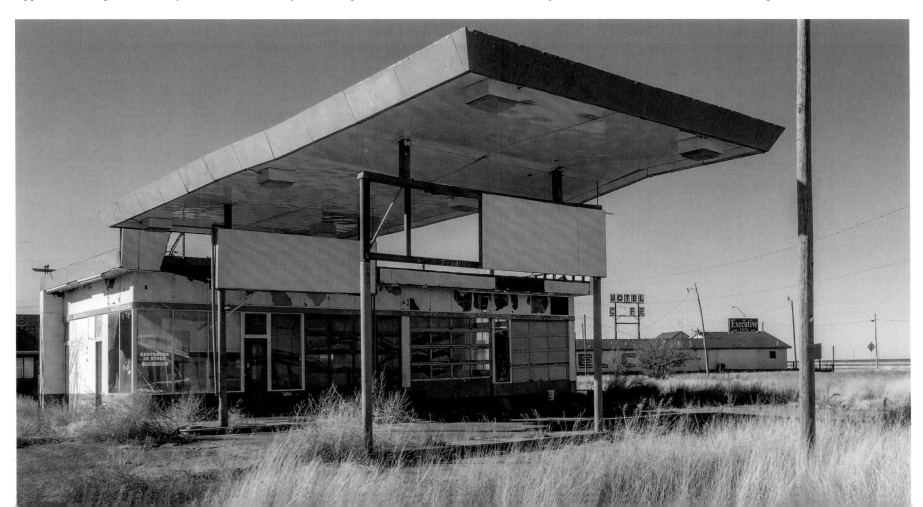

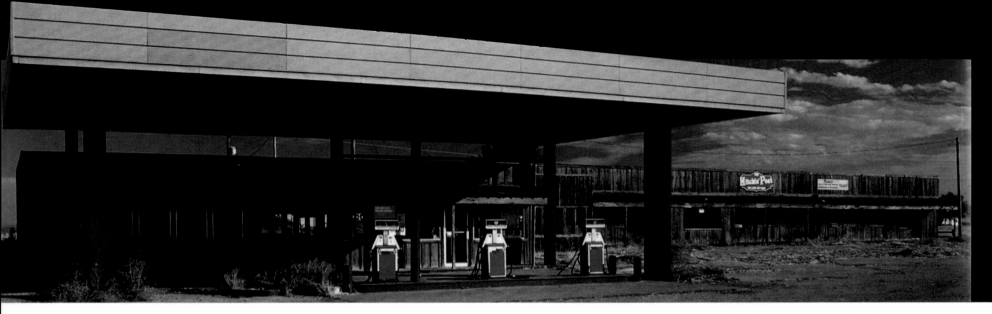

Above: The Hitchin' Post Café is next to the old railroad tracks.

WILDORADO IS ANOTHER RAILROAD SETTLEMENT, noted for its large cattle stockyard next to old Route 66. When Route 66 came through the town in 1926, the growing number of travelers crossing the Texas Panhandle passed through Wildorado. This passing trade boosted the local economy during the Dustbowl and Depression of the 1930s, but the resident population dwindled. This wasn't Wildorado's only problem. The town's isolation led to the Wilderado Bank being robbed no less than eight times between 1925 and 1928. The grain elevator and mercantile store were also burglarized. When leisure travel became more popular in the 1940s, the town became more prosperous, and businesses sprang up to cater to Route 66 travelers. As the old Route 66 Ozark Trail evolved into a real highway, the town became increasingly prosperous. But when Interstate 40 replaced the old road, all the businesses on the south side of the road were demolished. These lost businesses included the Wildorado Bank, Rodeo Café, Pop Well's Station & Café, Dee McDade's Texaco, Davis Mercantile/Post Office, A.F. Moore's 66 Dealership, and Tapscott Mobil Station. Very little has survived the carnage, although the Royal Inn Motel is still open to travellers. The Fort Wildorado Trading post also remains. Deserted by the Mother Road, Wildorado has slipped back into obscurity.

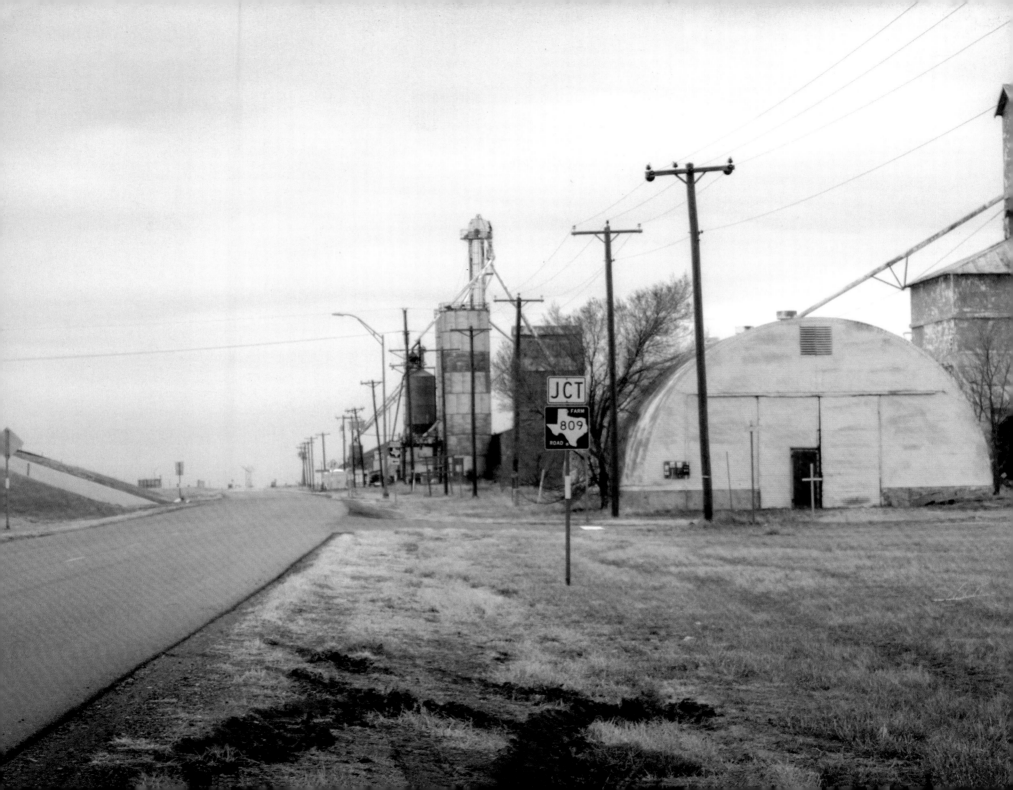

LANDERGIN, TEXAS

LANDERGIN IS NOW A TINY GHOST TOWN on the old Route 66. It was founded by the Irish Landergin brothers, who ranched Texas Longhorns in the area. The arrival of the Mother Road in the mid-1920s resulted in a small village springing up. But Landergin never really got going and the town gradually faded into the past. For many years, George and Melba Rook ran Route 66 Antiques and the Neon Soda Saloon in Landergin. The couple has now been inducted into the Route 66 Hall of Fame. Only a grain elevator, filling station, and roadside café now remain in Landergin.

Above: An abandoned gas pump.

Left: The deserted café disappears behind the rustling grasses.

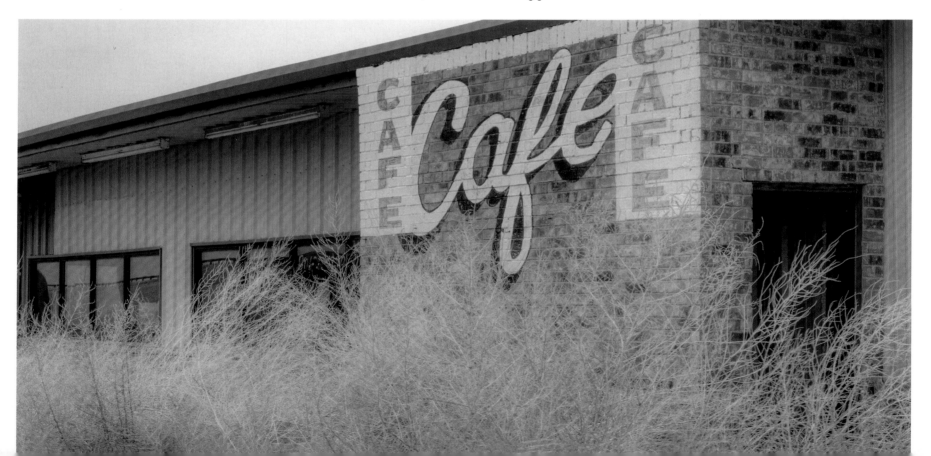

ADRIAN, TEXAS

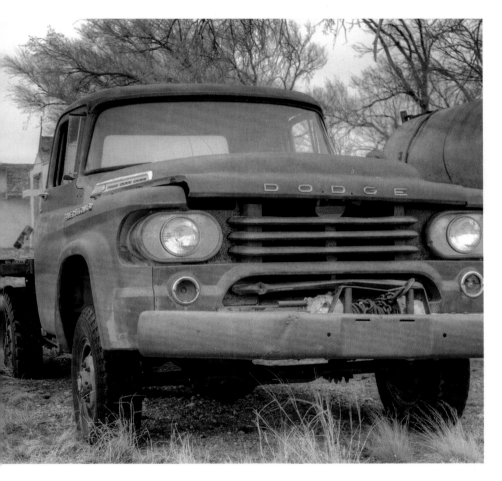

Above: The MidPoint Café shuts for the winter.

Left: An abandoned Dodge outside the MidPoint Café.

ADRIAN IS A "ONE-BLINK" TOWN located at the exact mid-point of old Route 66. It is fifty miles west of Amarillo. The Mother Road came to the town in 1937 when it was re-aligned to pass through Adrian and Vega. A painted strip across the road now marks the point where both Chicago, Illinois and Los Angeles, California are exactly 1,139 miles away. The town now consists of mainly abandoned buildings including the Bent Door Midway Station. This was constructed by Robert Harris in 1947 from strange bent doors and windows salvaged from a local air force base. The town also has a couple of abandoned gas stations. The only remaining "live" businesses are the famous MidPoint Café, The Adrian Farm and Ranch Museum, and a Stuckey's store. The MidPoint Café was built in 1929 and is famous for its "Ugly Crust" pies. Although the gift store is open year-round, the café shuts for the winter.

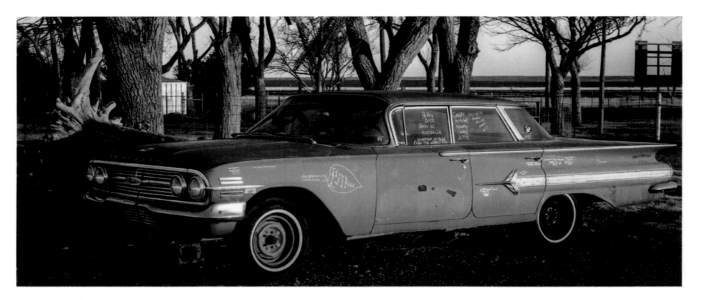

Left: A rusting roadside relic.

Below: The Bent Door Midway Station at Adrian, Texas, complete with a rusting Phillips 66 gas sign.

Opposite Right: An old Coke machine at the Midway Station.

Opposite Left: The Bent Door Midway Station at Adrian, Texas.

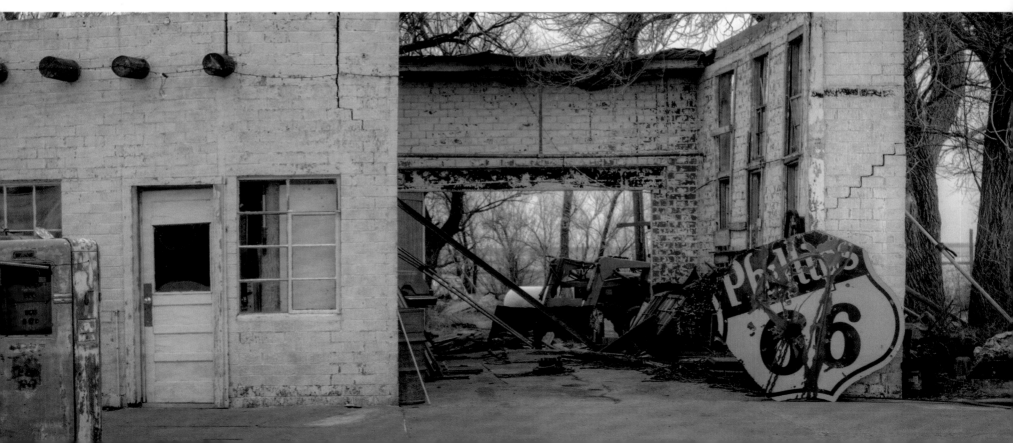

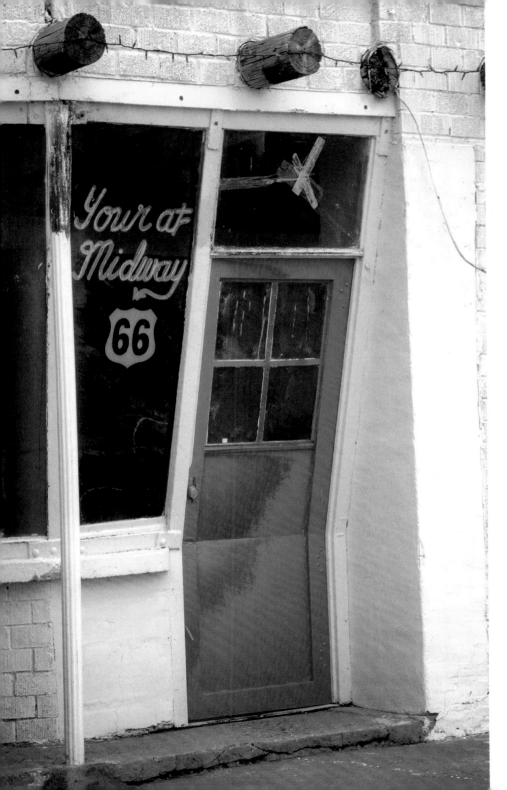

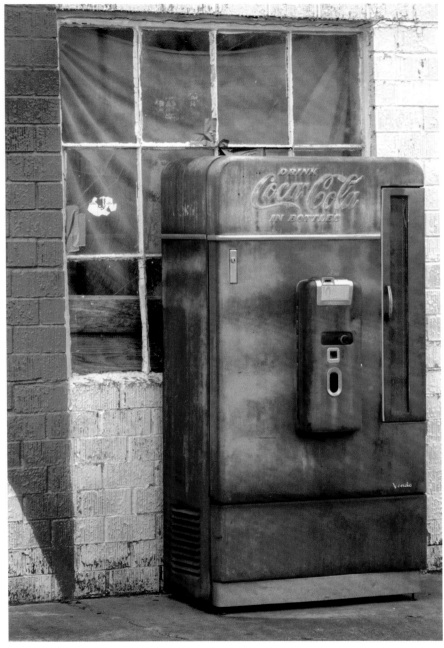

GLENRIO, TEXAS

IN 1926, THE OZARK TRAIL WAS incorporated into the United States highway system as part of Route 66. By the 1930s, several gas stations, a restaurant, and at least one motel had been built on the northern right of way of Route 66. On the south side of the highway, a welcome station offered assistance, and water to cool overheated radiators. During the 1930s, Route 66 was transformed into a continuous two-lane paved highway across Texas. Interestingly, there were no bars on the Texas side of the community, as Deaf Smith County was dry, and no service stations on the New Mexico side because of that state's higher gasoline tax.

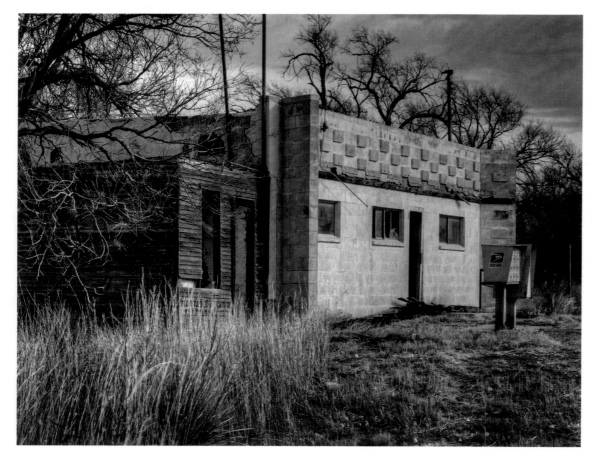

During the 1940s, 1950s, and 1960s, travelers thronged the highway and Glenrio thrived. Cars often had to queue to be served gasoline. A new cluster of businesses were constructed in the 1950s. Two survive; a Texaco Gas Station and a nearby diner, both designed with an Art Moderne influence.

Glenrio's boom times ended in 1975 when Interstate 40 bypassed the town. Today, the Glenrio Historic District includes the old Route 66 roadbed and 17 abandoned buildings. These include the Little Juarez Diner, the State Line Bar, and the State Line gas station. Most are on overgrown sites, and have missing windows. They recall the long ago times when Glenrio fed and entertained thousands of travelers.

Left: Glenrio's Post Office was the last business in the town.

Opposite: The remains of the Little Juarez Café.

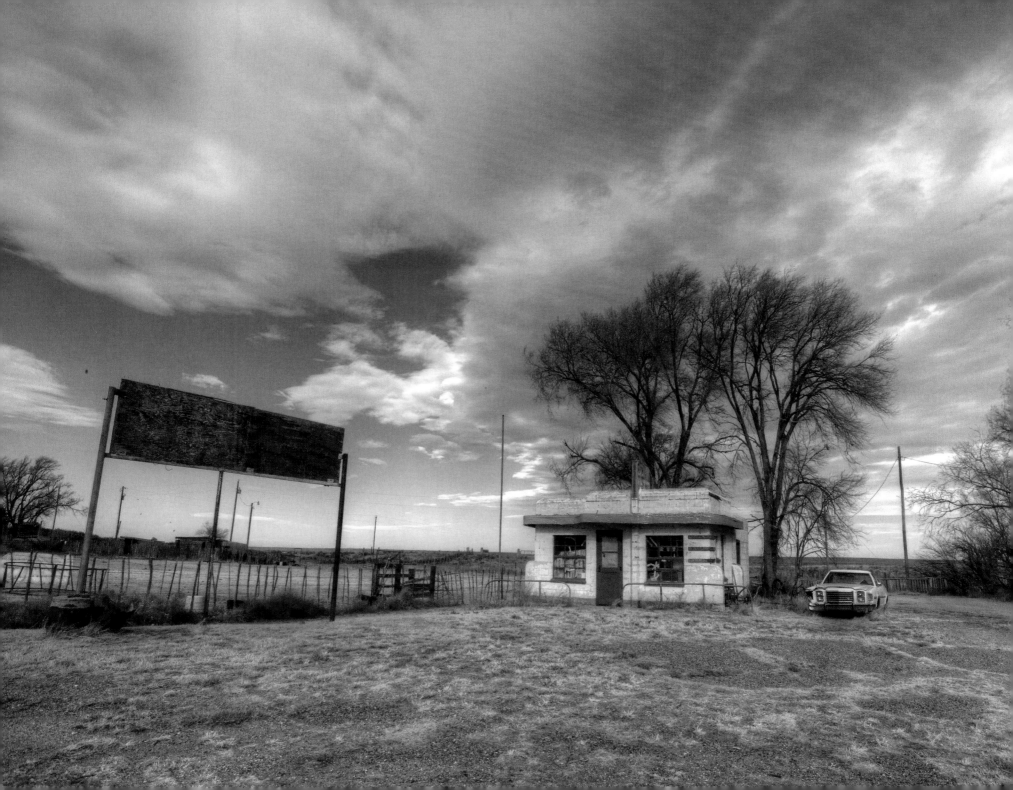

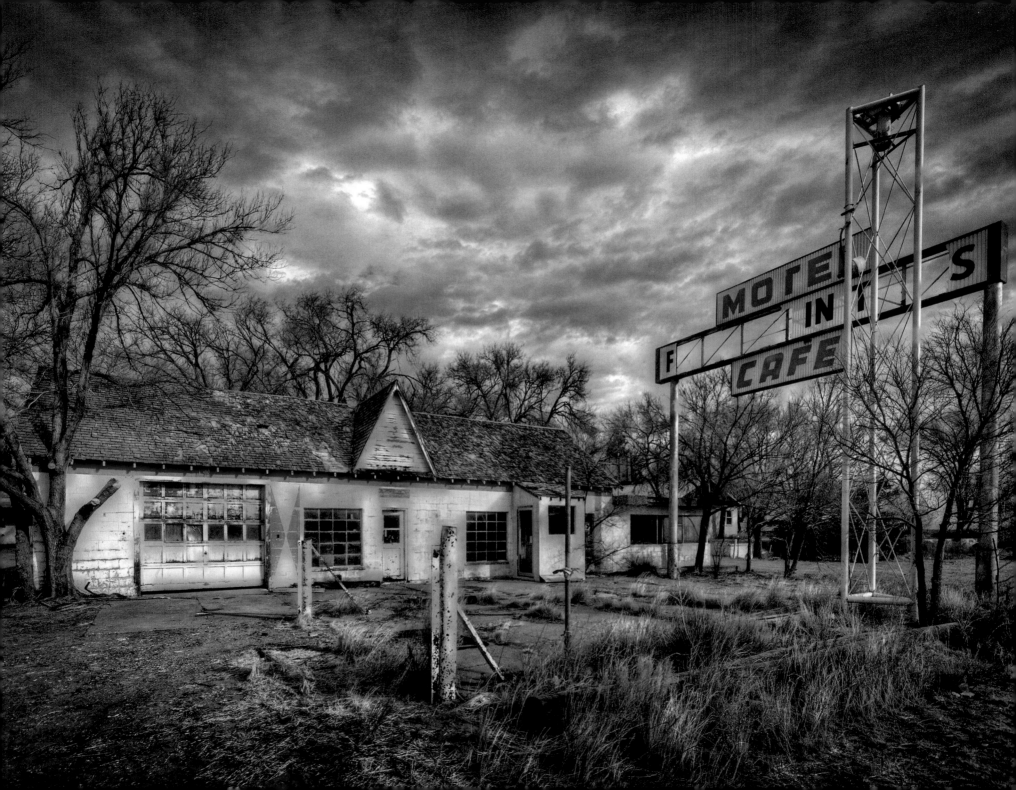

Below: A lonesome chair outside an abandoned gas station.

Right: An old gas station in the ghost town of Glenrio.

Opposite: Glenrio's abandoned gas station and motel.

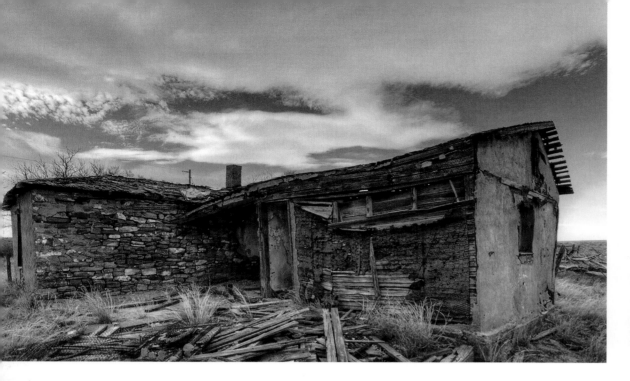

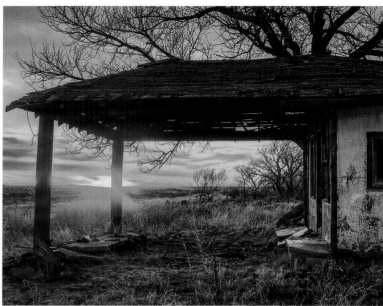

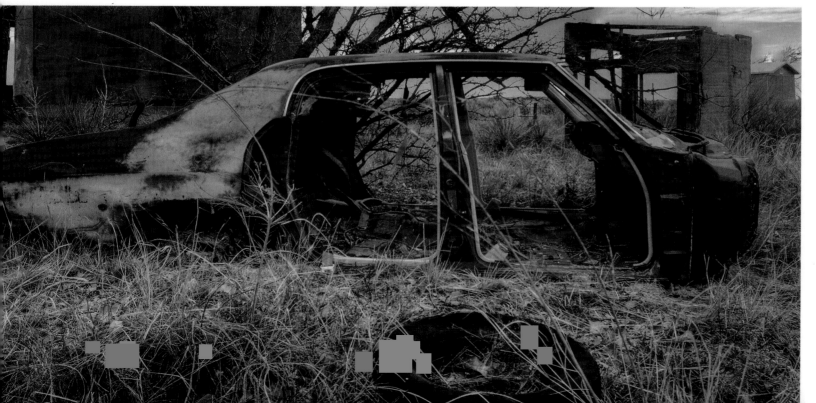

Top Left: An abandoned home in the ghost town of Glenrio, Texas.

Top Right: An abandoned gas station in the ghost town of Glenrio, Texas.

Left: A junk car in Glenrio, Texas.

Opposite: An abandoned gas station at Glenrio, Texas, just off the Interstate 40 exit.

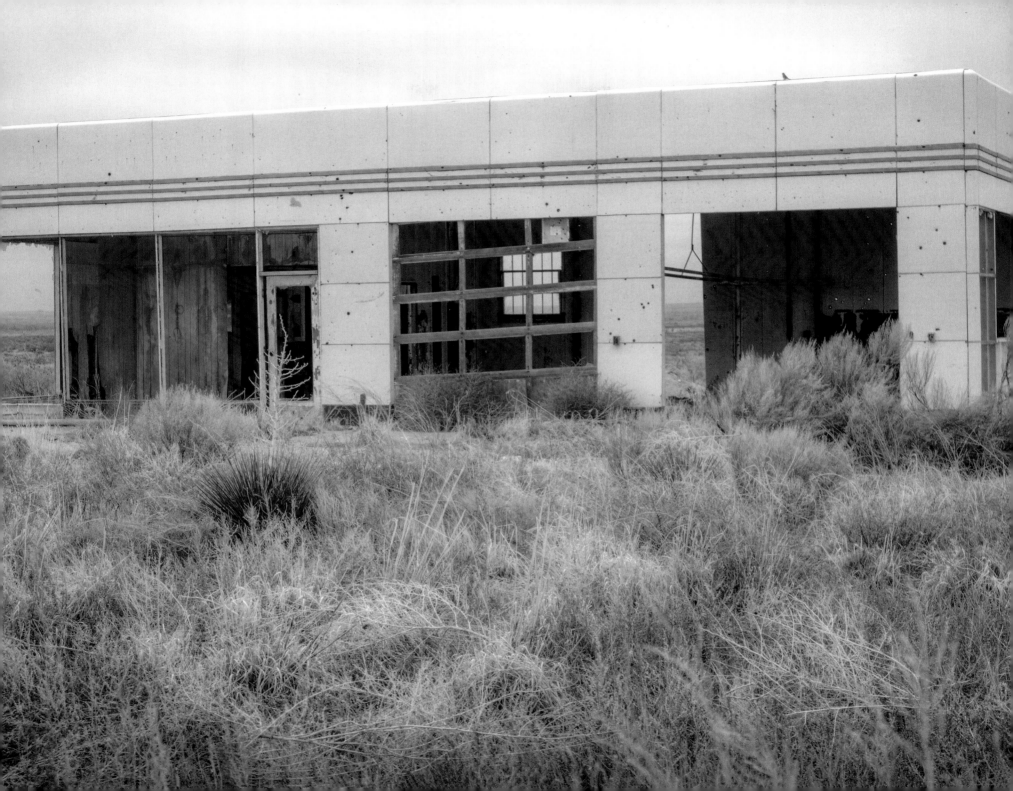

ROUTE 66 IN NEW MEXICO

ROUTE 66 RUNS EAST TO WEST across New Mexico, "The Land of Enchantment." It passes through a unique landscape of plains, grassland, mountains, and deserts scattered with cacti and yucca. It is a land of spectacular sunrises and sunsets and turquoise-blue skies. The area has a fascinating geology and is enhanced by the traditional southwestern architecture of adobe and stucco. The New Mexico stretch of the Mother Road was first commissioned in November 1926 and followed stretches of the Ozark Trails network. This was just fourteen years after New Mexico became a state of the union in 1912. The new highway ran through Navajo and Apache lands, across the area's scenic and rugged terrain, via Albuquerque and Santa Fe. It passed through mountain ranges and desert plains, and was designed to link isolated trading posts and urban communities. These gradually morphed into traveler-orientated towns with camps, motels, and motor courts. The road gave many Americans their first taste of the exotic heritage of the south west and their first brush with Native American and Spanish culture. Native Americans have lived in the region for over ten thousand years, leaving many beautiful adobe pueblos behind them. The oldest of these dates from around 1200 A.D. The Spanish explorer Francisco Vazquez de Coronado arrived in region in the 1500s. The Spanish brought Christianity with them, and the state's oldest church dates from 1625.

The original surface of the Mother road in New Mexico was composed of gravel, rock, and dirt, with rough timber bridges to cross the area's many creeks and streams. But the road was fully modernized during the Great Depression. The National Recovery Act of 1935 allotted six million dollars to the state of New Mexico to straighten and surface the road and to construct new bridges. Hundreds of unemployed young men labored on the road under the New Deal work relief scheme. Many of them returned to travel Route 66 as the country gradually returned to prosperity. By 1937, Route 66 was New Mexico's only fully paved highway and it became an artery that nourished the many communities along its route. The Mother Road became a true "road of dreams" taking thousands of Americans to new lives in the West.

The advent of the New Mexican stretch of Route 66 led to an explosion of roadside "Mom and Pop" businesses of every kind, to cater to Americans on the move. The American public wanted rapid mobility and took to their newly acquired cars to explore their country. Cabin camps provided the first lodgings along Route 66. These were generally pretty basic and uncomfortable. These camps

Opposite: A Route 66 sunset at the ghost town of Endee in New Mexico.

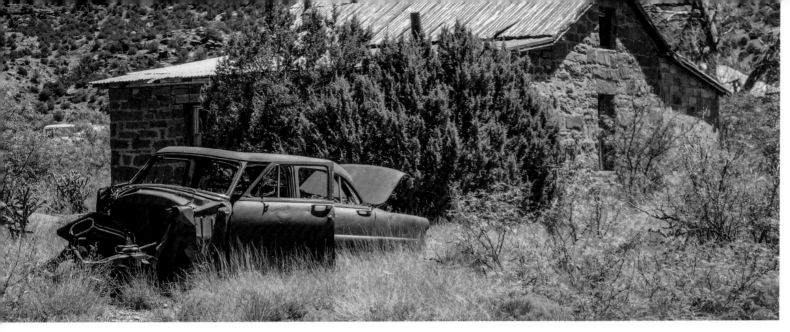

Left: An abandoned car and a dilapidated building at Cuervo, New Mexico.

Opposite: A ruined interior at Endee, New Mexico. Endee is now a Route 66 ghost town.

gradually evolved into motor courts (with individual cabins and bathrooms), which (in turn) were replaced by modern motels. These offered a host of modern luxuries including swimming pools, free television, air conditioning, and neon lights. Despite the 1930s modernization of the road, Jack Rittenhouse's 1946 guide maintained that the New Mexican stretch of Route 66 was still not as wide or well-paved as the road in Texas. Rittenhouse strongly advised travelers to carry water with them in this "very arid region." Some parts of the road were constructed at 7,000 feet above sea level and breakdowns were commonplace.

In the post-war years, many de-mobbed GIs took the route through the New Mexico's desert plateaus and mountain ranges as they immigrated to California. Many of them had received their military training in California and dreamed of returning to the sunny state in the peace years. Route 66's southern orientation meant that it had a much milder climate than more northern routes, and

the road remained open year-round. The road facilitated the westward movement of labor and capital, and had led to the United States Government investing 70 billion dollars in California between 1941 and 1945, as the state became pivotal in the war effort.

The course of the now de-commissioned road is now (mostly) followed by that of Interstate 40, but 260 miles of the original Mother Road are still drivable. The road was straightened and re-aligned in 1937 and cut from a statewide length of 506 down to 399 miles. The re-aligned road passed along Albuquerque's Central Avenue, and one of its most famous stopping points was the town of Tucumcari, in the east of the state. At its zenith, the town had 2,000 motel rooms and its advertising slogan "Tucumcari tonite!" became a symbol of travel along the road.

The eleven surviving stretches of Route 66 in New Mexico are now listed on the National Register of Historic Places. They were designated a National Scenic Byway in

1994. The New Mexico stretch of the road has some of the best examples of surviving Route 66 kitsch. Preserved vintage neon signs are particularly popular along this part of the road, and are protected by the Route 66 Neon Sign Restoration Project. Some of Route 66's most famous icons are also located in New Mexico. These include the Blue Swallow Motel, Tee Pee Curios, the Blue Hole of Santa Rosa, the La Fonda Hotel, Clines Corner Retail Center, the El Rancho Hotel, the KiMo Theatre, Grants Café, and the 66 Diner.

A section of the route near Albuquerque is famous as the "Singing Road." If you drive across this carefully constructed section of rumble strips and metal plates at exactly 45 miles an hour, the road surface plays "America the Beautiful."

The New Mexican part of Route 66 is a wonderful part of any trip along the road, as it passes through a particularly beautiful landscape of ponderosa pines and atmospheric ghost towns.

Left: A ruin in the ghost town of Cuervo, New Mexico.

Right: An abandoned garage in the Ghost Town of Cuervo, New Mexico on Route 66.

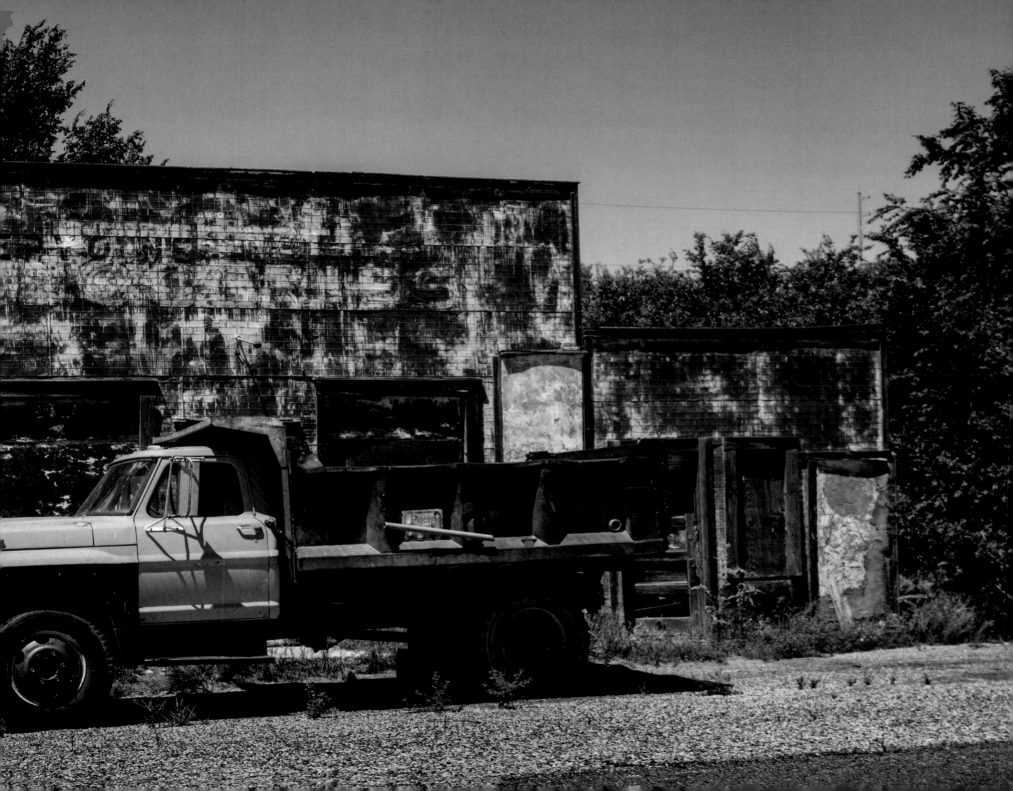

ENDEE, NEW MEXICO

Endee is located just inside New Mexico, on a lonely stretch of road just five miles past the border town of Glenrio, Texas. There are just a few abandoned buildings to show that the town was ever inhabited. Endee was founded in 1882 as a Wild West town for cowpunchers. Legend has it that the town was so rough that the townsfolk dug a trench on Saturday to bury unlucky gunfighters on Sunday morning.

The town is now completely abandoned. During the busy years of Route 66, the Endee Motor Court played host to many travelers along this stretch of the road. It was a basic kind of place with just an outhouse for bathroom facilities. The business is now long-since closed down and the few remaining buildings are ruined and crumbling.

Below: An abandoned car at Endee, New Mexico.

Opposite: The ironically named Modern Restrooms at Endee, New Mexico.

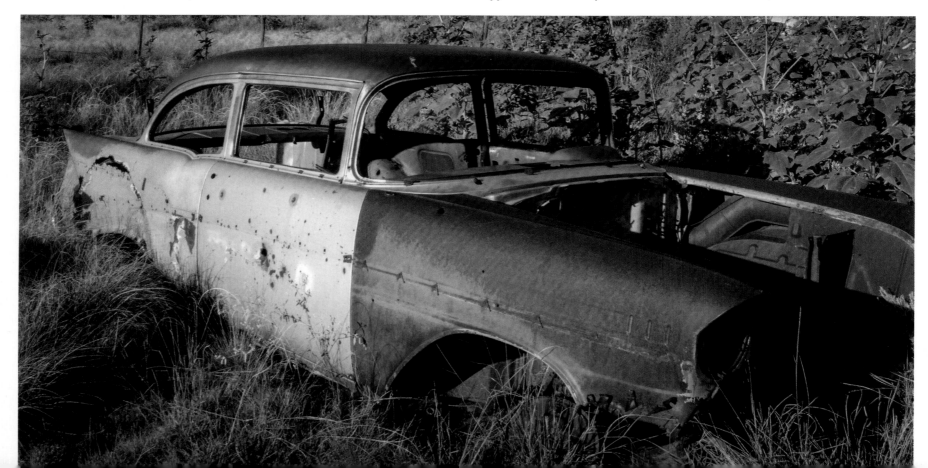

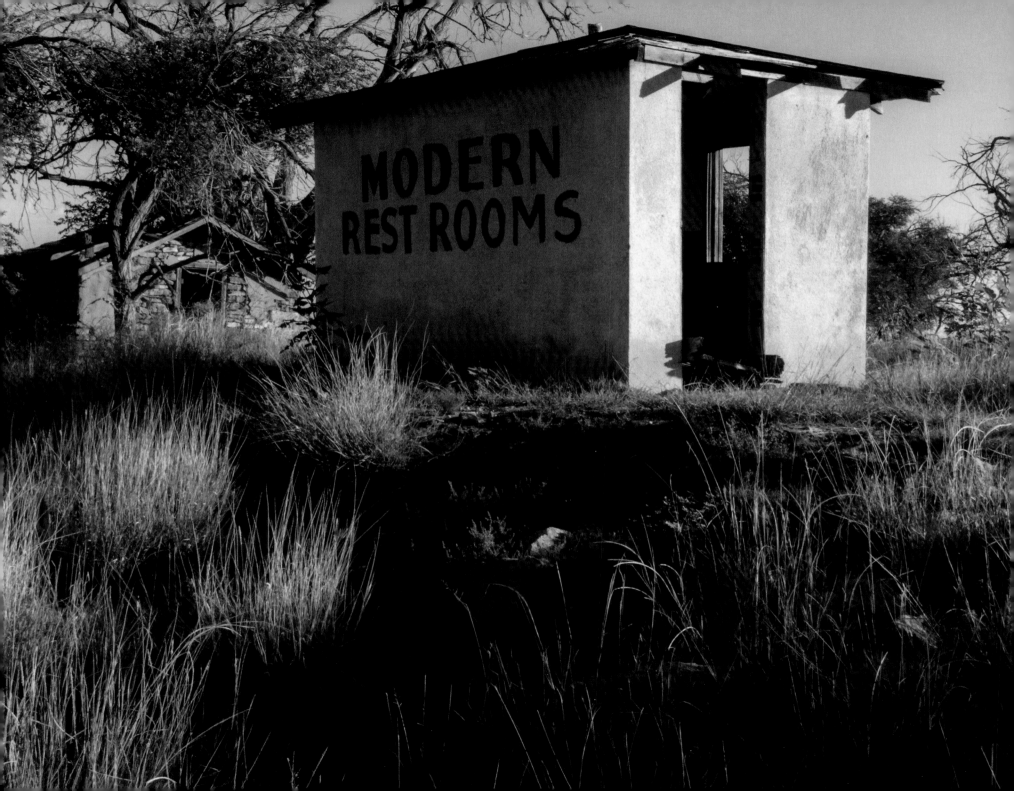

SAN JON, NEW MEXICO

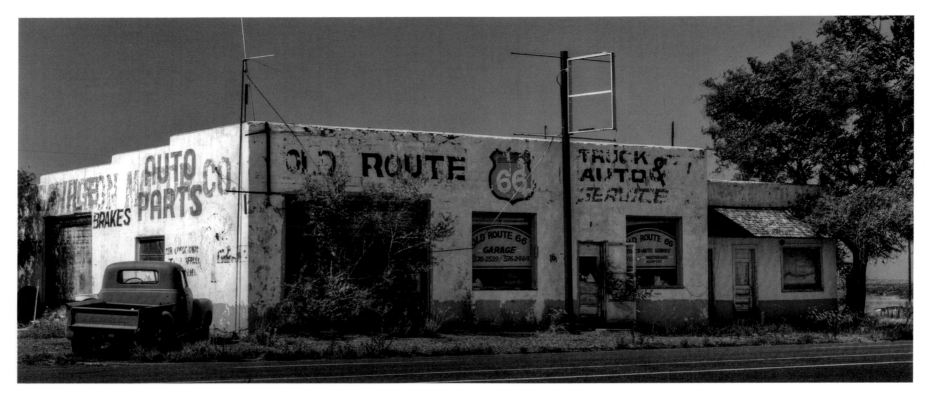

FOUNDED IN 1902, SAN JON is the next notable destination on the New Mexican stretch of old Route 66. The town was a thriving center of ranching and railroad shipping before the Mother Road came to the region. San Jon made its fortune providing nighttime hospitality for the local cowboys. In the Route 66 years, San Jon became prosperous from a completely different kind of clientele. The town had several gas stations, garages, motor courts, stores, a café, and a hotel. The San Jon Motel was opened in 1946.

Above: Numerous businesses once throve along Route 66 in San Jon, New Mexico.

Opposite: An abandoned truck and gas station at San Jon, New Mexico.

Sadly, the 1981 re-alignment of Interstate 40 led to the slow demise of the town, and many local businesses closed and crumbled. The streets of San Jon are lined with mostly empty buildings. Most travelers press on to the better facilities available at Tucumcari.

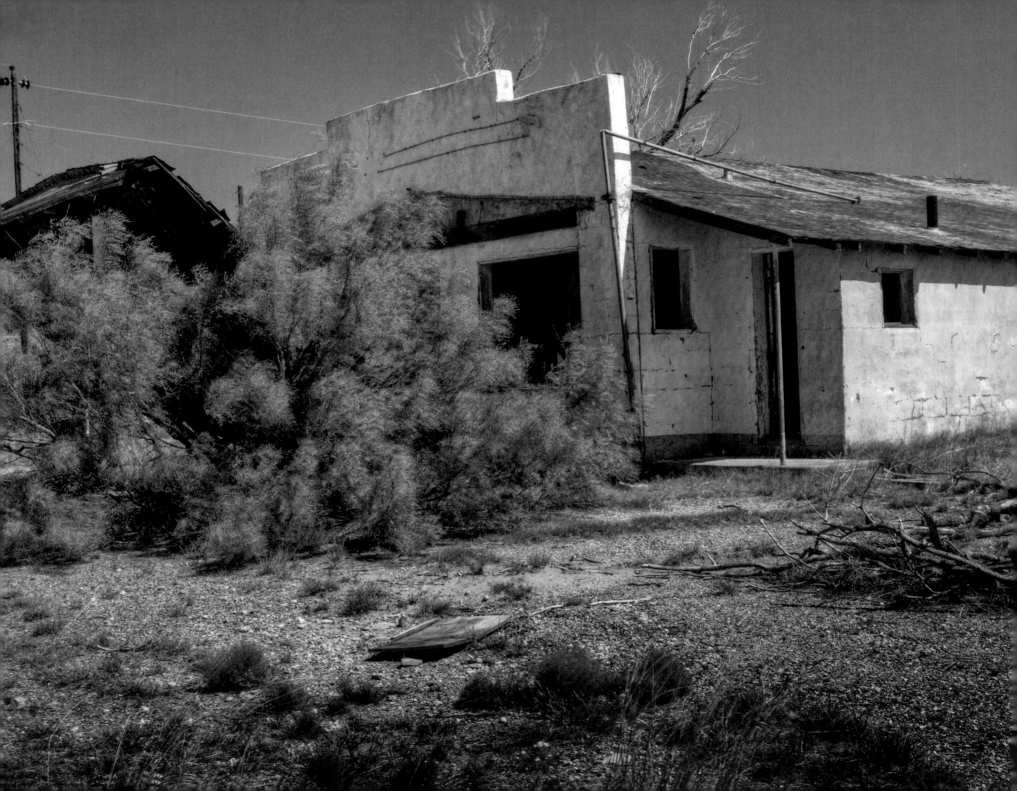

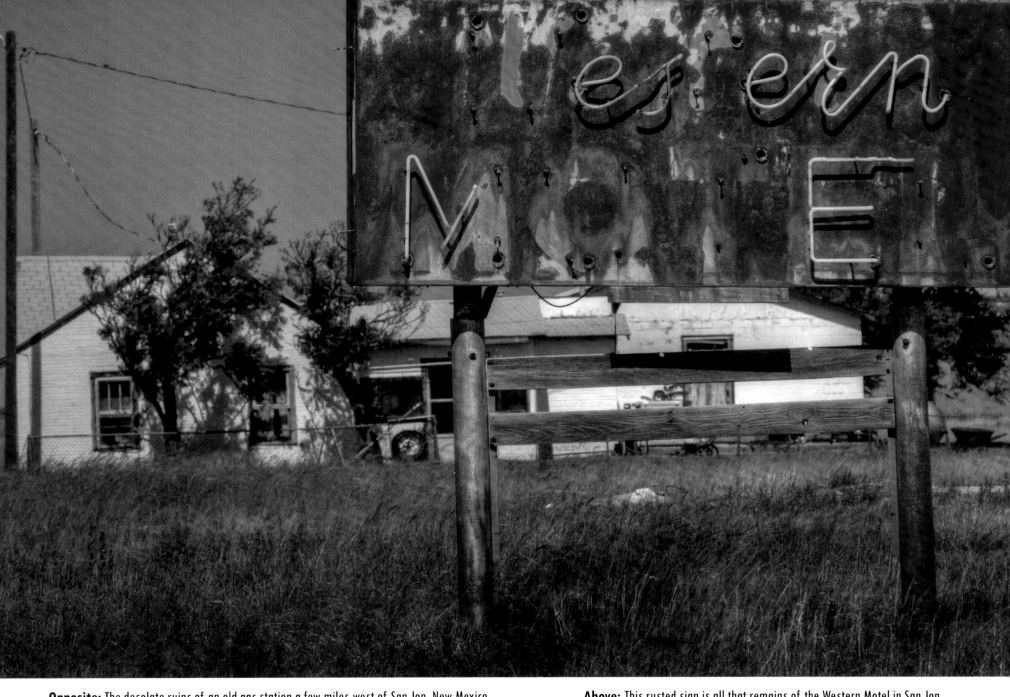

Opposite: The desolate ruins of an old gas station a few miles west of San Jon, New Mexico.

Above: This rusted sign is all that remains of the Western Motel in San Jon.

TUCUMCARI, NEW MEXICO

THE NAME TUCUMCARI COMES FROM the Apache language. Founded in 1901 the town is now the largest on the desolate stretch of the old highway between Amarillo, Texas and Albuquerque, New Mexico. It became known as "The Gateway to the West." During the busy years of the Mother road, the famous advertising slogan "Tucumcari Tonite!" invited a stream of travelers to lodge in the town's 2,000 motel rooms. Even today, the old road runs through the heart of Tucumcari along Route 66 Boulevard, and most of the town's hotels and lodging houses line the road. But when the road was re-aligned it separated the downtown area from the passing trade and the town began to decay and decline. In 2014, a series of suspicious fires destroyed many of Tucumcari's abandoned buildings, including the Tucumcari Motel and the Payless Motel.

Tucumcari is now the quintessential Route 66 town, full of iconic retro buildings. These include the Blue Swallow Motel, Tee Pee Curios, and the La Cita Sombrero Mexican restaurant. The Convention Center's Route 66 sign also attracts a constant flow of photo-snapping tourists. Tucumcari is also famous for its murals. Painted on the sides of the town's buildings, many have a Route 66 theme. Some are painted in a super-real style, while others are more playful. Several of the town's restaurants and hotels offer maps showing where the murals can be found. A host of ghostly and derelict buildings stand in abandoned parts of Tucumcari including the Ranch House Café, Six Shooter Siding, Redwood Lodge, and the Apache Motel.

Above: The Relax Inn on Route 66 in Tucumcari, with its sign opposite, is one of the many motels that have not thrived in recent years.

Next page: The Old Ranch House Cafe in Tucumcari New Mexico, was opened in 1953 by Pearl and Dugan Barnett.

MONTOYA, NEW MEXICO

MONTOYA IS LOCATED IN QUAY COUNTY, New Mexico on the original route of the Mother Road. The town is the site of the famous old Richardson Store. First opened in 1908, the wooden store thrived during the decades that Route 66 went through Montoya. A large wooden canopy shaded the fuel pump area. When Montoya was bypassed, Richardson's store fell into disuse and the roof fell in. Despite this, the store is listed on the National register of

Historic Places. Montoya's post office, established in 1910, originally doubled as a gas station and a store. Shut down long ago, the fading relic still stands.

When the road was re-aligned onto Interstate 40 in 1956, the Montoya quickly declined into a ghost settlement.

Below: The advertised "Cold Beer" is long gone from this Montoya ruin.

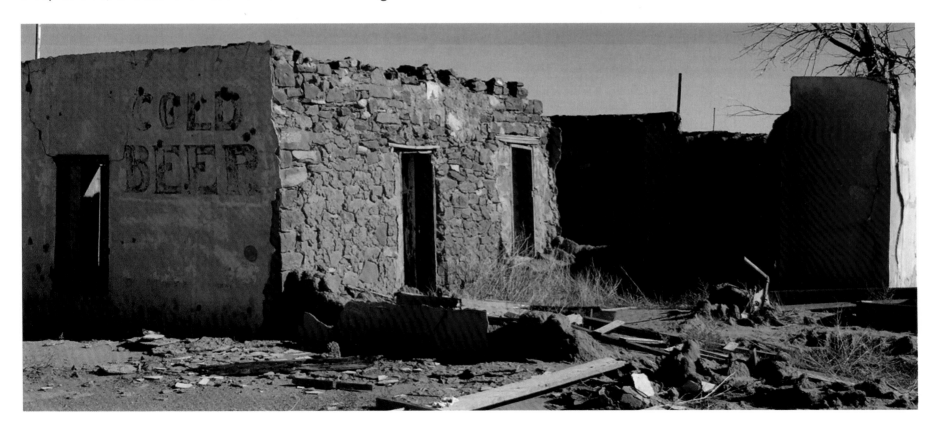

NEWKIRK, NEW MEXICO

TWELVE MILES ON FROM MONTOYA, Newkirk was founded in 1901, built around a siding on the Chicago, Rock Island and Gulf Railroad. The town is located in Guadalupe County, New Mexico and is now a true ghost town with a population of just seven people. The area was first inhabited by the Querecho Apaches and later by the Spanish conquistadors.

The original orientation of Route 66 passes through the town. During the heyday of the road, Newkirk had four gas stations (including Wilkerson's Gulf Station, the Shamrock, and a Phillips 66 gas station), two lunchrooms (including Carlo's Place), a few lodging cabins, and De Baca's Trading Post.

Wilkerson's is now abandoned. It closed down in 1989. The ramshackle building now has shattered windows, crumbling adobe, and cracked plaster. The town also has a disused adobe church with a corrugated iron roof and flimsy, leaning steeple. Weeds grow right up to the church door, which hasn't opened for mass in many years. Carlo's Place is just an empty and faded tavern. Just beyond the crumbling building are several dilapidated shacks and a derelict wooden train car.

Previous page: A crumbling roadside bar in Montoya, New Mexico.

Opposite: The old Wilkerson station on Route 66 in Newkirk, New Mexico. Wilkerson's used to be a Gulf station.
It closed in 1989.

Following page left: An old iron-roofed church on Route 66 in Newkirk, New Mexico.

Following page right: The old post office in Newkirk, New Mexico was established in 1910 and served as a gas station and store.

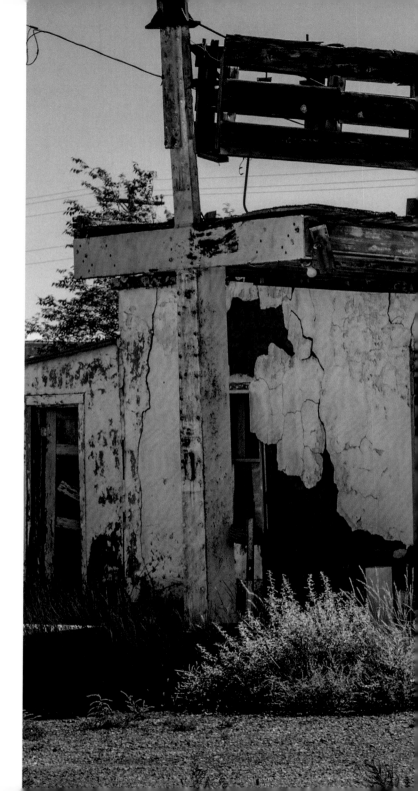

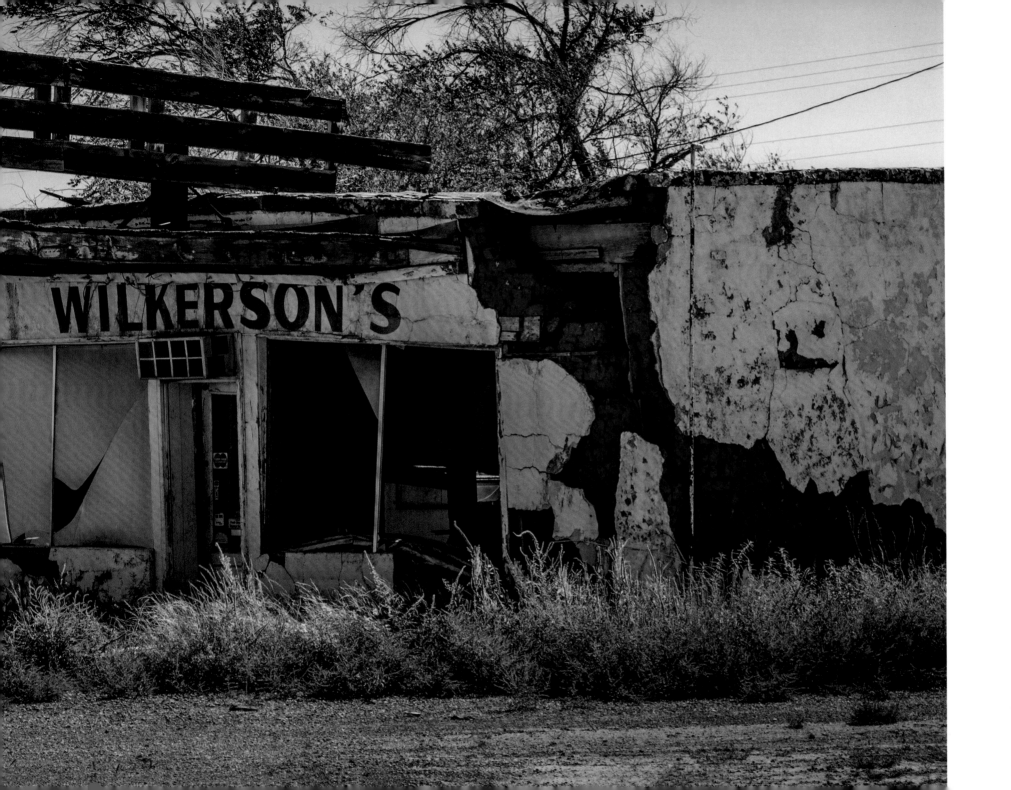

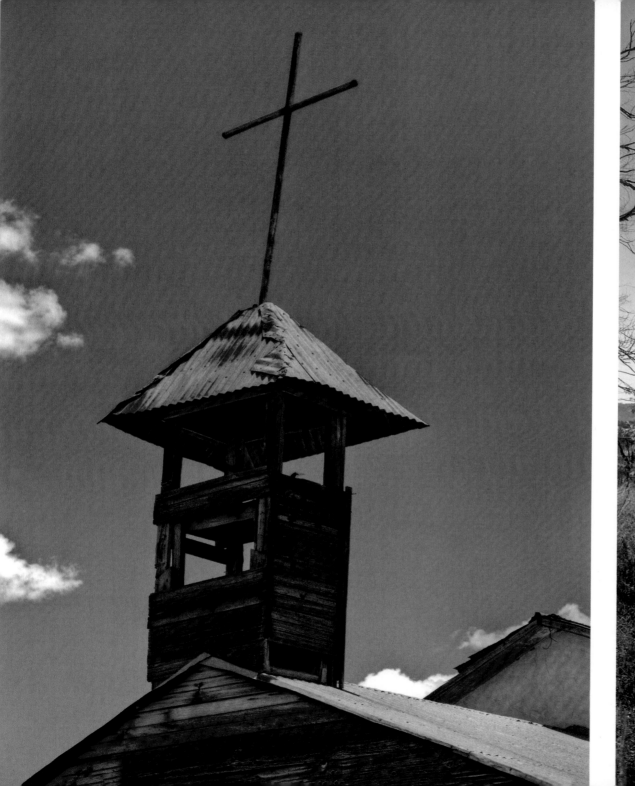

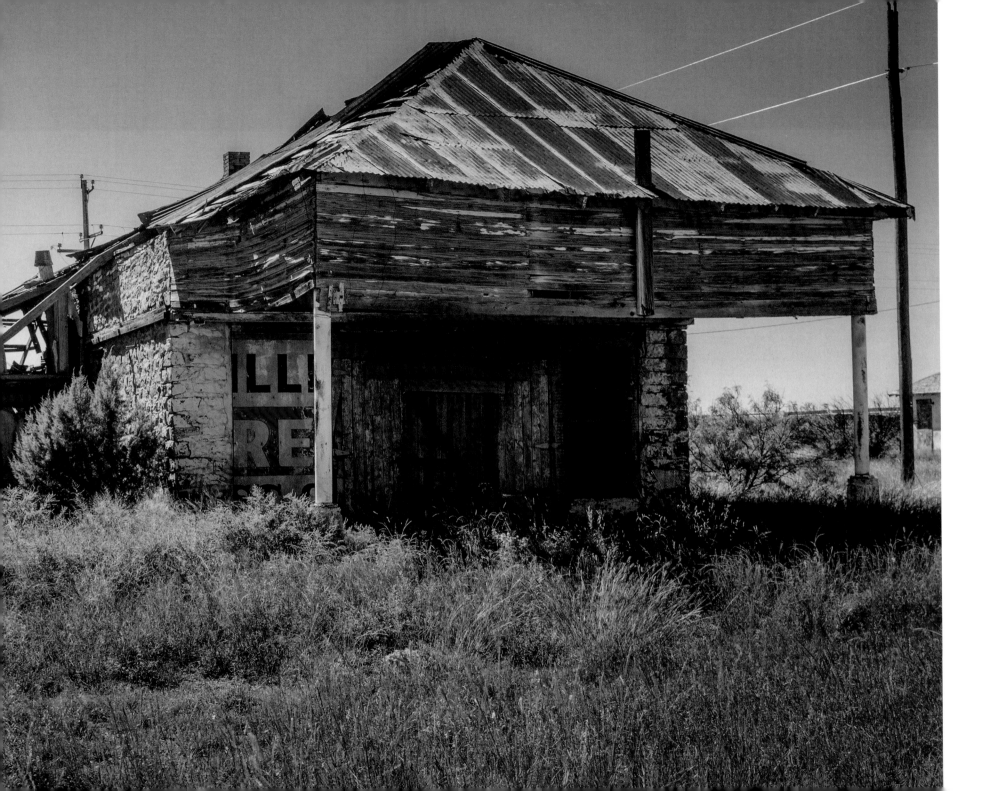

CUERVO, NEW MEXICO

CUERVO IS SPANISH FOR CROW OR RAVEN. This desolate ghost town is now located on a long-abandoned stretch of America's Main Street. The miles between Montoya to Cuervo follow the ancient Ozark Trail and pass over pinyon and juniper covered hills and mesas. The original asphalt road surface and concrete culverts of Route 66 are now completely broken up and derelict.

Cuervo was originally a railroad water stop town whose main business was cattle ranching. When Route 66 passed through, the population of the town exploded to 128 people in 1946. The town built two gas stations, a school house, two churches, and a motel. But when the road was re-aligned in 1952, Cuervo was torn in two and quickly fell into an irreversible decline. The town now has only a handful of residents and many visitors have commented on an unwholesome vibe in the ruins of the town. It is true that satanic graffiti appeared on the walls of the Getty Memorial Baptist Church, which now stands in the middle of an isolated field. Cuervo is now filled with crumbling and deserted adobe and wooden homes and the land around the town is littered with rotting and stripped-out cars. A small red sandstone Catholic Church is one of the area's few surviving structures. The town's post office finally closed in 2011.

The bright red earth of Cuervo is now covered by encroaching vegetation, acacia, sage, and cactus. The relics of the ghost town slumber under New Mexico's wide blue sky.

Above: A water tower at Cuervo, New Mexico.

Opposite: Cuervo's Catholic Church.

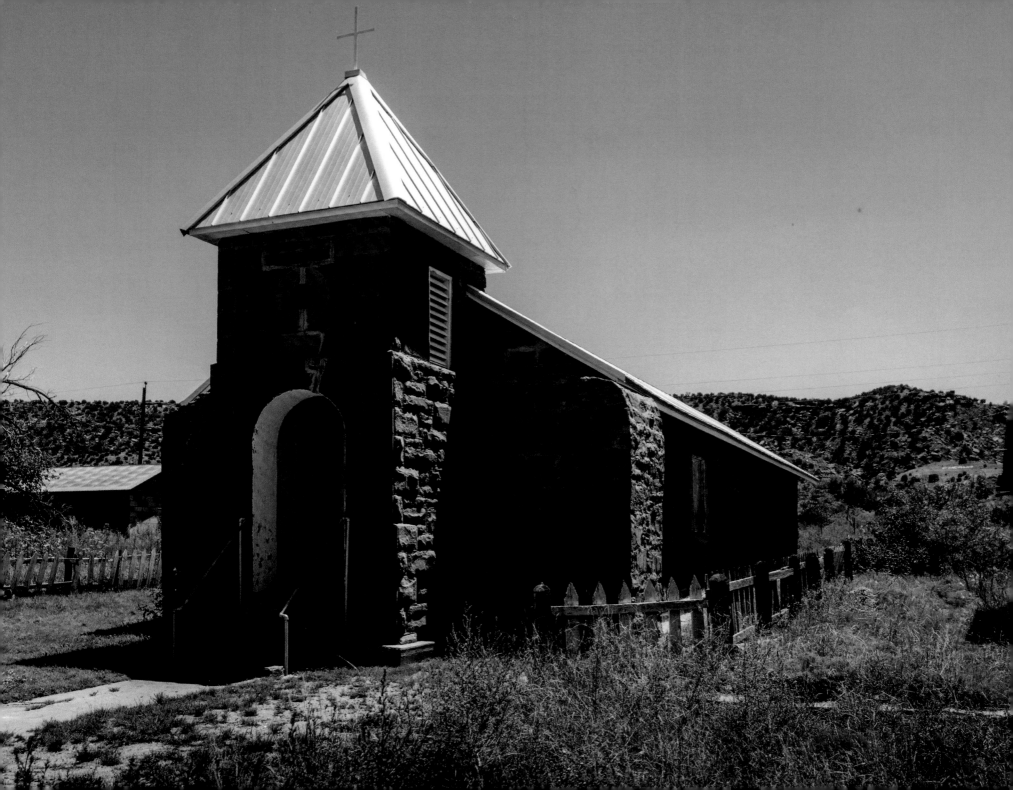

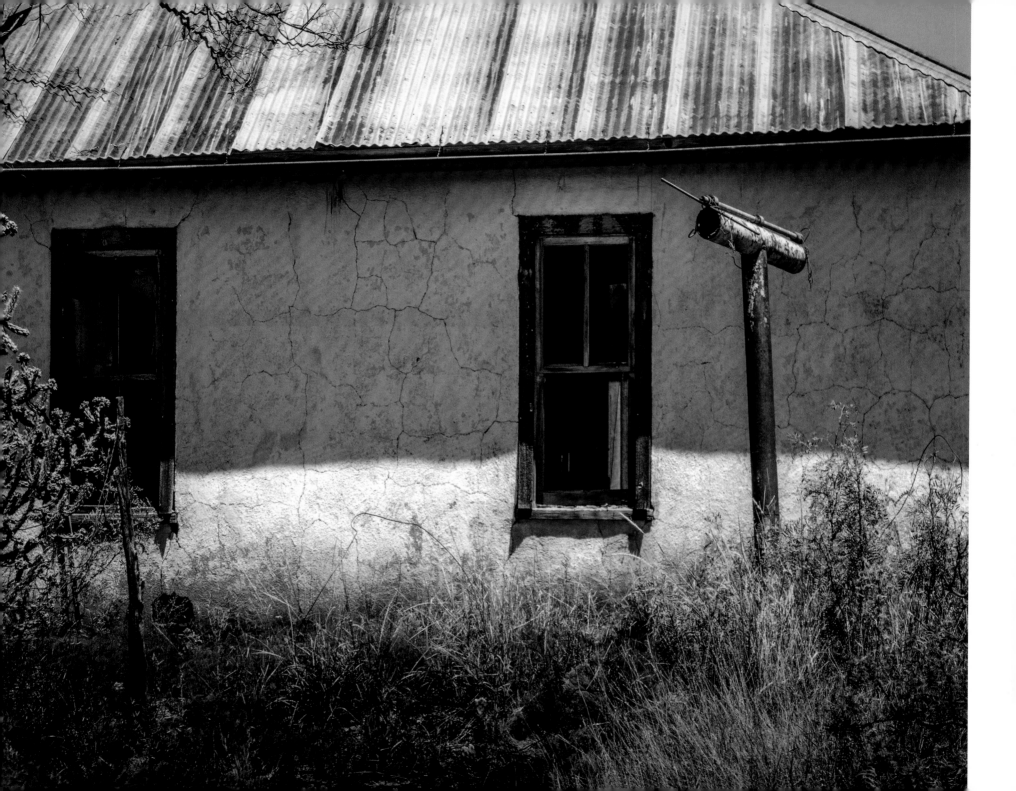

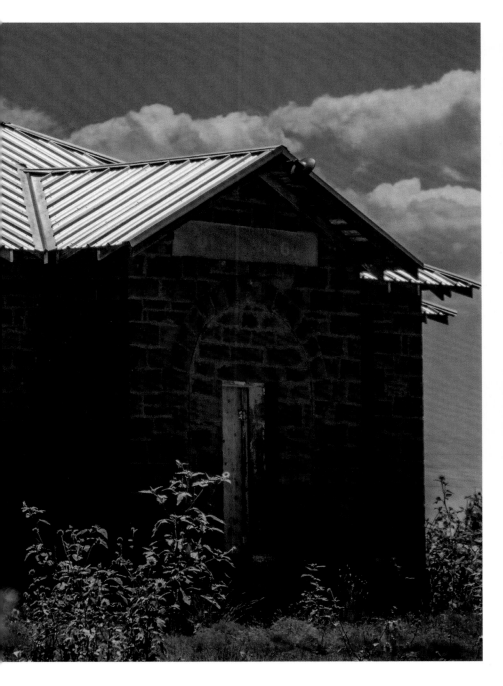

Opposite: An abandoned house in Cuervo, New Mexico.

Left: The entrance to the red stone church at Cuervo, New Mexico.

Above: An abandoned house in Cuervo, New Mexico.

Overleaf Left: An abandoned car sits in the red earth of Cuervo, New Mexico.

Overleaf Right: A sign for the original Comfort Inn in Tucumcari, forty miles away.

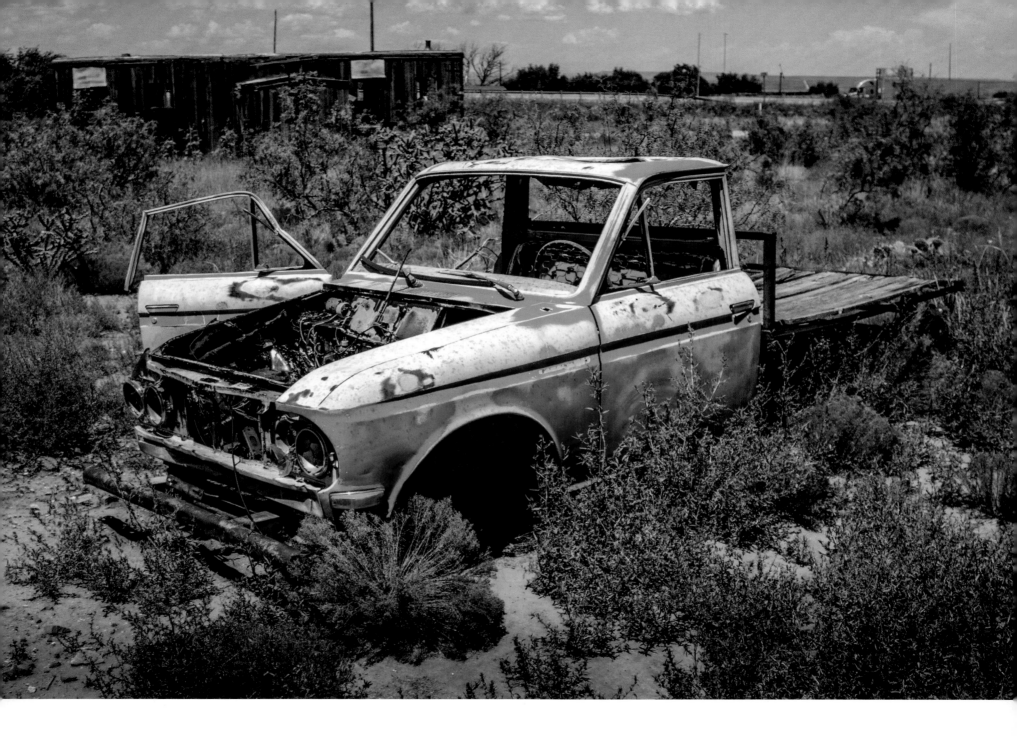

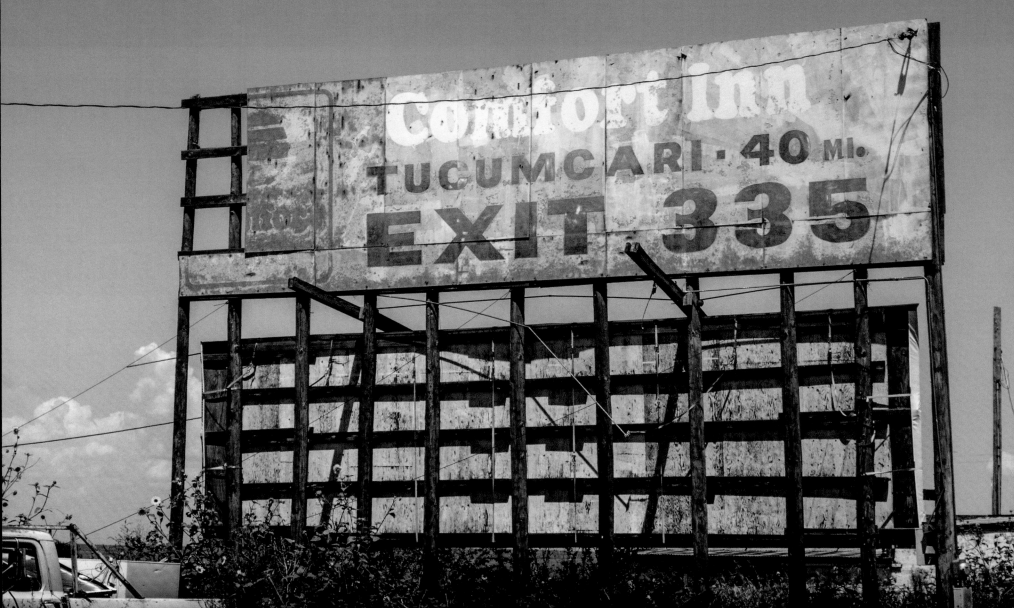

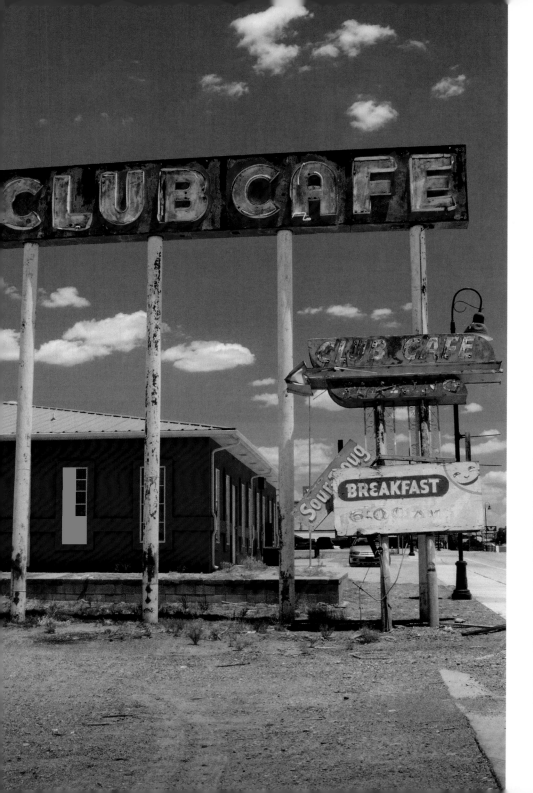

SANTA ROSA, NEW MEXICO

Santa Rosa is a Spanish town in northeastern New Mexico, located on the Pecos River. Surrounded by an arid landscape, Santa Rosa began as a cattle ranch. The town's name comes from a chapel built by local landowner Don Cleso Baca to honor his mother.

The area still boasts a drivable stretch of Route 66. Despite the arid landscape, Santa Rosa is known as the "City of Natural Lakes" in honor of the area's many natural waterways, including the Santa Rosa Blue Hole. This deep water hole is famous for its crystal clear waters and scuba diving. The town even has its own airport, the Santa Rosa Route 66 Airport.

The Mother Road passed through Santa Rosa between 1926 and 1937. During the 1930s, it is estimated that 65 percent of all westbound traffic and 50 per cent of all eastbound traffic used the road, and there was a flurry of commercial activity in Santa Rosa. But in late 1937, Route 66 was re-aligned to bypass the town. This re-alignment also cut out the much larger city of Santa Fe, so that the road went straight to Albuquerque. In 1946, Jack Rittenhouse commented that Santa Rosa had a population of 2,310 and this is pretty much the same today.

The town now boasts several interesting buildings including Bozo's Route 66 Auto Museum. Santa Rosa also

Left: The sign is all that remains of the once-famous Club Café on Route 66 in Santa Rosa, New Mexico.

has a good selection of motels and lodgings including the restored Sun 'n Sand Motel, the La Mesa Motel, and La Loma Motel. There are also two local campgrounds, in the great Route 66 tradition.

If you're hungry, Santa Rosa's Route 66 Restaurant serves pleasant Tex-Mex food. The restaurant has a good vintage atmosphere and plenty of Mother Road memorabilia. The Café Club restaurant is now defunct, but its towering neon sign still stands, and its empty parking lot is littered with other signs and shattered letters. The Café Club was the originator of the famous "fat man" logo, but this is now painted on the side of another Santa Rosa eatery, Joseph's Café.

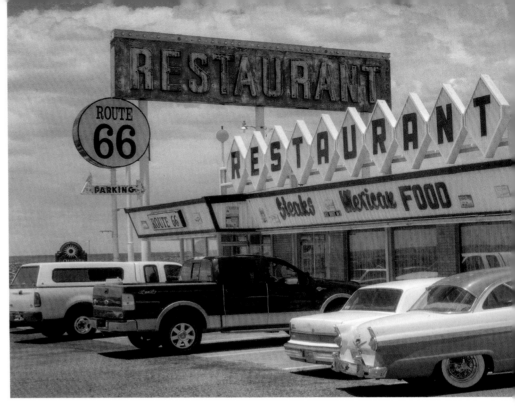

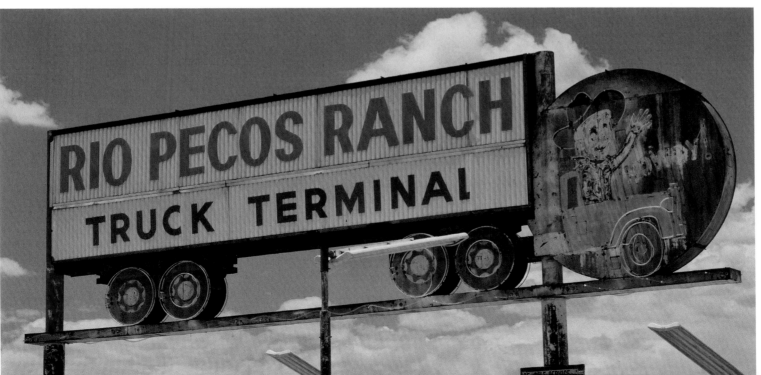

Above: The Route 66 Restaurant located in Santa Rosa, New Mexico.

Left: The Rio Pecos Ranch Truck Terminal opened around 1955. The truck driver once had an animated waving hand.

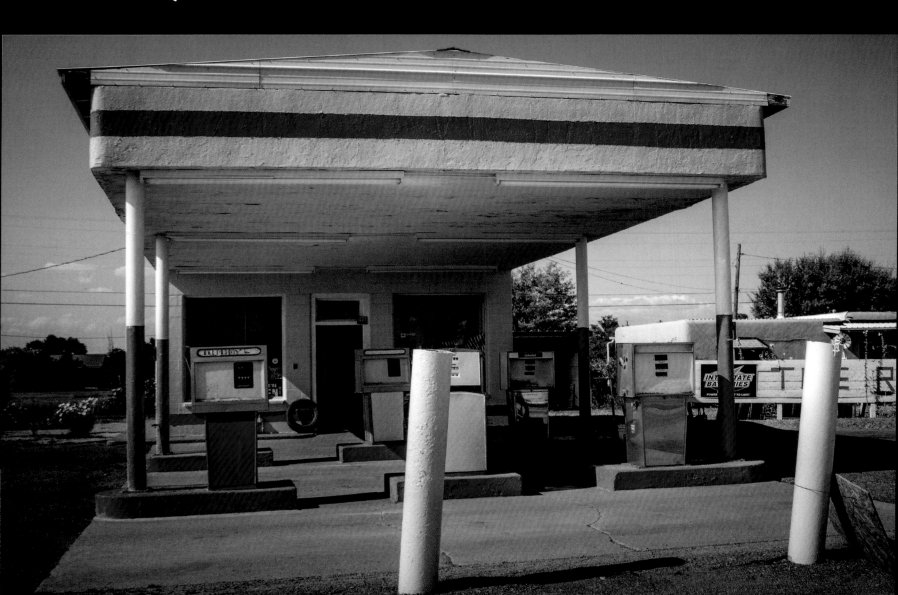

MORIARTY, NEW MEXICO

HOME OF THE PINTO BEAN FIESTA, Moriarty started life as the heart of a ranching community. The town was named after local rancher Michael Timothy Moriarty who settled the area with his family in 1887. Moriarty is located in the Estancia Valley, where the Sandia Mountain Range meets the high desert, next to the salt flat that was once the vast Lake Estancia. The area has been in habited for over 10,000 years. Moriarty grew when the railroad came to the town, and had a station and depot. The redundant tracks were finally lifted in the 1970s.

A new wave of prosperity came when Route 66 came to Moriarty in 1926, although the road surface wasn't fully paved until 1937. This was when the highway was re-aligned in the "Santa Fe Cut-Off" in a project was funded by the Federal Aid Program. The area around Moriarty was badly affected by the Dust Bowl drought of the mid-1930s and many people were forced to leave make their way west along the Mother Road.

As years went by, prosperity returned to the region when irrigation solved New Mexico's drought problem and Route 66 tourists brought their custom. Several hostelries opened in the 1950s, including the Lariat Motel. This independent concern was constructed by Paul and May Danneville in

Opposite: The Whiting Brothers gas station at Moriarty, New Mexico.

Right: The iconic Whiting Brothers sign.

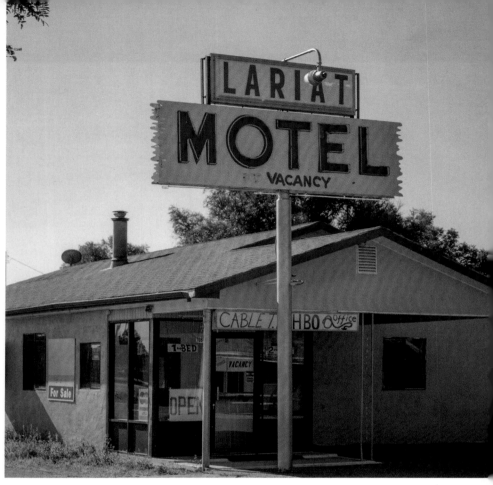

1957. It had thirteen steam-heated rooms with television, a restaurant, and a Texaco gas station. Moriarty's twelve-unit Cactus Motel was opened by Charles M. and Maria McPherson in 1952. The town's Sunset Motel also dates from this era and has now been in business for over sixty years. It has become an American classic, complete with its original furnishings.

Moriarty is now home to some of the best Route 66 sites in New Mexico, including old bars, gift shops, and hotels. These businesses include Cline's Corner (gas, food, and souvenirs), JR's Tire shop, the Longhorn Ranch, the Green Evans Garage, the Sands Motel, and the last operating Whiting Brothers gas station. Whiting Brothers once operated a chain of a hundred gas stations along Route 66. The business was started by Art and Ernest Whiting in 1917 at St. Johns, Arizona. Moriarty is now home to several restored business signs, including that of the 1951 El Comedor de Anayas Restaurant, complete with its neon Sputnik-style rotosphere and the Sands Apartments sign.

In 2000, Moriarty had a population of 1,765.

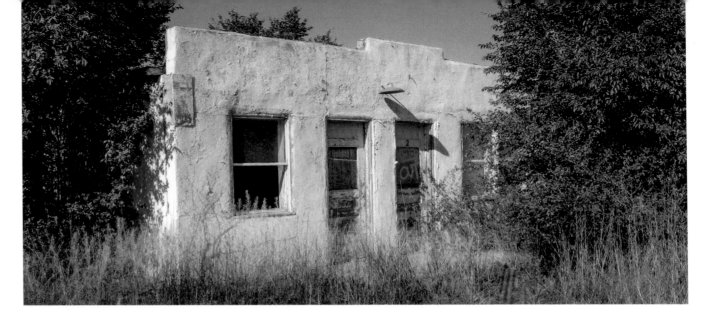

Opposite, far left: "Retribution" refers to Governor Hannett's 1920s realignment, which bypassed Santa Fe.

Opposite, near left: The Lariat Motel was one of the many mom-and-pop businesses on Route 66.

Right: A crumbling house in Moriarty.

Below: The Sands Apartments are still rented out.

Above: These beehive-shaped adobe bread ovens are known as "hornos."

EDGEWOOD, NEW MEXICO

THE OLD WILL ROGERS HIGHWAY runs east-west across central New Mexico. Until 1937, the road took a longer route through several small towns including Edgewood. This part of old Route 66 is now designated as a New Mexico Scenic Byway. Edgewood's commercial district lies along the old road, but this entire stretch of Route 66 was decommissioned in 1985.

Located in Santa Fe County in the Santa Fe Mountains, Edgewood has a pleasant small town atmosphere. It was founded by homesteaders moving into the American West. They founded the town using land "grabbed" under the Homestead Acts.

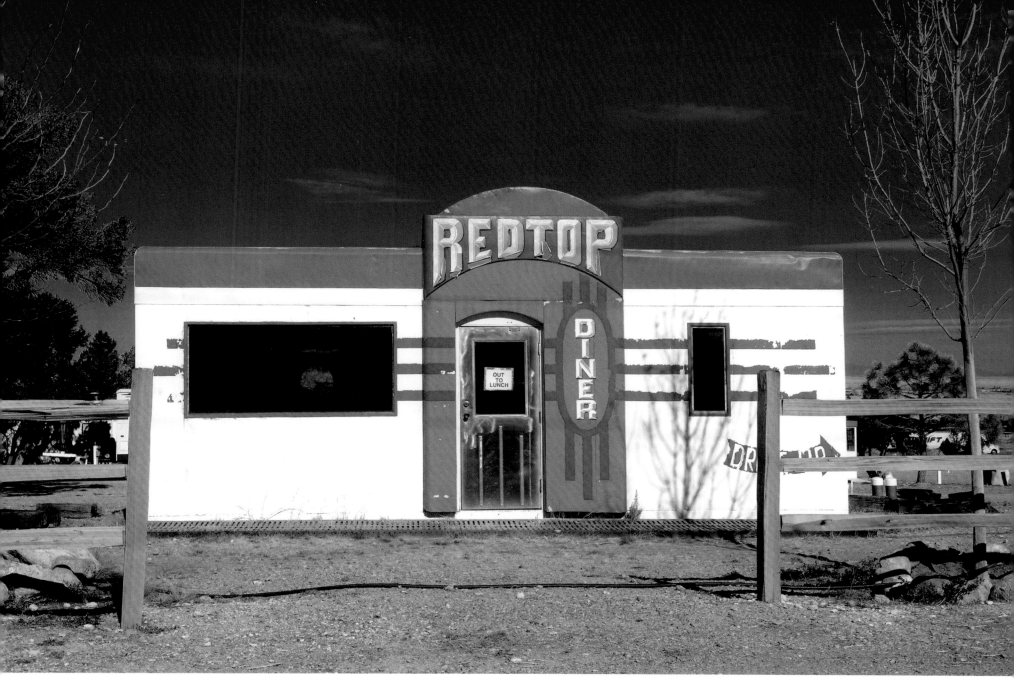

Above: The tiny eight-stool Red Top Diner has been relocated to Edgewood, New Mexico.

ALBUQUERQUE, NEW MEXICO

Above: Ruins at Albuquerque, New Mexico.

ALBUQUERQUE WAS FIRST FOUNDED in 1706 on the banks of the Rio Grande. It is still proud of its Spanish Colonial heritage. It is now the largest city in New Mexico and owes much of its prosperity to its proximity to the Mother Road. Before 1937 Route 66 entered the city of Albuquerque from the north following Forth Street and, for a brief time Second Street. Later, the highway followed Central Avenue. Although the road was re-aligned in the late 1930s, this stretch still boasts historic neon signs that glow along the city's "motel row." Motor courts were built alongside the route in the 1930s and 1940s, followed by motels constructed between the 1950s and the 1970s. These included the iconic El Vado Motor Court, whose adobe cabins were opened to tourists for over six decades. Modern Albuquerque is still full of cafés (including the 66 Diner) and gas stations to serve nostalgic Route 66 travelers. Kellys Brewery serves beer to thirsty tourists.

The famous Mountain Lodge Motel was located on old Route 66 in Bernalillo County, twelve miles east of Albuquerque. The motel was built in a secluded mountain

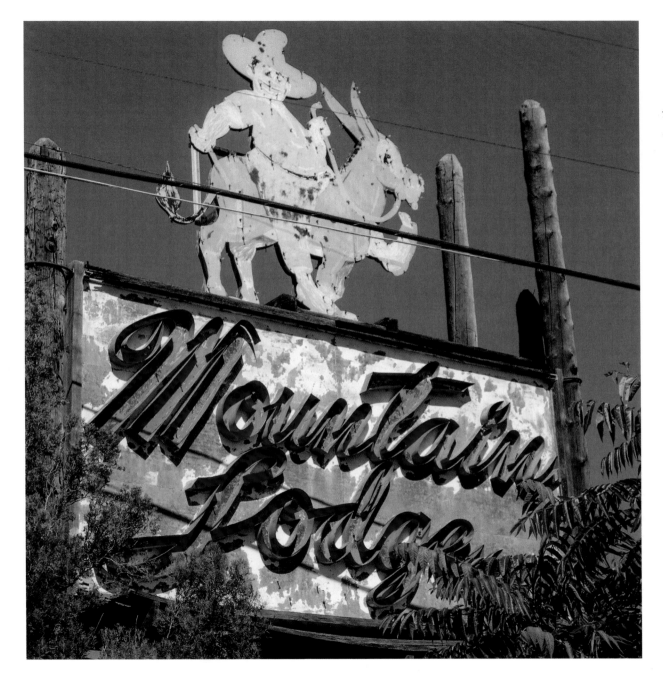

environment in the beautiful Tijeras Canyon in the heart of the Sandia Mountains. The Mountain Lodge had twelve centrally steam heated rooms, with fully carpeted bedrooms and tiled bathrooms. Each room had its own private garage. During the 1950s, the Mountain Lodge was owned and operated by Mr. and Mrs. C.B. Saunders. Very sadly, the historic motel was lost to a devastating fire in December 2014.

Route 66 chronicler Jack D. Rittenhouse was born in Albuquerque in 1912. In 1946, Rittenhouse made a slow and detailed journey along the length of the highway in his 1939 American Bantam Coupe. He published his iconic *Guide Book to Highway 66* the same year, and it proved to be a stimulus to tourism along the road.

Left: The Mountain Lodge Motel burned down in 2014.

PARAJE, NEW MEXICO

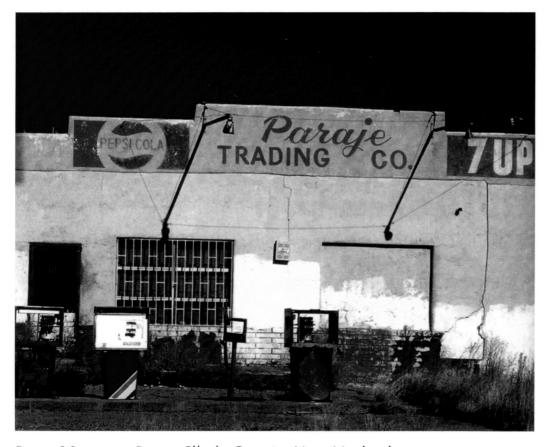

Basin and meant that local farmers could grow maize, squash, and beans. Some of the land around the village is now used for grazing, and there is mining at nearby uranium mines. Although this is a hot and arid desert region, heavy showers can cause waves of wild flowers to bloom. The railroad came to Paraje in the 1880s.

Paraje is now mostly a collection of ruined and abandoned stone and adobe buildings. The abandoned Paraje Trading Post has now been demolished, and the Philip Bibo's Trading Post is also in ruins. The Paraje Gas Station and Trading Center is also closed. But the village still has a beautiful adobe church, the San Esteban del Rey Mission, the Great American Diner, and the Zodiac Bar. Paraje is dominated by a couple of tall white water towers.

Local Legend has it that the ruins of Paraje are haunted by the sad ghost of a poor young boy who was killed when his family home burned down. This unquiet spirit is known as Pajama Boy.

ROUTE 66 CAME TO PARAJE, Cibola County, New Mexico in 1926 and still goes through this virtual ghost town. Paraje is one of six villages of the Laguna Pueblo. The area around the village is farmland, originally settled by the San Felipe Indians, who were followed by Spanish settlers. Paraje means "location" or "place" in Spanish. The Paraje Irrigation Ditch brought in water from the Rio Grande

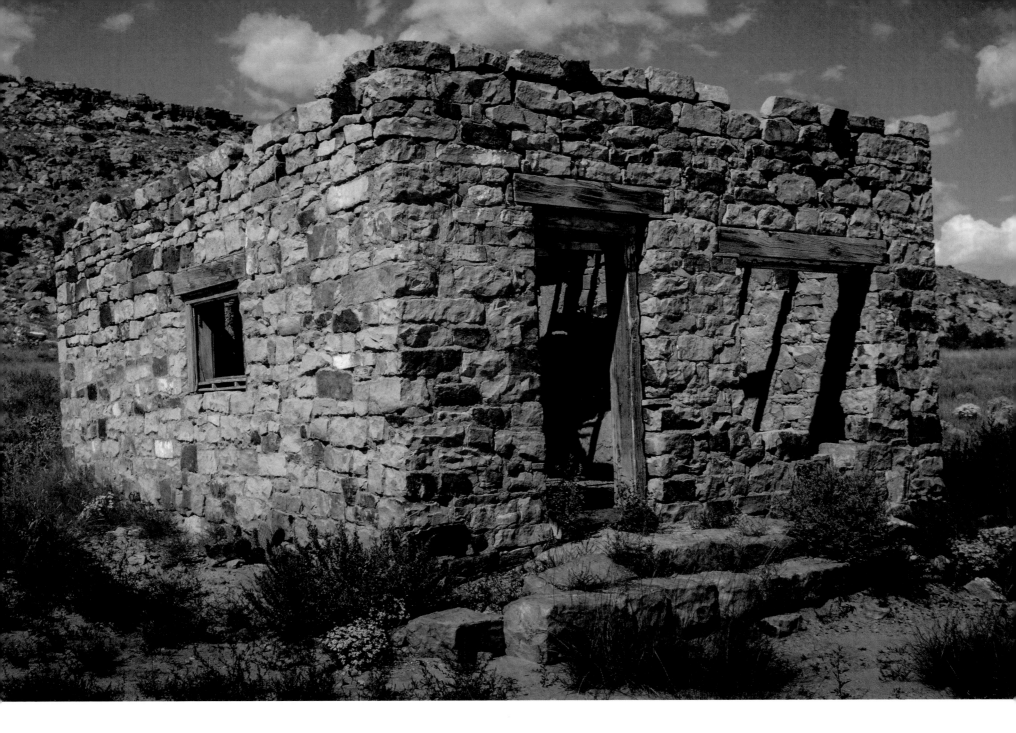

BUDVILLE, NEW MEXICO

THREE MILES FURTHER ON FROM PARAJE, and located on the Laguna Indian Reservation, Budville was named for Cubero businessman H.N. "Bud" Rice. Bud owned the Budville Trading Company, which he opened in 1928. Just thirty feet from the Mother Road, the building and its old gas pump is now one of the most photographed nostalgia sites on old Route 66. Bud ran a garage and trading business on the site, and towed auto wrecks from along the highway. Very sadly, Bud was murdered in a botched robbery at the Trading Company in 1967. His murderer was never identified. His wife continued the business for a few years, but it finally closed in 1979. Another local business, Kings Café and Bar (which was later called the Midway), is still serving. Budville is also famous for the Dixie Tavern and Café (founded in 1936). Dixie's originally sold Native American rugs and craftwork, and rented out cabins to travelers along the highway.

Budville also has a spooky cemetery. Most of the graves date from the nineteenth century and the names on the headstones bear witness to the Hispanic heritage of the area.

Below: The Midway was originally called Kings
Opposite: The Budville Trading Company was the scene of a heinous murder.

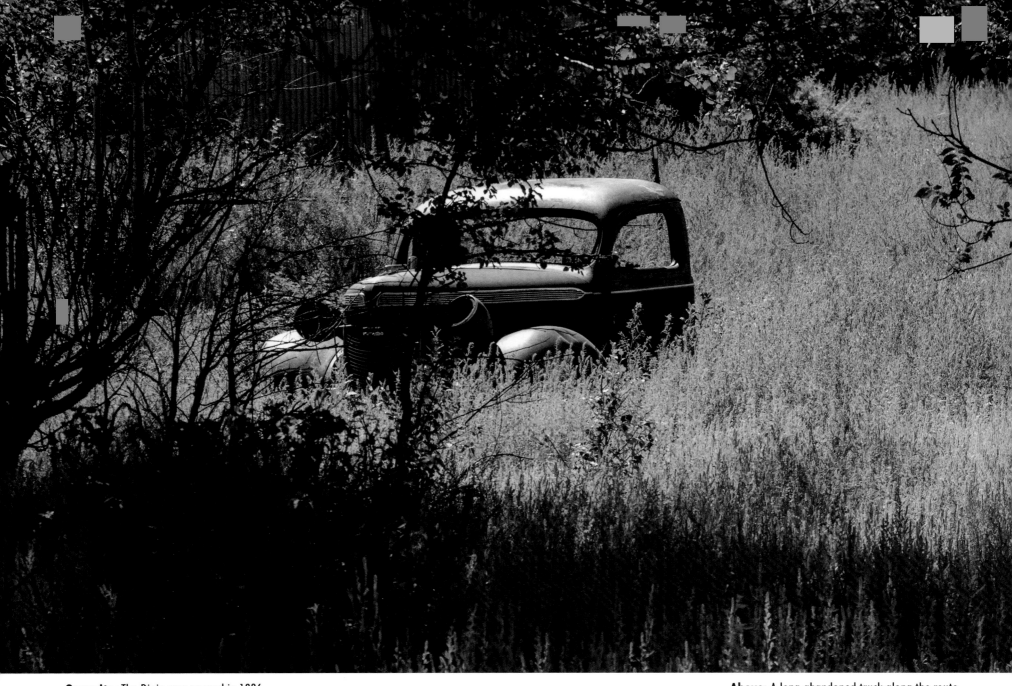

Opposite: The Dixie was opened in 1936.

Above: A long-abandoned truck along the route.

CUBERO, NEW MEXICO

A FEW MILES DOWN THE ROAD, the Route 66 traveler comes across the ghost town of Cubero, Cibola County. It was named for the Spanish state governor, Pedro Rodriguez Cubero. The town is located on the desert plain with a fabulous view of Mount Taylor and its foothills. Cubero's Native American name is very appropriate, as it means "West Doorway." The town was on the first alignment of Route 66 that ran through the San Jose River Valley.

Wallace and Mary Gunn ran the local trading post, selling general goods and Navajo rugs and jewelry. When the road was re-aligned and hard-surfaced in 1937, the Gunns re-located their business to be alongside the new road. The couple went into partnership with Sidney Gotlieb and built the Spanish-styled Villa de Cubero Trading Post. This became a famous Mother Road destination. The "Villa" had a "De Luxe Tourist Court" of ten individual cabins, complete with tiled bathrooms (plumbed with hot and cold water). It was the first stopping place west of Albuquerque, and one of the few motels in Pueblo County. Although the Villa did not serve alcohol, and never had television in its guest rooms, it became a favorite hideaway of the Hollywood elite in the early 1950s. Lucille and Desi Arnaz, Ernest Hemingway, Gene Tierney, and the Von Trapp Family all stayed at the Villa de Cubero from time to time.

Cubero is now mostly boarded up. Although the trading post continues to trade, the motor court is abandoned. The Gotlieb Oil Company also remains open, serving Conoco gas.

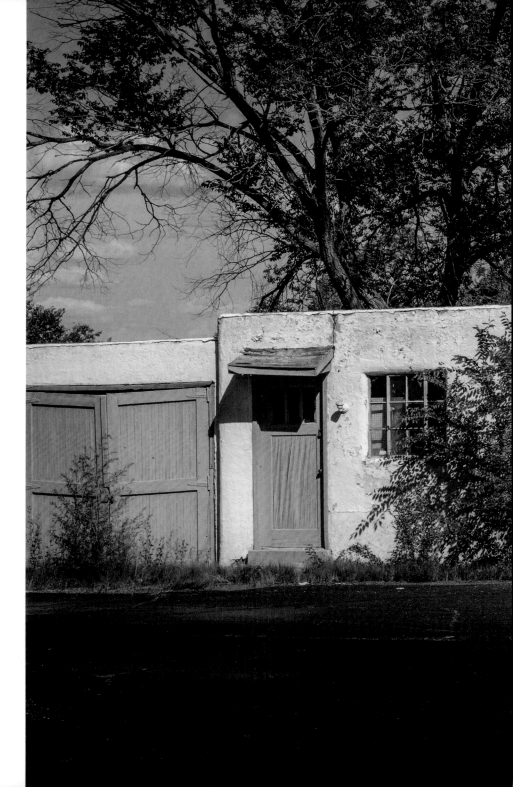

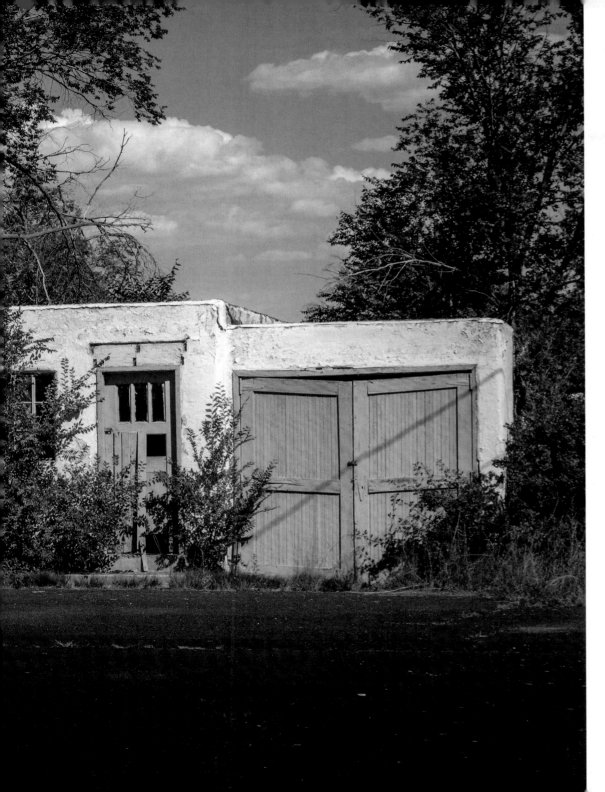

Left: The Villa de Cubero was the first stopping place west of Albuquerque.

Above: The paint peels off another old building to the west of the town.

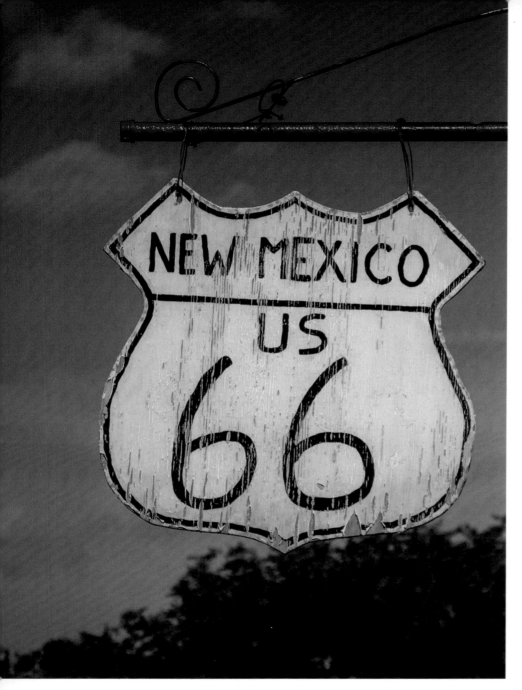

Above: San Fidel is on the Santa Fe Loop of Route 66.

SAN FIDEL, NEW MEXICO

SAN FIDEL IS ON A STRAIGHT SECTION of the original orientation of Route 66. Between 1926 and 1937 this part of the Mother Road ran along the San Jose River Valley. Located in Cibola County, the village of San Fidel itself is next to the San Jose River, at the base of the San Mateo Mountains. It lies in an arid desert landscape. San Fidel retains its Hispanic feel, and has a Mission-styled church, St. Joseph's. The village post office, founded in 1919, is still in business.

In 1946, Jack Rittenhouse counted 128 citizens living at San Fidel and said that the settlement had "café, gas, small garage, curios, store, no cabins or other accommodation." He may well have been referring to the White Arrow Garage. Built in 1943, this small business is now just a picturesque ruin. There is still nowhere to stay in San Fidel, but the famous Acoma Curio Shop, first opened in 1916, deals in local Native American crafts, as the town did when Rittenhouse passed through.

The remains of the famous Whiting Brothers Gas Station can be found 2.7 miles to the west of San Fidel, halfway to McCartys. Built around 1940, the business was originally called the Chief's Rancho Café and sold gas, grocery, curios, and food. Jack Rittenhouse mentioned the business in his 1946 guide. The main building was gutted by fire in 1996, and only the bare bones of the structure remain, covered by graffiti and desert undergrowth. A couple of nostalgic signs still stand.

Opposite: The Whiting Brothers Service station was gutted by fire in 1996.

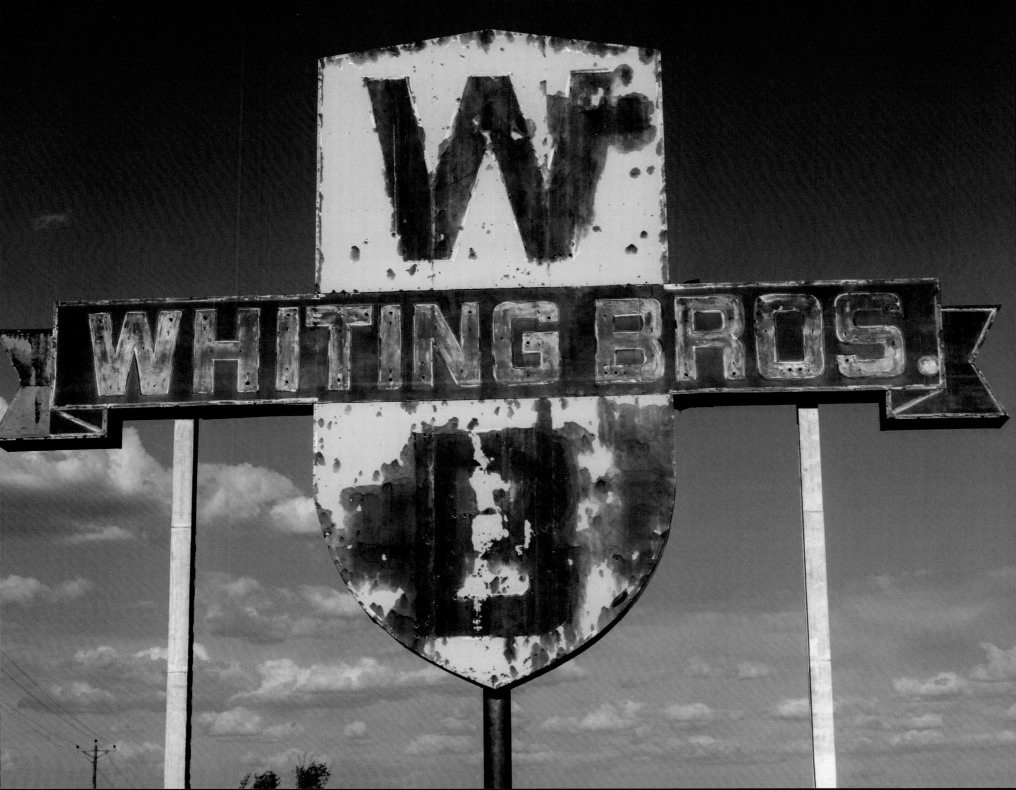

Right: San Fidel's Post Office.

Opposite, far right, and below: Crumbling buildings at San Fidel.

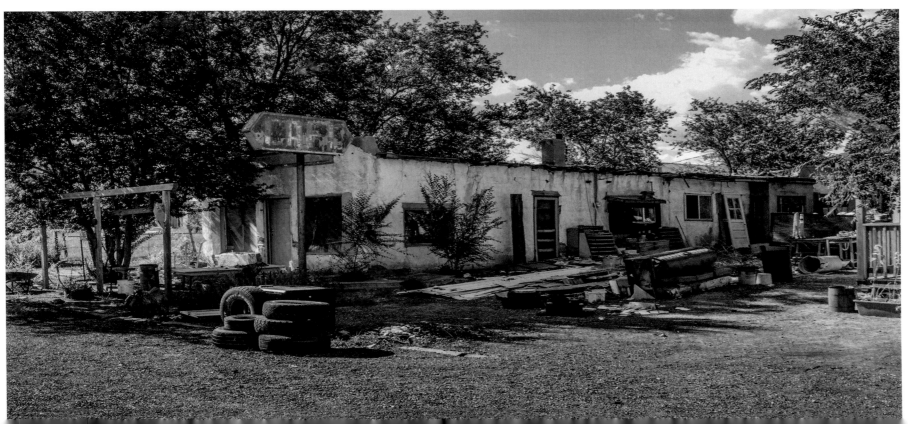

McCARTYS, NEW MEXICO

THE LONELY AND ALMOST DESERTED village of McCartys is 4.7 miles along old Route 66 from San Fidel. In 2010, its population was just 48. Before the Mother Road came to the area, McCartys was the center of a farming and trading community on the Acoma Indian Reservation. The village was named for the railroad contractor that built the local stretch of the line.

This section of Route 66 is now listed on the National Register of Historic Places. It was a challenge to build as it crosses the rough and barren Malpais badlands. The Mother Road first came to the area in 1926 and was re-aligned in 1936. It was straightened and paved in the New Deal work programs of the Great Depression. The program also constructed a steel truss bridge to carry Route 66 over the San Jose River. Ultimately, McCartys was bypassed in 1956 when the Mother Road was superseded by Interstate 40.

The area around McCartys is known as the "Gateway to Acoma Pueblo," 14.5 miles to the south. The village itself is most notable for the Santa Maria de Acoma Mission and Church to the west of the village. Built in 1933 in the classic Mission style, the Spanish Colonial building has two square towers and a flat roof. Most of the village's remaining buildings are ruined or abandoned.

After McCartys, old Route 66 continues on to the settlements of Grants and Thoreau, where it crosses the state line into Arizona.

Right: Crumbling adobe building at McCartys.

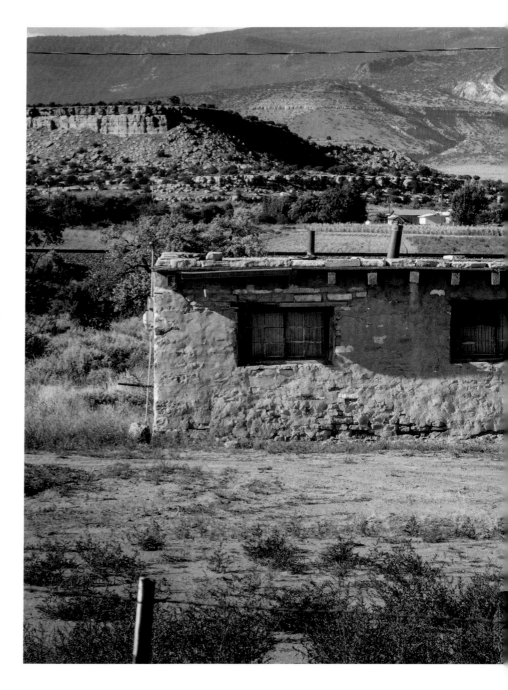

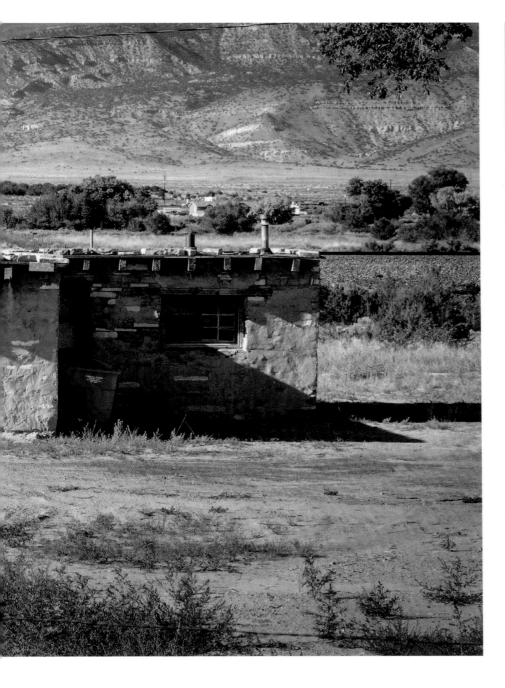

Above: The exterior of the Santa Maria de Acoma Church.

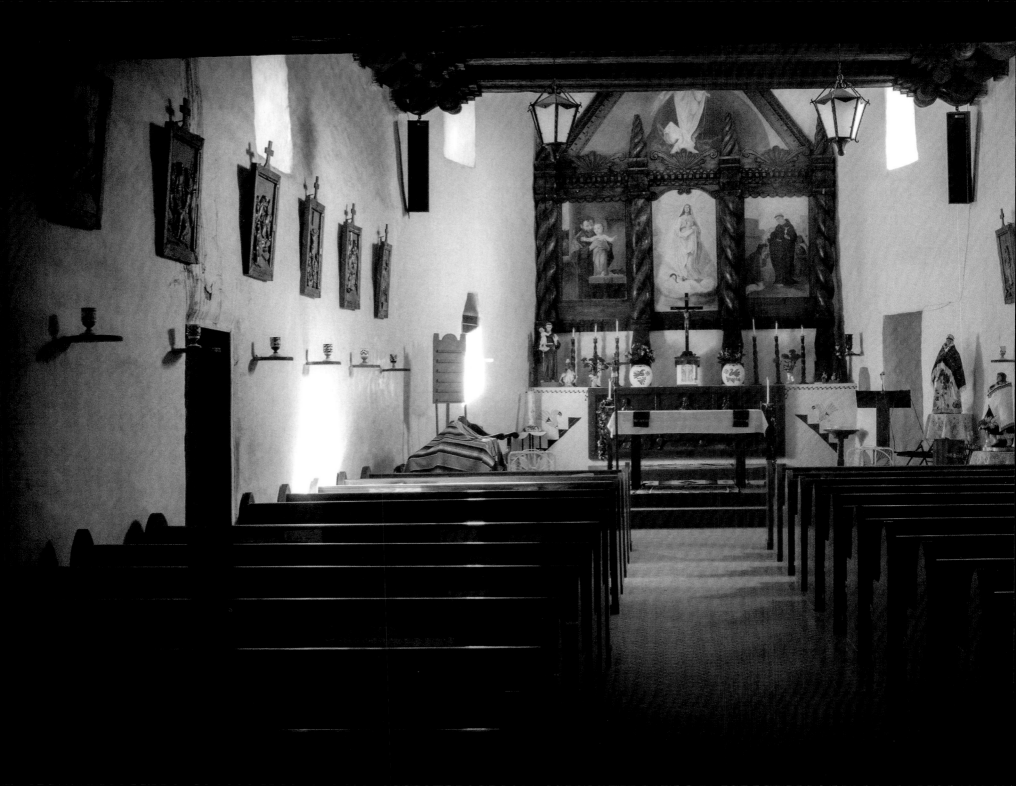

SKY CITY

NEXT RIGHT TURN

Opposite: The beautiful interior of the Santa Maria de Acoma Church in McCartys.

Above: The Acoma Sky City Cultural Center is still open.

ROUTE 66 IN ARIZONA

OLD ROUTE 66 CAME TO ARIZONA IN 1926 and ran across the Grand Canyon State from the Great Plains to coastal California. It stretched for 401 miles and took over the role of the Santa Fe Railroad in bringing travelers into the region. Williams, Arizona was the last point on the Mother Road to be bypassed by an interstate. The road started at Lupton in the east and ran to Topock in the west. It followed ancient trade trails and the tracks used by the California gold miners across the empty desert and the route of the Santa Fe Railroad. Very little of the original road was paved, except through the towns. But in 1933, Arizona received more than five million dollars from the National Recovery Administration highway funds to upgrade the surface. President Roosevelt's sweeping unemployment relief program meant that by 1938 the road was paved all the way from Chicago to Los Angeles.

Left: Route 66 stretches for 401 miles across Arizona.

Opposite: A vintage car parked outside the 1950s Twisters Soda Fountain on Route 66 in Williams, Arizona.

It was always wild with many hairpin turns and some of the steepest gradients along the route. The road rises to an elevation of 3,500 feet above sea level. The Arizona stretch of the road is one of the most picturesque, running through many different kinds of fantastic scenery including lush green pine forests, volcanoes, the Petrified Forest, meteor craters, snowy peaks, Navajo reservations, National Parks, and the Painted Desert. The Arizona section also has some of the most extreme weather along the route, with winter snow and extreme summer heat. The scarcity of water along the route means that travelers need to carry large water tanks. The state's beauty has inspired many writers, filmmakers, photographers, and artists. Route 66 in Arizona became a hugely popular tourist attraction from day one, as thousands of Americans were attracted to the romance of the cowboys and Native Americans of the Old West. There was an explosive increase of traffic along the road that made Arizona's towns buzz with activity. It became a symbol of freedom and opportunity. This popularity has resulted in a wonderful legacy of nostalgic attractions. These include restaurants, hotels, motor courts, motels, trading posts, and Pueblo-style buildings. Arizona also boasts one of only two surviving wigwam motels on the road. Route 66 tourism became a major economic resource in Arizona as many flocked to see the state's picture-perfect scenery and historic attractions. The state now boasts some of the best-preserved stretches of Route 66, including the longest passable stretch of the road —

159 miles between Ash Fork and Kingman. Today's tourists are attracted by the dozens of well-preserved ghost towns, icons of twentieth-century car culture, and the Western way of life. The Arizona Route 66 Museum is located in Kingman's Historic Powerhouse. But short stretches of the road surface has now deteriorated into gravel and dirt and the occasional wire fence crosses disused sections.

Ultimately the Arizona stretch of Route 66 was bypassed by Interstate 40. The Federal Aid Highway Act of 1956 funded the project with 375 million dollars, which took over a decade to complete. It was finally de-commissioned in 1985.

LUPTON, ARIZONA

In 1930, a guide book described Lupton as "a western cow town, named for a pioneer." It had a population of 75. The pioneer was George William Lupton, who worked for the Atchison, Topeka, and Santa Fe Railroad. The railroad reached Lupton on May 1, 1861. In 1946, Jack Rittenhouse noted that Lupton's population had fallen to 33.

Lupton is now little more than a collection of trading posts, including the Tepee and Chapparral trading posts. The first of these is the Yellowhorse Trading Post. It is located on the Navajo Nation Reservation under the area's spectacular red sandstone Painted Cliffs, just to the left of the New Mexico state line. The trading post was founded by the Yellowhorse family in the 1950s, who sold Navajo rugs and petrified wood to travellers along the highway. In the 1960s, Juan and Frank Yellowhorse added Shell gas pumps and advertising signs. The Yellowhorse family still runs the enterprise, selling authentic Native American silver jewelry, pottery, and artwork. Purchases at the store attract 3% Navajo Nation sales tax.

Below: The famous Yellowhorse Trading Post.

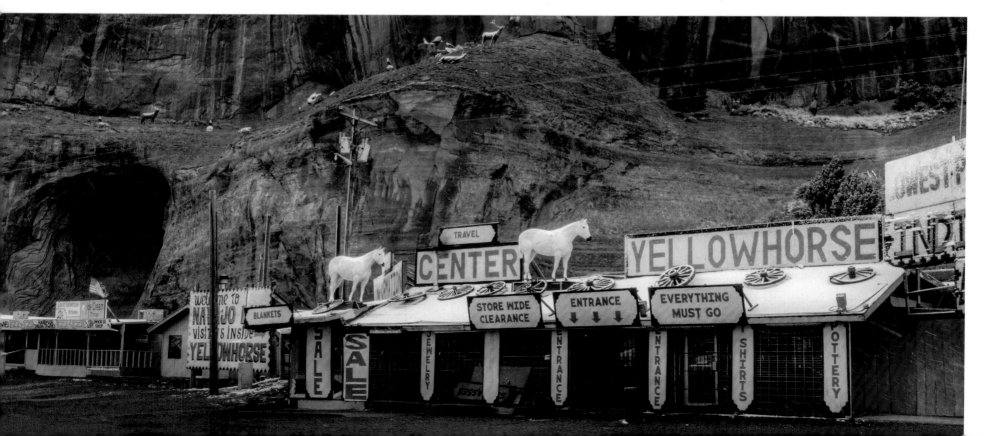

HOUCK, ARIZONA

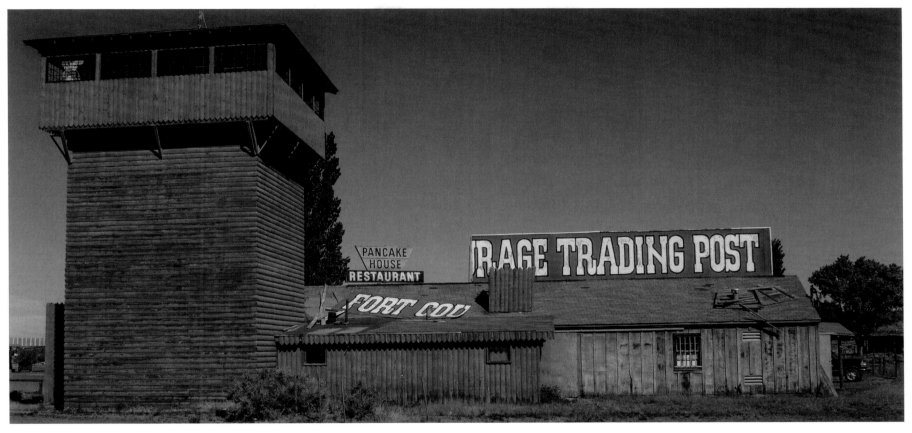

THE PIONEER SETTLEMENT OF HOUCK, Arizona was founded by a mail carrier. He established a trading post there called Houck's Tank. In 1880, Houck was the scene of the murder of William Walker and William Smith by Native Americans.

The design of Houck's Fort Courage Trading Post, located on old Route 66, was inspired by the 1960s television sitcom, F-Troop. The short-lived show was set in the western Frontier

of the 1860s. The trading post is now closed. Like so many trading posts in the area, it used to sell typical gift-shop junk and local Native American crafts. The trading post also had a couple of observation towers and some authentic props from the television show. Before its demise, Fort Courage had its own pancake house and a gas station.

CHAMBERS, ARIZONA

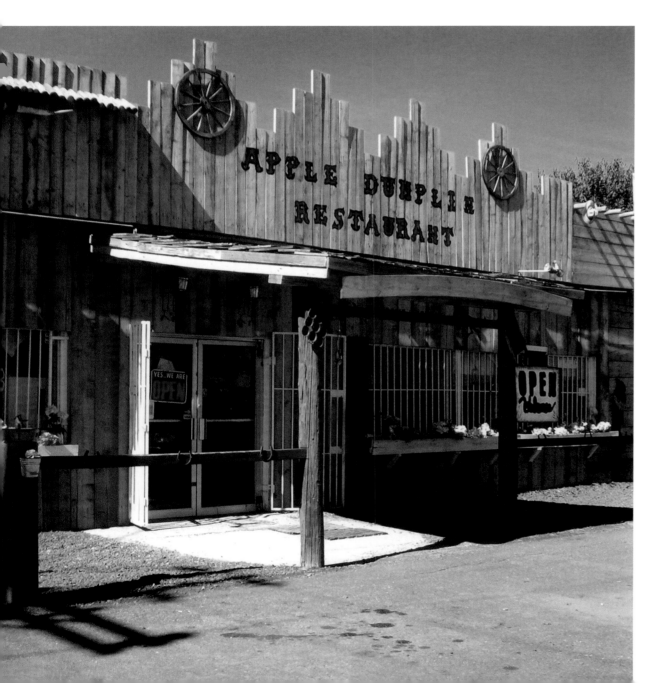

CHAMBERS IS LOCATED IN APACHE COUNTY, Arizona, at 5,755 feet above sea level. Apache County was established in 1879. The settlement was founded by Charles Chambers sometime before the railroad arrived in 1881. A post office opened there in 1908. It became a popular stopping place on Route 66, which came to the area in 1926. The local stretch was paved by 1927 with trading posts and gas stations, including the Wide Ruins Trading Post. The Apple Dumplin' Restaurant was founded by Kathy Simshauser in 2003, serving simple American classics. The building had an old western-style wooden front, and the inside walls were covered with local memorabilia. These included John Wayne's burial bill from a local funeral home. The business was put up for sale in 2012.

Chambers is now just a scattering of houses, with a Mobil gas station and lodging at the chieftain Inn. The motel was opened in the 1970s and has a swimming pool and restaurant.

Left: The Apple Dumplin' was built in a classic western style.

THE PETRIFIED FOREST, ARIZONA

THE PETRIFIED FOREST NATIONAL PARK is the only national park on the route of the Main Street of America. Route 66 bisected the main park highway and was the first paved road in the area. It paralleled the railroad, following the Beale and National Old Trails Road. A variety of motor courts, restaurants, and other businesses lined the route. Traces of the old roadbed and a line of weathered telephone poles mark the path of the famous road. The Petrified Forest area was designated a National Monument on December 8, 1906. The Painted Desert was added later, and on December 9, 1962, the whole monument received National Park status. Today, the park covers a staggering 93,532 acres.

The extraordinary petrified wood found in the dramatic landscape of the region is made up of almost solid quartz. Each piece is like a giant crystal, often sparkling in the sunlight. The colors are produced by impurities in the quartz, such as iron, carbon, and manganese. Many vistors to the park have been tempted to take a sample of petrified wood, although this is now illegal. But as far back as the 1930s, visitors began to report that after taking a piece of petrified wood from the park, they were cursed with bad luck. This curse continues to be experienced today. Many pieces of stolen rock are returned to the park rangers every year, together with details of the misfortunes that followed its removal.

A 1932 Studebaker exhibit has also been installed adjacent to the old road. The car was donated to the National Park Service by Frank and Rhonda Dobell, owners of Arizona Automotive Service in Holbrook, Arizona.

This part of Route 66 was bypassed by a new alignment (now Interstate 40) in the late 1950s.

Right: Petrified wood is made from solid quartz.

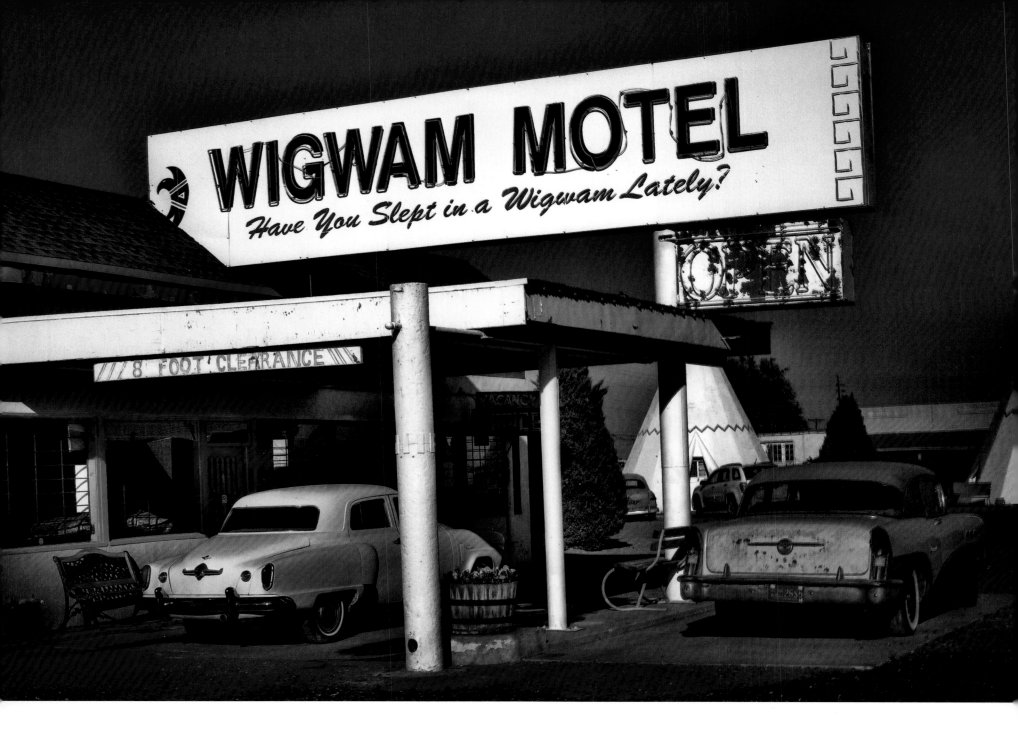

HOLBROOK, ARIZONA

HOLBROOK, ARIZONA WAS FOUNDED IN 1882, a year after the Atlantic and Pacific Railroad was built along the old Beale Camel Road. It soon became a typical rowdy train town, awash with whiskey and prostitution. A celebrated gunfight took place here in 1887, a spin-off of the Pleasant Valley Range War. The Aztec Land and Cattle Company, better known as the Hashknife Outfit, began operations in 1884 and became the second largest cattle ranch in America. Holbrook had calmed down considerably by the time Route 66 arrived in the town: Holbrook became a mainstay on old Route 66 and tourism became

Opposite: The Wigwam Motel was built in 1950.
Below: A 1932 Studebaker in Arizona's Petrified Forest.

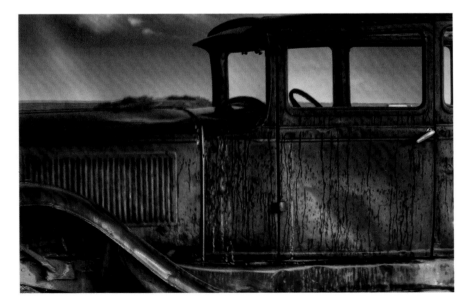

Above: The Wigwam's famous slogan.

a major industry for this Wild West town. With the Painted Desert, Petrified Forest and Indian Reservations all close by, Holbrook was full of Route 66 travelers. Remnants of the businesses that sprang up to service them can still be found in Holbrook. Trading Posts, old cafes, and colorful motels still line the road today. One of the most interesting and probably most photographed Route 66 attractions is Holbrook's Wigwam Motel. Originally built in 1950, it survived the demise of the Mother Road and proudly asks "Have You Slept in a Wigwam Lately?" Chester E. Lewis began the business and operated the motel until the town was bypassed in 1974. Lewis's sons Clifton and Paul Lewis and his daughter Elinor then renovated the motel and reopened it in 1988. Antique trucks and automobiles are scattered throughout the property.

There is a second Wigwam Village Motel along Route 66 in California.

JOSEPH CITY, ARIZONA

Joseph City was founded by Mormon pioneers in 1876 and named after the Latter Day Saints prophet Joseph Smith. The Mormons hoped to dam the Little Colorado River to irrigate their crops. The town was originally located two miles to the north east of its current situation, halfway between Holbrook and Winslow. Route 66 came through the town in the 1920s, but Joseph City didn't become a major stopover destination until the 1940s. It now has a population of around 1,400.

The Jack Rabbit Trading Post started business in 1949, offering food, gas, and camping. Located 5 miles west of Joseph City, it soon became famous for its slogan "Here It Is" and its billboard became one of the most iconic on Route 66. Complete with its enormous fiberglass rabbit, the Jack Rabbit sells curios, liquor, and Indian crafts. The Trading Post is run by Antonio and Cindy Jaquez.

Below: The Jack Rabbit started trading in 1949.

WINSLOW, ARIZONA

WINSLOW, ARIZONA WAS FOUNDED as a railroad stop along Beale's famous Camel Road and became a popular Route 66 destination. Remnants of the Mother road can still be found throughout the town. Winslow has several lodging houses including the La Posada Hotel, which opened in 1930. The town is now most famous for the legendary street corner immortalized in the Eagles' song "*Take it Easy.*"

The town has several other attractions, including the work of local painter Tina Mion and the Old Trails Museum.

Standin' on the Corner

Well, I'm a standin' on a corner
in Winslow, Arizona
and such a fine sight to see
It's a girl, my Lord, in a flatbed
Ford slowin' down to take a look at me

The Eagles 1972

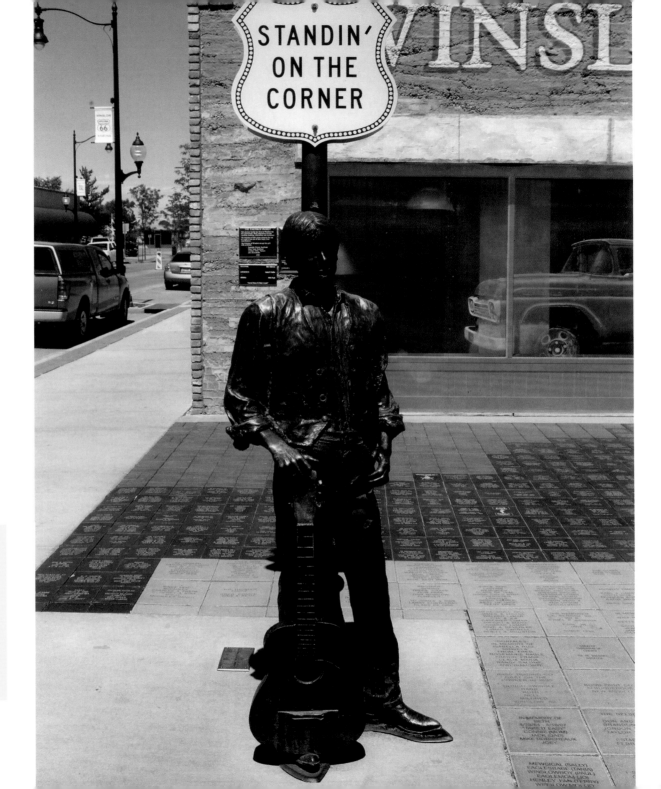

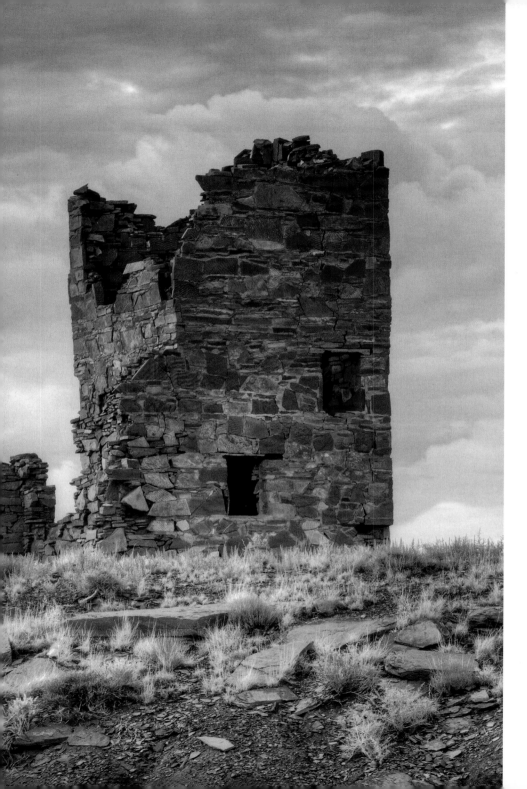

METEOR CITY, ARIZONA

A FEW MILES FURTHER ALONG OLD ROUTE 66, Meteor City was actually a trading post rather than a settlement. The original business was a gas station, built in 1938. A store was added in 1941. The store was originally housed in an ordinary rectangular building, but a bizarre stucco geodesic dome was added to the roof in 1979. Burned down in 1990, this was subsequently rebuilt. The site also boasts a vintage teepee, and the world's longest map of Route 66. This was painted on a long white wall by Route 66 postcard artist Bob Waldmire. The map is over a hundred feet long and underwent an extensive restoration in 2003. In recent years, Meteor City has gone out of business and the site is returning to nature. Its other iconic attraction, the world's largest dream catcher slowly fades in the desert sun.

Just west of Meteor City is the road to the Meteor Crater. This massive hollow was formed approximately 50,000 years ago when a meteor hit the earth. The formation is about 4,000 feet across and 570 feet deep. D.M. Barringer built an observatory just off of the Mother Road so that travelers could see the geological feature from The Mother Road. For just 25 cents, they could see the crater from the observation tower. This is now in ruins.

Left: Meteor City's observation tower is crumbling away.

Opposite: The desolate but beautiful Arizona landscape.

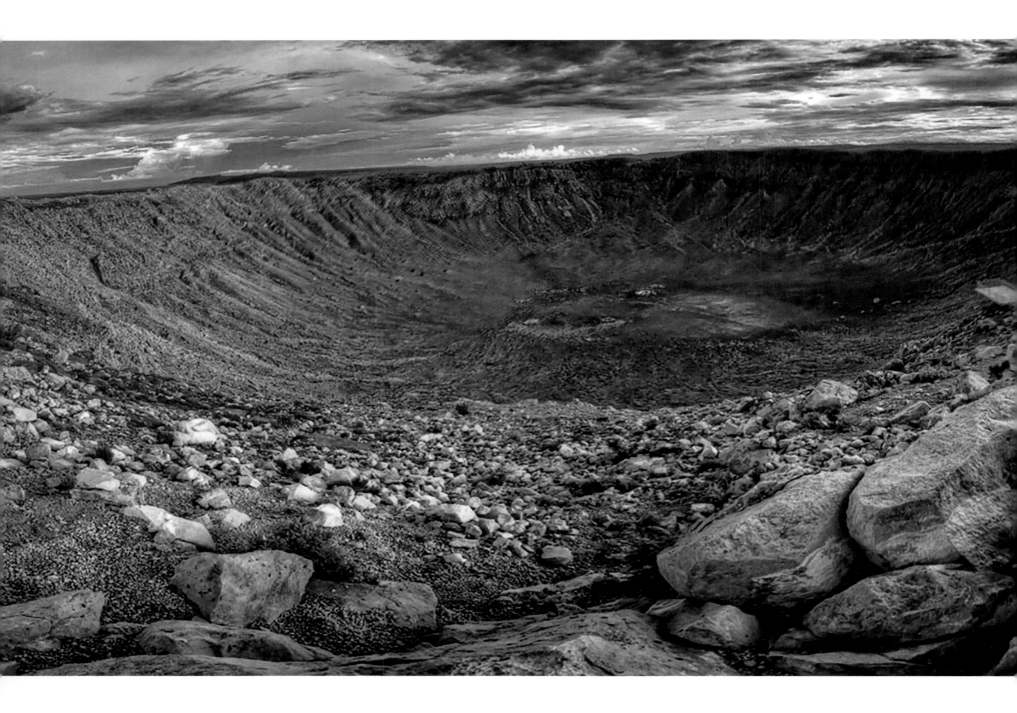

Opposite: The massive meteor crater.

Below: The dome-shaped building at the Meteor City Trading Post was built 1979. It burned down in 1990 and was subsequently rebuilt.

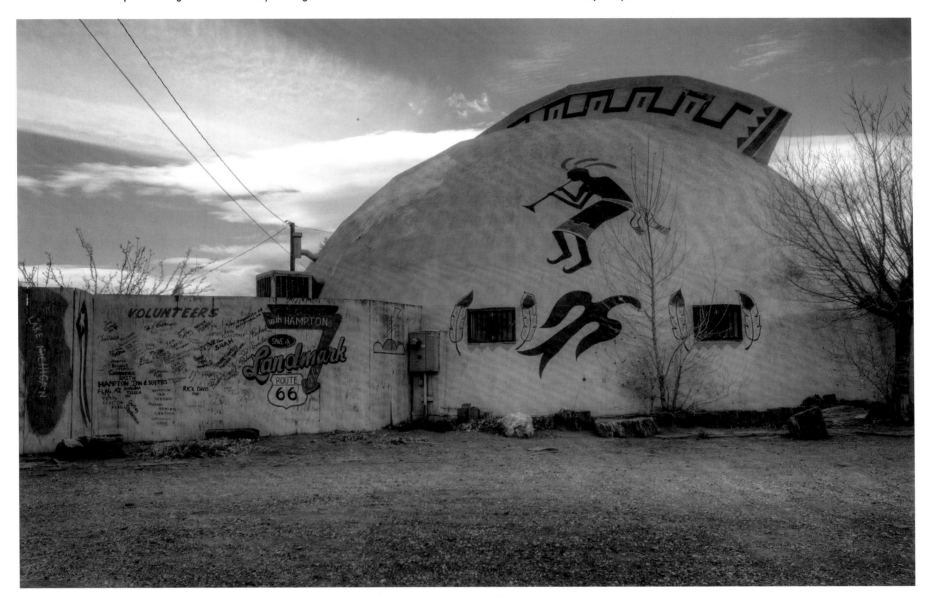

CANYON DIABLO AND TWO GUNS, ARIZONA

CANYON DIABLO IS A ROMANTIC GHOST town on the Navajo Reservation in Coconino County, Arizona. The road crosses the canyon on an old bridge. The settlement had started when the construction of the Atlantic and Pacific railroad was held up for six months as the construction workers built a bridge across the chasm. Canyon Diablo soon attracted every kind of rough entertainment including brothels, saloons, dance halls, and dancing. It soon became violent and lawless. The town died just as quickly when the railroad moved on, and now only a few stone foundations remain. Where Route 66 passed close to the town it crossed the Canyon on a concrete bridge. A small settlement soon sprang up there. This was named Two Guns in honor of a wild local hermit called "Two Gun" Miller. Two Guns soon had a gas station, campground, and roadhouse. It even had a small zoo, complete with mountain lions. Passing motorists sometimes stayed awhile, taking in the sights and visiting the nearby Apache Caves, but the town soon developed an unsavory and violent reputation. Two Guns was abandoned a few decades later. The few stone ruins remain, scattered along the rim of Canyon Diablo

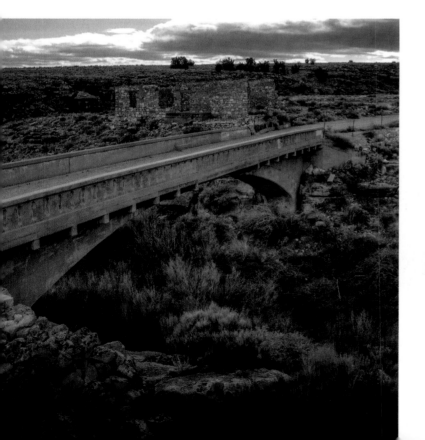

Above: The Two Guns zoo even had mountain lions.

Left: Route 66 crossed Canyon Diablo on a concrete bridge.

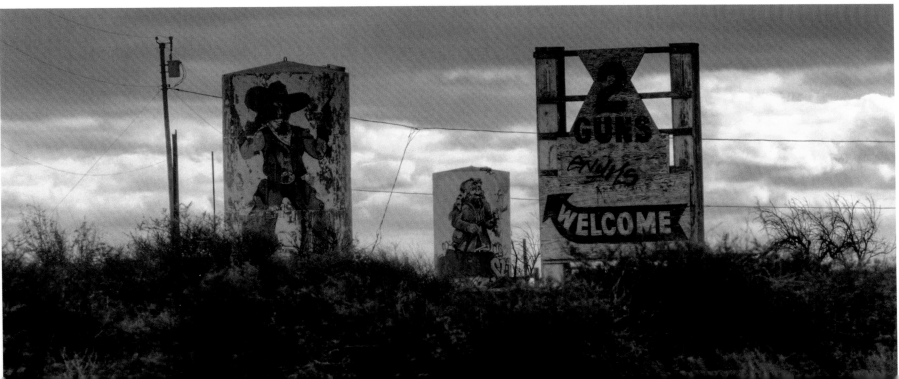

Left: Two Guns Route 66 sign.

Below: Two Guns only stayed in business for a few decades.

TWIN ARROWS, ARIZONA

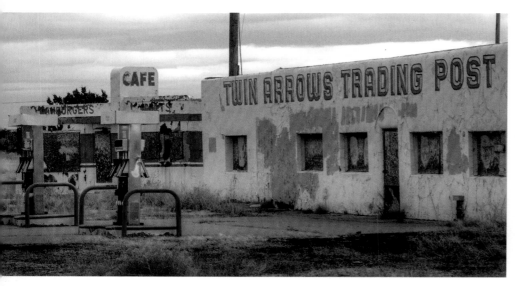

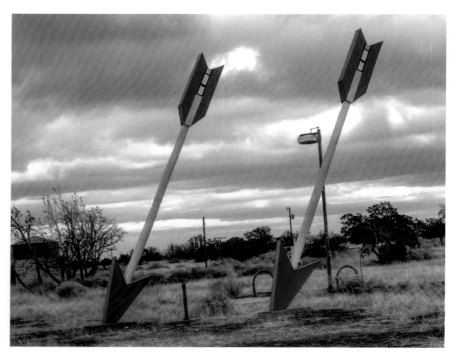

Above and Opposite: The famous Twin Arrows Trading Post.

Above: The twin arrows were made from painted telephone poles.

HEADING WEST ON ROUTE 66 from the ghost towns of Two Guns and Canyon Diablo, travelers soon come to the iconic site of the Twin Arrows Trading Post. This can be found on the 1937 Route 66 alignment. Route 66 first crossed the nearby Padre Canyon on a concrete bridge in the 1920s, but this was replaced by a larger structure on the 1937 alignment. The Twin Arrows business was first opened in 1946 as the Padre Canyon Trading Post. Unfortunately, its first owner, Ted Griffith, was very seriously injured by a passing truck in 1955. The business was subsequently taken over by the Troxell family. The Troxells renamed it the Twin Arrows Trading Post and placed two huge "arrows" in the parking lot to draw the attention of Route

66 travelers driving through the desert. The arrows were made from telephone poles and were adorned with wooden feathers. Jean and William Troxell ran a Valentine Diner, gas station, and gift shop at the site. But the construction of Interstate 40 in the 1970s left the Twin Arrows stranded as the high speed traffic just kept driving past. The trading post subsequently changed hands several times and closed down for good in 1995. The buildings are now abandoned and crumbling, although the twin arrows were restored in 2009. The Hopi Tribe now own the property and hope to restore the business at some point. In the meantime, the hot dry climate of the high desert plains continues to take its toll.

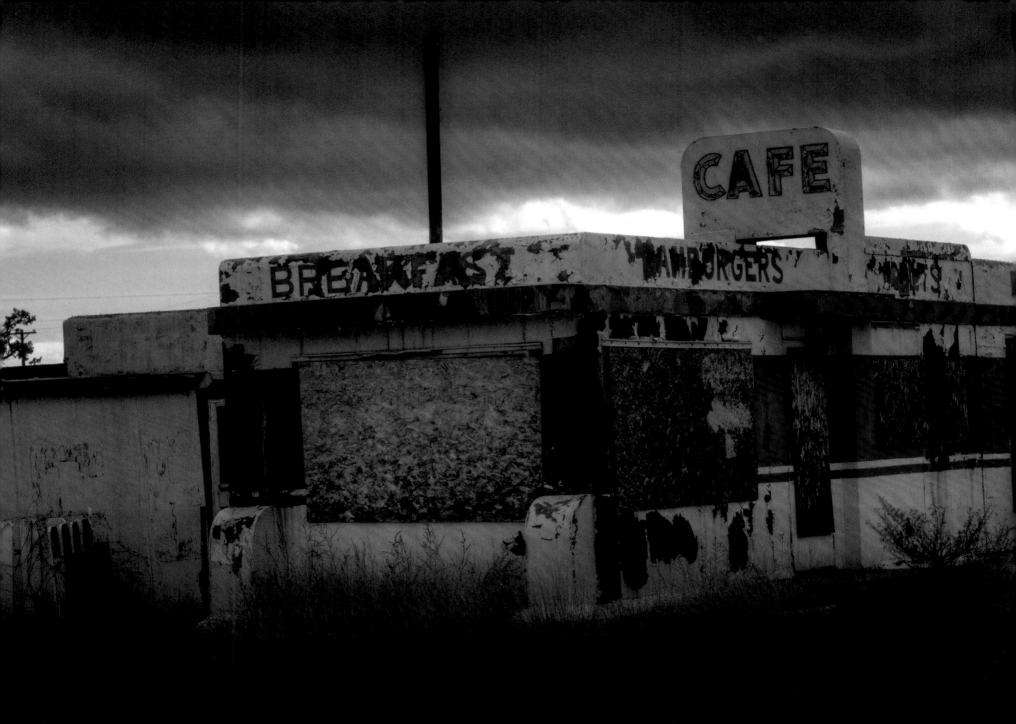

FLAGSTAFF, ARIZONA

FLAGSTAFF IS LOCATED IN ARIZONA'S COOL HIGH mountain country, surrounded by dark forests and blue mountain lakes. Arizona's highest mountains, the San Francisco Peaks provide a backdrop to the town. Founded in 1876 Flagstaff was named for a tall lone pine that served as a marker for wagon trains journeying to California. The trail was to become Route 66 and ran along the Flagstaff's main street.

The town is now filled with memories of the Mother Road. Several old motor courts survive, as do the Galaxy Diner, the Museum Club, Charly's Pub and Grill, and the red-tiled El Pueblo Motel.

Below: Flagstaff started out as a railroad town.
Opposite right: Mother Road era motel signs.

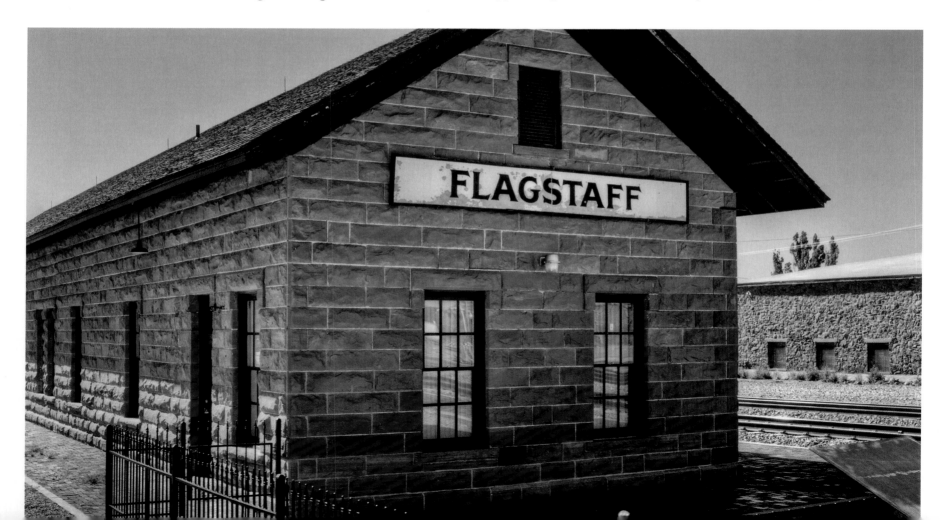

WILLIAMS, ARIZONA

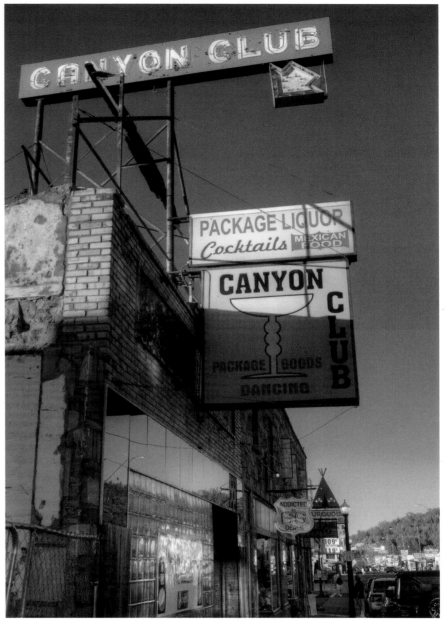

WILLIAMS WAS THE FINAL ROUTE 66 TOWN to be bypassed by Interstate 40. Bobby Troup attended an event to commemorate the opening of the final stretch of Interstate 40, and sang his iconic song. Williams continues to celebrate its links with the Mother Road with regular Route 66 Cultural Heritage Days. Cool summers and high elevations make this Northern Arizona town one of the most picturesque and traveller-friendly stopovers on the old road. Vintage trains also run from Williams, which is known as the "Gateway to the Grand Canyon," located just two hours away. The historic town nestles at the base of Bill Williams Mountain, surrounded by a huge forest of Ponderosa Pines. It also has one of the best-preserved sections of Route 66, located in a stunning western setting. Williams offers modern Route 66 travelers a great selection of lodging, meals, shopping, and entertainment. Most of these businesses still cluster along the old highway.

Above: Williams has a well-preserved section of Route 66.

SELIGMAN, ARIZONA

FORTY-THREE MILES ON FROM WILLIAMS, Seligman is a hugely important town on the Mother Road, known as the "Birthplace of Historic Route 66." Bypassed by Interstate 40 in September 1978, Seligman was deserted overnight as thousands of cars thundered by just a couple of miles to the south. For ten long years, Seligman went into a spiral of decline. Businesses closes, townspeople moved away, and many buildings were abandoned. In 1987 the people of Seligman met to form the Historic Route 66 Association of Arizona. They convinced the State of Arizona to dedicate the stretch of road between Seligman and Kingsman as a historic highway and this is now the longest remaining stretch of the road. In the town itself, the Seligman Commercial Historic District protects many commercial buildings from the Route 66 era. These include the Snow Cap Drive-In, founded in 1953 by local resident Juan Delgadillo and the Aztec Motel and Gift Shop.

The town got its name from Jesse Seligman. Seligman was a prominent New York banker who financed the local railroad. It is beautifully situated in northern Arizona's Upland Mountains, alongside the Big Chino Wash (a tributary of the Verde River). Route 66 came through the town in 1926, and was paved by 1938. Seligman's heyday came in the 1940s, when returning veterans and other travelers flocked to the exotic Southwest. In 1947, the

Left: The historic Aztec Motel.

Opposite: Burma Shave signs appear at regular intervals on the highway.

photographer Andreas Feininger immortalized Seligman as the quintessential Route 66 town in his photograph, "Route 66, Arizona." The image was published in *Life* magazine.

One of the unusual attractions along the Kingman-Seligman segment of Historic Route 66 is the appearance of recreated historic Burma Shave signs at regular intervals. Between 1925 and 1963, these signs were common on the highways and byways of America. Traditionally, a series of six signs were spaced far enough apart to read in a speeding car. Each one had a few words of a witty saying, with the last sign always having the Burma Shave logo.

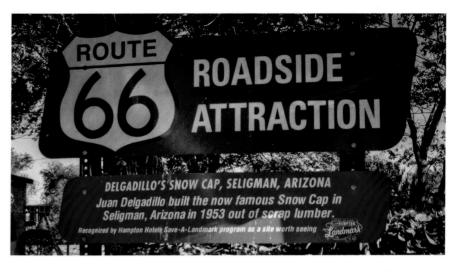

This page, opposite and pages 188–189: Seligman, known as the "Birthplace of Historic Route 66," has recovered from its decline and now preserves its old commercial buildings for visitors to enjoy.

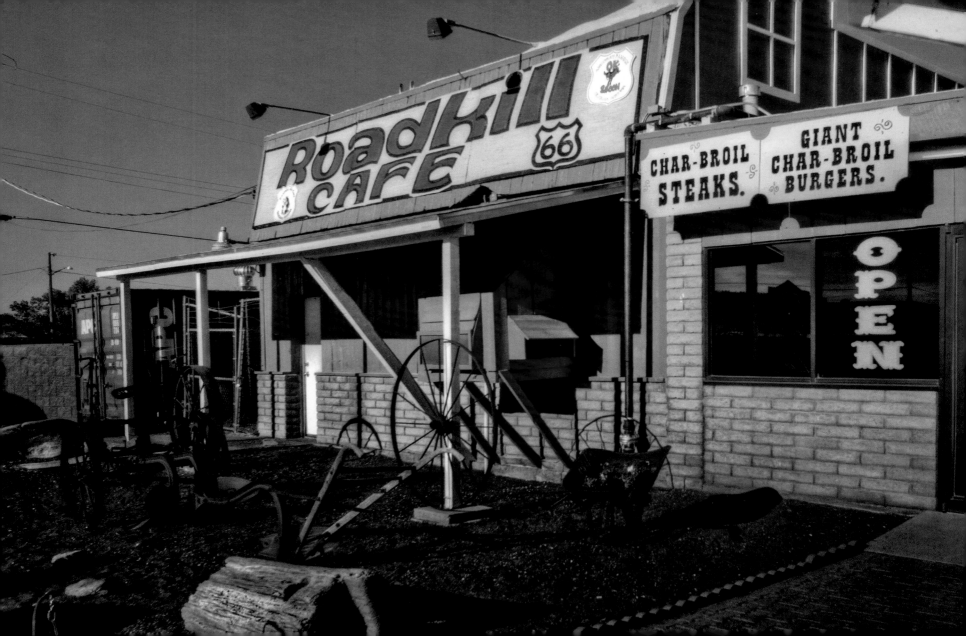

GRAND CANYON CAVERNS, ARIZONA

THE GRAND CANYON CAVERNS ARE LOCATED twenty-two miles northwest of Seligman and a dozen miles east of Peach Springs, sited on the longest stretch of Route 66 that is still in use. Among the largest dry caverns in the United States, the Caverns are still one of the prime tourist draws on Route 66. They are in a wonderful setting of beautiful scenery, teeming with prairie dogs, mountain lions, bobcats, falcons, owls, eagles, hawks, elk, and antelope. Cowboy and woodcutter Walter Peck (literally) stumbled on the Caverns in 1927 and charged travellers 25 cents to lower them down. The original gravel surface of the Mother Road ran just outside the entrance to the Caverns.

Above: The Caverns Inn has a unique cave suite.

Today's travelers to Grand Canyon Caverns can fuel up at a 1960 Modernaire filling station (one of only four left in the United States. There is also a café, motel, and gift shop. You can even spend the night in the Grand Canyon Caverns Cave Room, located 220 feet below the surface. This extraordinary suite is furnished with two queen sized beds, pull-out sofa, recliner, rocking chair, and a small dinner table. There is also a television and DVDs (as there is no television signal). Guests also have a small bathroom and kitchenette. This extraordinary lodging, "The deepest and darkest kick on Route 66" dates to the Cuban Missile Crisis of 1962, when one of the caves was equipped as a fallout shelter. It still contains survival rations supplied by the Office of Civil Defense.

PEACH SPRINGS, ARIZONA

TWELVE MILES DOWN THE ROAD, Peach Springs is a near-ghost town located in the Hualapai Indian reservation. The town dates from 1883 and owes its existence to the sweet water of the local spring, named for a grove of peach trees. Route 66 came through the town in 1926 and brought a flood of business. The successful Peach Tree Trading Post opened in 1928, built from local stone and Ponderosa pine beams. The town also had several cafes, motor courts, and tourist businesses that catered to travelers along the road. In the Route 66 years, Peach Springs was one of the busiest communities on the highway between Kingsman and Flagstaff. But when the town was bypassed by Interstate 40, Peach Springs went into decline. A local business owner recalled "Before the bypass, Route 66 was almost like a big city street. After completion of Interstate 40, it was ghostly quiet." The town has now been somewhat revived by Historic Route 66 tourism. Peach Springs is also the headquarters of the Hualapai Tribe. The town consists of the Hualapai Lodge, a motel, a small grocery store, and a gas station.

Right: The local stretch of Route 66 is ghostly quiet.

VALENTINE, ARIZONA

VALENTINE IS A LOVELY SPOT on the Mojave Desert stretch of Historic Route 66. This ghost town dates back to 1898 and was famous for its heart-shaped postmark. Thousands of Valentine cards and messages would flood into the tiny post office each year. Very sadly, tragedy struck on August 15, 1990 when post office manager Jacqueline Ann Grigg was shot dead in a botched raid. Jacqueline's husband subsequently bulldozed the building and left the area. After a brief period of activity during the Route 66 years, Valentine dwindled to just a handful of residences when Interstate 40 bypassed the town. The most prominent local building is the Indian School. Closed in 1937 the school was established to house and "assimilate" young Hualapai Indians onto the "White Man's Road." Boys were taught a trade while girls attended classes in domestic duties. The school still stands as a reminder of less enlightened times.

Right: Valentine's Indian school is derelict and crumbling.

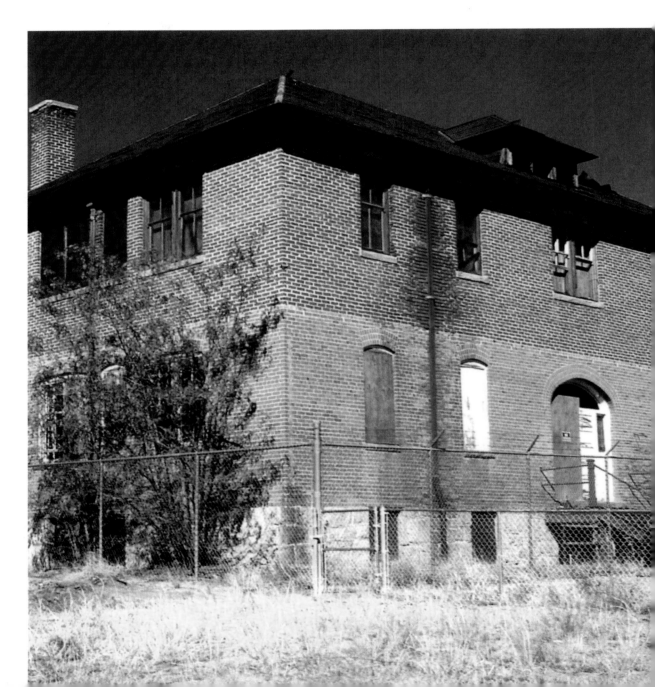

HACKBERRY, ARIZONA

DATING BACK TO 1874, Hackberry is the oldest town on this stretch of Route 66. Previously a cattle town, silver mining town, and a railroad town, Route 66 came there in 1926. Hackberry became a tourist town and various stores and service stations opened up to serve these travellers. A few decades later, the town was bypassed by Interstate 40 and Hackberry was stranded sixteen miles away from the new highway. The Northside General Store and its Conoco Station soon closed. Route 66 enthusiast Bob Waldmire bought the abandoned store in 1992 and re-opened it as

Above: The Hackberry General Store was brought back to life in the 1990s.

the Hackberry General Store and Visitors Center. Bob had travelled the road extensively in his 1972 Volkswagon Microbus. Today's Hackberry General Store has a vintage diner and souvenir store. It is decorated with a variety of service station memorabilia, including a Model T flatbed truck, antique gas pumps, several vintage cars, and a cherry red 1957 Corvette.

KINGMAN, ARIZONA

KINGMAN IS ONE OF ARIZONA'S HIDDEN TREASURES, hidden in the scenic Hualapai Valley in the Mohave Desert. It was founded in 1882 as an Atlantic and Pacific Railroad town, named for railroad surveyor Lewis Kingman. Kingman became a supply and shipping center for the miners and ranchers of western Arizona. Route 66 came to the town in 1926, following the National Old Trails Road, which becomes Andy Devine Avenue as it entered the town. The new highway boosted Kingman's economy, as did the construction of the nearby Boulder Dam between 1931 and 1936. When the town was bypassed by Interstate 40, the new road drew away the traffic from the downtown area. But after decades of decline, the town began to revive. The Arizona Route 66 Museum opened in May 2001 and the town is full of heritage attractions, accommodation, and restaurants. These include Route 66 Ice Cream and Sweets and Rutherford's 66 Family Diner. The town had many lodgings including the El Trovatore Motel. This was founded in 1937 and the tourist court was added in 1939. Kingman's Quality Inn is dedicated to the Mother Road, and full of Route 66 memorabilia.

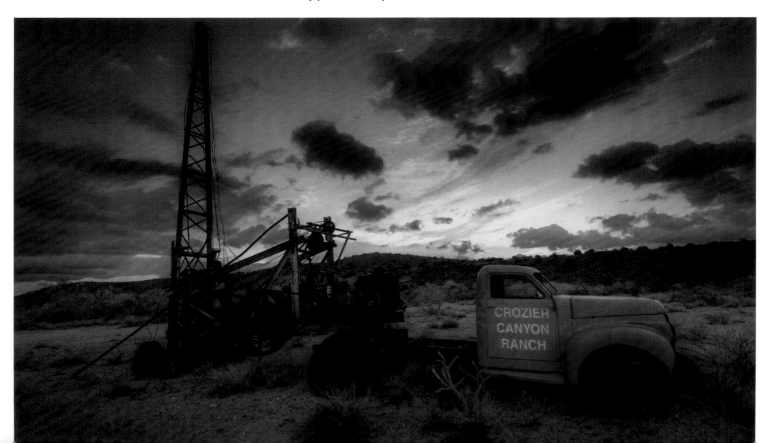

Left: Kingman is situated in the dramatic landscape of the Hualapai Valley which is in the Mohave Desert.

COOL SPRINGS CAMP, ARIZONA

TWENTY MILES WEST OF KINGMAN, Route 66 came to Cool Springs in 1926. Under the ownership of James Walker, the small camp soon evolved into eight tourist cabins, a Mobil Oil Station, and a café. Cool Springs used to offer motorists a welcome break before they tackled the treacherous and winding ascent through the Black Mountains. The Cool Springs gas station made a cameo appearance in the John Ford movie The Grapes of Wrath, which starred Henry Fonda as Okie Tom Joad. Despite the building of the Yucca Bypass in the 1950s, the camp at Cool Springs continued to operate until 1966 when it burned to the ground. Only a crumbling stone foundation remained in the desert, in front of the dramatic Thimble Butt.

Ned and Michelle Leutchner bought the site in 2001 and gradually restored the camp. Electrical power was restored to the site in 2004, for the first time since 1966. Fully restored, the camp was re-opened to the public in that year, complete with a gift shop and museum.

Right: Mr. D'z Route 66 Diner in Kingman has classic pink and turquoise décor.

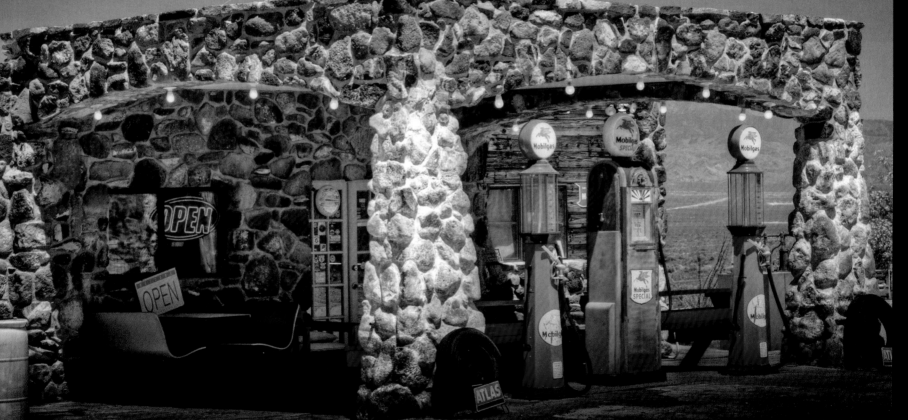

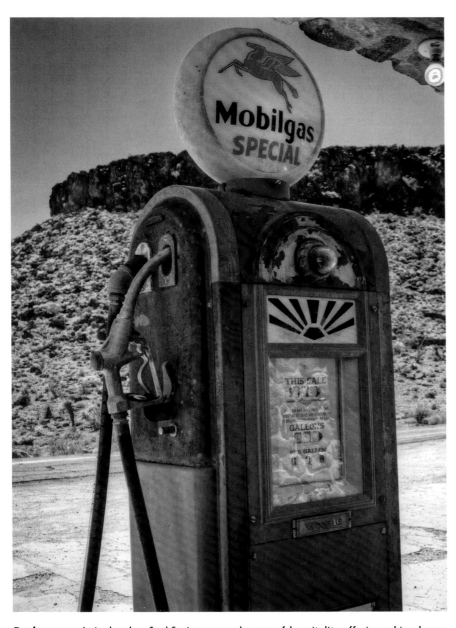

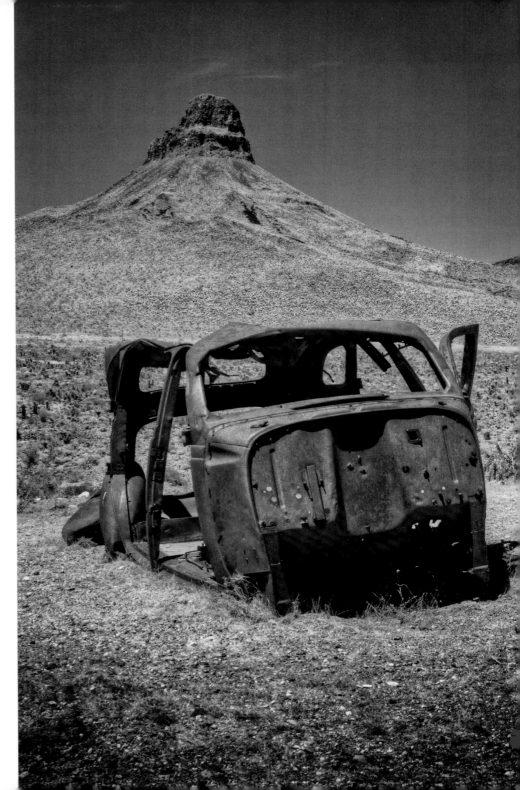

Both pages: In its heyday, Cool Springs was a beacon of hospitality offering cabins, home cooked meals, fresh water, and gasoline.

THE SITGREAVES PASS, ARIZONA

THE 3556 FOOT HIGH SITGREAVES PASS sits on the Oatman Highway section of old Route 66, as it travels through the Mojave Desert on the pre-1952 alignment of the road. The Pass was named for Captain Lorenzo Sitgreaves who travelled the area in 1851. It remains one of the most alarming stretches of the road to drive. The road surface is extremely steep and narrow; full of hairpin bends, and steep drop-offs. Early cars (that had no fuel pumps) had to be driven up the pass in reverse to make it up the Gold Hill Grade. Right at the top of the pass, there is a fantastic view of the spectacular countryside. The dramatic spot is sometimes used for weddings or scattering ashes. The Summit Gas Station and Ice Cream store was located at the summit. The business burned to the ground in 1967, leaving just a few rusting bolts and crumbling stone foundations.

Below: Route 66 crosses the Mojave Desert.

OATMAN, ARIZONA

OATMAN IS A FORMER MINING TOWN, deep in Mohave County's Black Mountains. The town began as a tent camp in 1915 when two prospectors struck a ten million dollar seam of gold. The Oatman Hotel was built in 1902 and became famous as the honeymoon destination of Clark Gable and Carole Lombard in 1939. Route 66 brought life back to Oatman but the town was bypassed in 1953, when a new highway was built between Kingman and Needles. Although its population has now shrunk to just 150, Oatman is famous as the home of the many semi-tame burros that roam through the town. These animals are descended from pack animals that were turned loose by the early gold miners, and have become obese from eating the carrots and hay cubes sold by the local shopkeepers.

By the 1960s, Oatman was all but abandoned, but had a brief lease of life in 1962 when the movie *How the West Was Won* was filmed in the town. A staged gunfight now takes place every afternoon at noon.

Right: Oatman treasures its unusual donkey residents.

ROUTE 66 IN CALIFORNIA

THE FINAL 320 MILES OF THE 2,450 mile route of old Route 66 runs across the "Golden State" of California, in the road's third time zone. Needles is the first Californian town on Route 66, twelve miles from the border. The road runs through Los Angeles and ends at the Pacific Ocean at the "End of the Trail" sign on the Santa Monica Pier. Constructed in 1926, the road had a massive impact on the state, which now houses two Route 66 museums in Victorville and Barstow. Although many miles of the Mother Road no longer appear on maps (especially in the city sections), it is still possible to follow the route for hundreds of miles. The eastern part of the road followed the National Old Trails Highway and other sections ran alongside the tracks of the Atlantic and Pacific Railroad. Some miles of the road even shadow the much-feared San Andreas Fault. The Californian section of Route 66 runs through some of the most breathe-taking scenery in America: the Mojave Desert, sparkling cities, wide beaches, lush valleys, and mountain peaks (including the Cadiz Summit and the Cajun Pass). The road was truncated in 1964 and much of the signage was removed in 1974. The entire California section was de-commissioned in 1984.

California was the destination of many of the early Route 66 travelers, the "Promised Land" at the end of the road. Countless families were fleeing the Depression and the Dust Bowl and used the road as a shortcut to freedom.

Opposite: The final 320 miles of Route 66 traverse California.

They all longed to reach California's abundant resources and economic opportunities. 210,000 emigrants traveled there during the Depression. As John Steinbeck said, the road became *"the path of a people in flight."* Frank Lloyd Wright went further, saying "Route 66 is a giant chute down which everything loose in this country is sliding into southern California. These early travelers often camped out in the Desert on their way to the "sugar bowl." They weren't always welcomed by the locals. In the 1930s, some Californians barricaded the road against the entry of more "Okies" into the state. They made these emigrants show that they had at least $100 to prove that they weren't vagrants. Woodie Guthrie described how thousands were *"Leavin' home almost everyday, Hittin' the hard old dusty trail, to the California line."*

As the Mother Road became busier, it stimulated the establishment of many towns and even cities along its route. These communities were sustained by Route 66 and many became ghost towns when it was bypassed by Interstate 40. Several of these Californian road towns were completely lost to the shifting sands of the Mojave Desert. These included the settlements of Summit, Bagdad, and Siberia.

During World War II, The Road to Dreams became crucial

to the war effort, moving troops and supplies in and out of California. When hostilities finished, many GIs returned in the golden years of Route 66 tourism.

The California stretch soon became a cultural icon in its own right. The "dark desert highway" of the Eagle song *Hotel California* is scattered with iconic locations like Roy's Motel, the Café Summit, Emma Jean's Holland Burger, the Mitla Café, and the Wigwam Motel. The Wigwam Motel is located in San Bernadino, the gateway to Los Angeles. The motel dates from 1949 and had fifteen teepees. Fully-renovated, it is now the epitome of modern kitsch. Once in Los Angeles, old Route 66 follows Sunset Boulevard from the historic core of the city. The road promoted many aspects of Californian way of life including its cuisine and car culture.

Over the years, many miles of the road faded away. The

Above: The road to dreams is lined with derelict gas stations.

Opposite left: The "dark desert highway" passes several Mojave Desert ghost towns such as Goffs.

Opposite right: Roy's Motel and Cafe in Amboy, California was built in the 1930s.

California Historic Route 66 Association was established in 1990 and greatly stimulated interest in the road. The Association is a non-profit organization dedicated to the preservation, promotion, and enjoyment of the road in California.

For twentieth century pioneers, the Californian miles of the Mother Road have a special charm. Each new generation seems to re-discover the road.

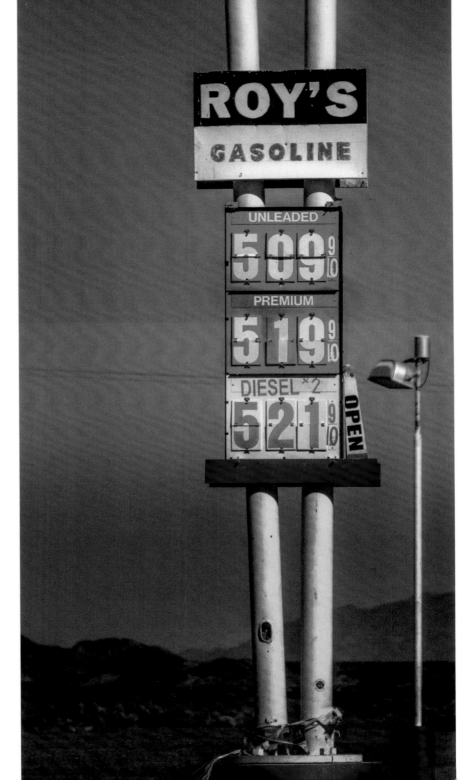

NEEDLES, CALIFORNIA

NEEDLES IS KNOWN AS THE HOTTEST town on Route 66. Its daytime temperature is often higher than 105 degrees Fahrenheit. Named for the spiky mountains around the town, Needles is an oasis in the desert. Travelers arriving in the town are welcomed by the famous Covered Wagon, which is located across the street from the Palms Motel, a 1920s motor court. Route 66 is well preserved in the town, with 10.8 drivable miles. The road passes many Mother road icons including Carty's Camp, the 66 Motel, and the El Garces Hotel. Part of the road runs along west Broadway Street, and little seems to have changed since the 1950s.

Above: The El Garces Hotel is a Route 66 icon.

Right: Needles is the hottest town on Route 66.

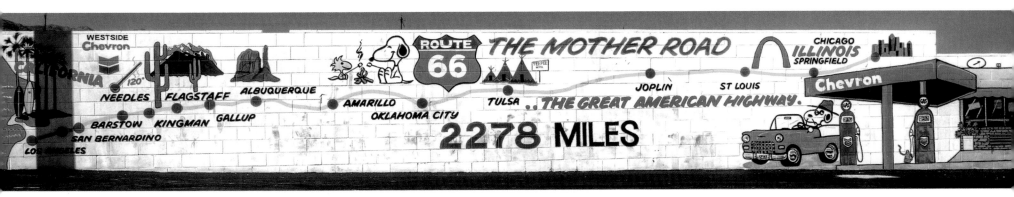

Above: An iconic map of the Mother Road.

Below: One of the many motels in Needles.

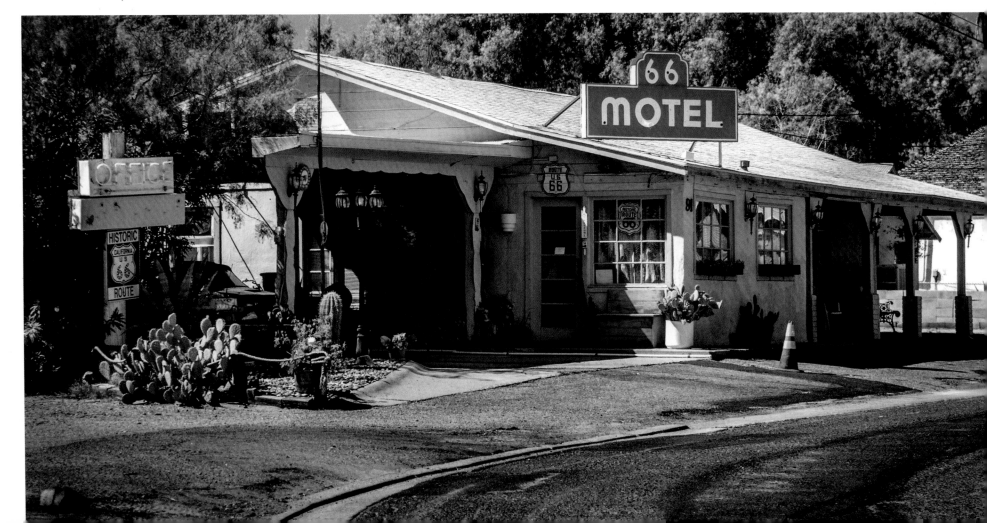

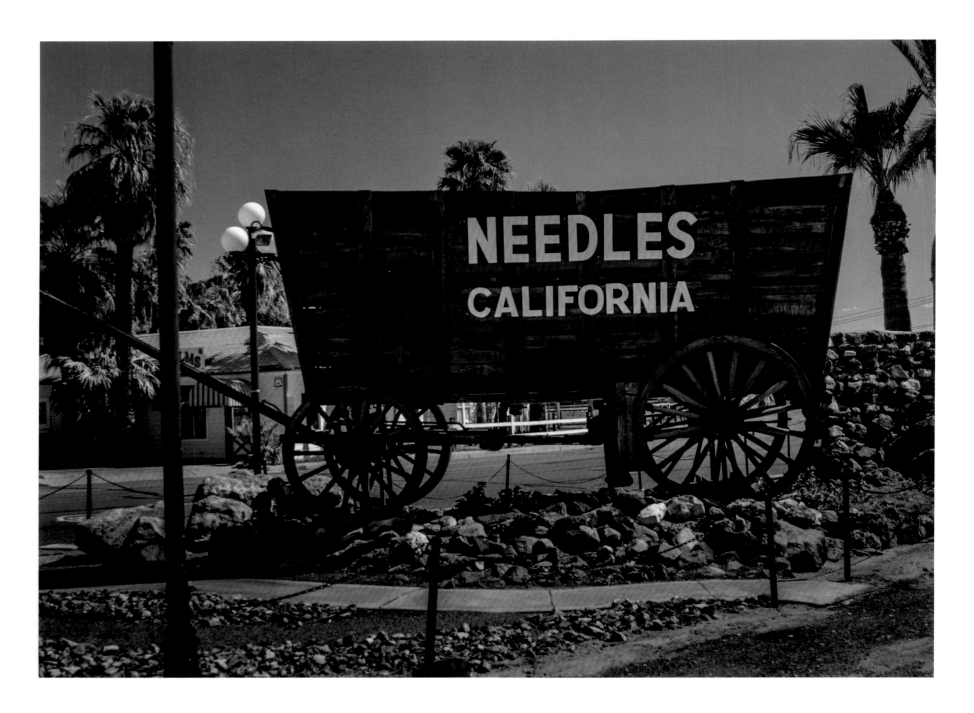

GOFFS, CALIFORNIA

Above: Route 66 spread the popularity of Mexican cooking.

Right: Goffs is now a ghost town.

GOFFS WAS A FAIRLY LIVELY STOP on the Mother Road until 1931 when a more direct road opened between Needles and Essex. This re-alignment moved the road six miles away and the town started its decline. Mostly a ghost town, Goffs now has a population of 23. This remote outpost has a well-kept historical center and restored schoolhouse. Many soldiers were billeted in the desert during World War II and the school was used as a café for the troops. The town now has just a single service station and a seasonally-open restaurant.

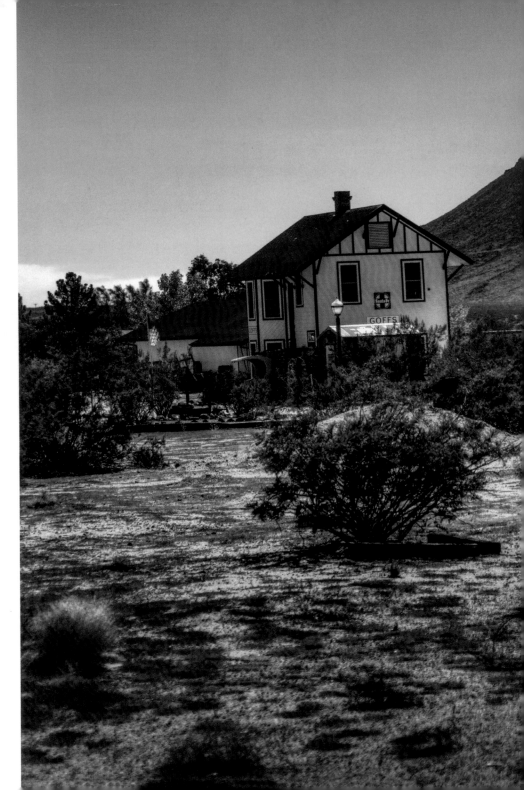

Above: The town of Goffs, California nestles in the Mojave Desert.

DANBY, CALIFORNIA

LIKE MANY OTHER MOJAVE DESERT TOWNS, Danby was originally a water stop for steam locomotives owned by the Atchison, Topeka and Santa Fe Railway Company. Training Camp Danby was nearby during the war, one of the nine airfields that made up the sprawling Desert Warfare Training Center under the command of George Patton. Route 66 brought gas station, café, and garage to the town, but like many other towns along Route 66, Danby died when the new Interstate 40 bypassed the area. It is now a true ghost town with just a few dilapidated buildings:

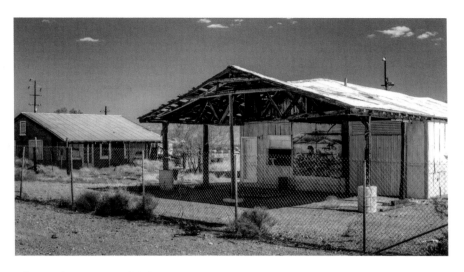

Above: There's not much left of the Mojave Desert ghost town of Danby, California.

Above: A mural in the desert town of Danby.

Right: The road stretches to the mountains.

CHAMBLESS, CALIFORNIA

CHAMBLESS IS A SMALL DESERT OASIS ghost town in the Mojave Desert of San Bernardino County, California, located south of Interstate 40 on the historic Route 66.Chambless is one of the so called "Alphabet" towns that provided water towers to service the Atchison, Topeka, and Santa Fe Railway across the Mojave Desert.

The town was named for James Albert Chambless who established a homestead near the National Trails Road in the early 1920s. Originally known as Chambless Camp, a store was built on this property in the late 1920s, and in 1932, a gas station, and motel, was added to the town, a post office followed in 1939. Cabins and a cafe were added as well. Reputedly unlike other towns on the route, Chambless had trees, porches and lots of shade. Through the years the original structures have undergone many changes, and several still remain today, however, the businesses have long closed down. The most enduring remnant is the Roadrunner's Retreat Café located roughly a mile and half west of the town. The imposing 1950s sign still stands above the crumbling ruins of the old restaurant which closed in 1995.

In 1990, Gus Lizalde, purchased the town of Chambless with the intention of restoring it to its former glory days. Since making the investment, Gus was able to reopen the gas station for a short period in the early 1990s, only to be forced to close due to unsafe underground fuel-storage tanks. In 2005, the population of Chambless was six residents and one dog, as posted on a sign entering the town.

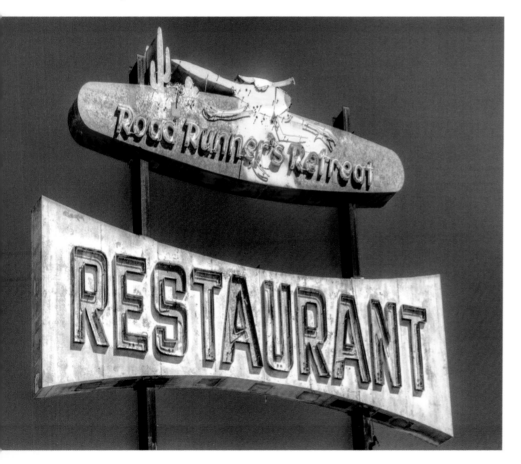

Left: The remains of the Road Runner Retreat on Route 66 in Chambless, California. The restaurant closed down in 1995.

AMBOY, CALIFORNIA

Above right: Amboy Church stands on Route 66.

Above left: Amboy's Post Office.

AMBOY IS A VIRTUAL GHOST TOWN in California's Mojave Desert, roughly sixty miles northeast of Twenty Nine Palms. The town was once a major stop along famous Route 66 but was bypassed by Interstate 40 in 1973. Traffic through the town became much less frequent. Amboy is home to the famous Roy's Motel and Cafe, a Route 66 Landmark that is currently under renovation.

The town was named in 1883 by Lewis Kingman, a locating engineer for the Atlantic and Pacific Railroad. It is the first in a string of alphabetical railroad stations in the Mojave Desert.

The famous Amboy Crater is still open and may be accessed from the south by taking Amboy Road to Route 66 and from the north by taking Kelbaker Road to Route 66. Designated a National Natural Landmark in 1973, Amboy Crater was recognized for its visual and geological significance. Although Amboy Crater is not unique, it is an excellent example of a very symmetrical volcanic cinder cone. The crater contains two lava dams that hold two small lava lakes. These now create an impression of miniature "dry" lakes."

Above: A fallen Shoe Tree on Route 66 near Amboy California. The tree fell in March of 2010, but continues to grow shoes.

Opposite: The Amboy Crater and Lava Field is an extinct volcano in the Mojave Desert.

Right: Roy's Motel and Cafe was built in the late 1930s by Roy Crowl and operated by him and his family until 1995.

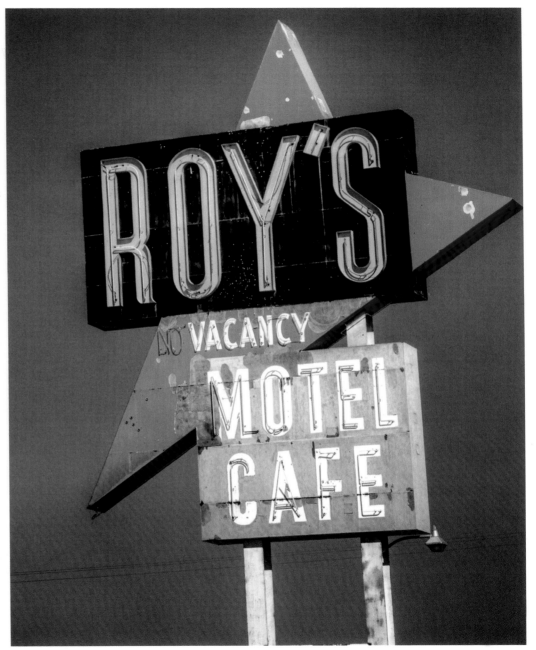

LUDLOW, CALIFORNIA

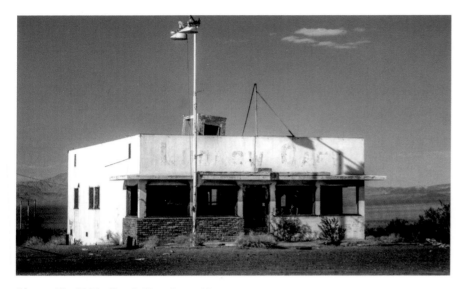

Above: The Old Ludlow Café on Route 66.

THE GHOST TOWN OF LUDLOW is located along the railroad tracks of the 35th parallel and became a water stop for the Atlantic and Pacific Railroad in 1882. Route 66 came to this ore mining area in 1926, but it was bypassed by Interstate 40. The town now stands to offer testimony of another failed dream. During the heyday of Route 66 Ludlow was a welcome stop for the tired and thirsty traveler, a great place to rest and get away from the heat of the Mojave Desert. Westbound drivers knew that the next day they would be on the golden shores of the Pacific Ocean. The Ludlow Cafe served its last ice cream malt years ago, and the last mechanic at the Ludlow Garage went home some time ago.

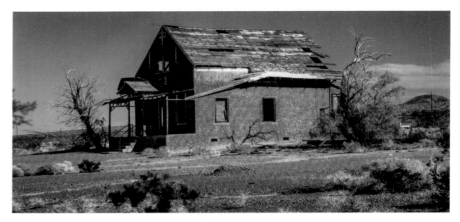

Above: An abandoned building on Route 66.

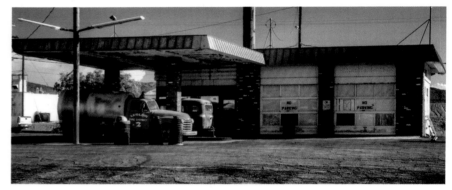

Above: An old gas station on Route 66 in Ludlow, California.

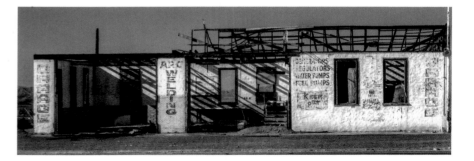

Above: Ludlow is now a true ghost town.

NEWBERRY SPRINGS, CALIFORNIA

THE LAND AROUND NEWBERRY SPRINGS has been a source of water in the Mojave Desert since the earliest days. The site of Camp Cady is located a few miles away and was a famous watering hole for wagon trains on the old Mormon Trail. In the 1880s the Atlantic and Pacific Railroad hauled water to the other stations in the area.

Route 66 came to the town a few decades later. The famous Route 66 movie *Bagdad Café* (1987) was filmed in the area and brought some notoriety to the locale. The local Bagdad Café was originally called the Sidewinder Café. Today, the café is still open for business serving breakfast, lunch, and dinner.

Below: Newberry Springs started out as a watering hole.

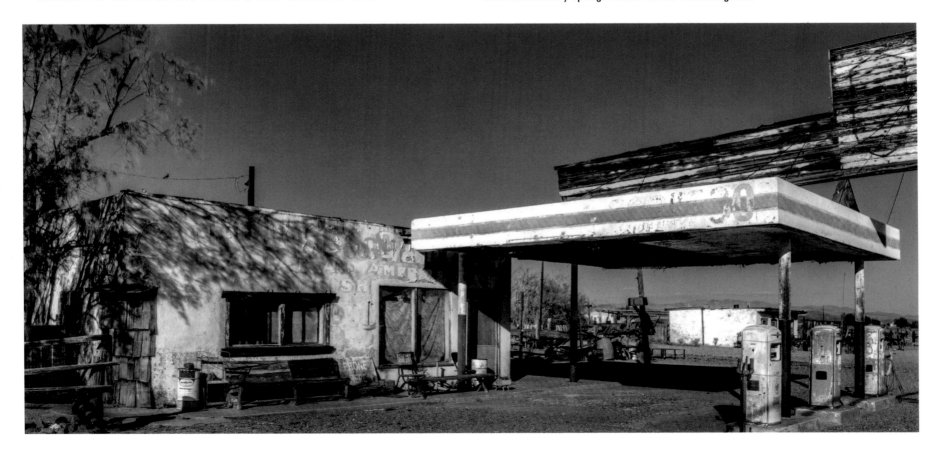

DAGGETT, CALIFORNIA

DAGGETT IS A SMALL TOWN in the Mojave Desert located approximately eight miles east of Barstow. This is an extremely arid area, with just four inches of rain a year. The old route of the Mother Road passes right through the town. For years, Daggett outfitted miners who worked in the region. Today it is a focus of more modern industries, including a modern airport, solar generating plants, agriculture, and light industry. It is also at the junction of two major railroad lines.

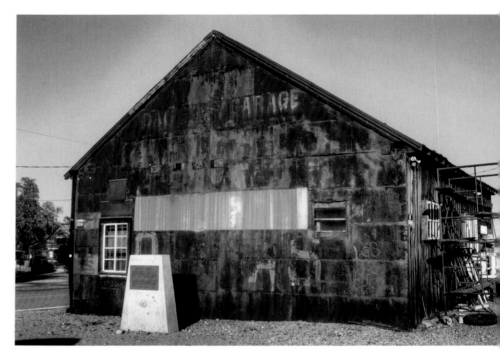

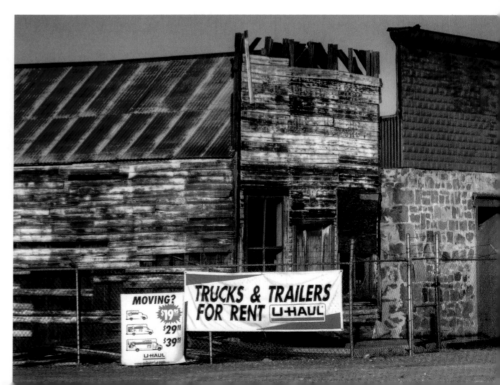

Above: The Ski Lodge Roof House opened in about 1926.

Right above: The Fouts brothers bought the Daggett Building in 1946 and operated a garage there.

Right below: The Peoples General Store in Daggett, California on Route 66.

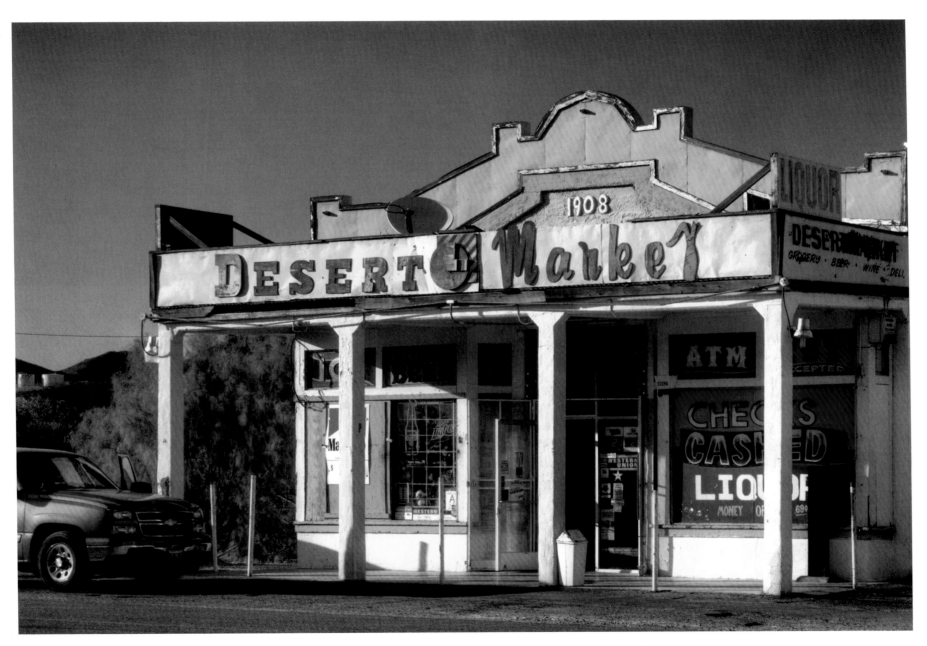

Above: The Desert Market store made history in 1953 when a safecracker stole almost $1000 in gold dust and nuggets.

BARSTOW, CALIFORNIA

BARSTOW'S ROOTS LIE IN THE RICH MINING history of the Mojave Desert following the discovery of gold and silver in the Owens Valley and in mountains to the east in the 1860s and 1870s. Barstow is named after William Barstow Strong, former president of the Atchison, Topeka and Santa Fe Railway who had a big influence on this region. It became a busy rail center and a jumping off place for immigrants entering the state on Route 66. Modern and historic facilities are still available along Barstow's Main Street, the original Route 66.

Just off Main Street, at First Street, travelers can drive over an old iron bridge that leads to the railroad depot once the site of the historic Harvey House, originally opened in 1911. This is one of the Fred Harvey Company hotels and restaurants, a chain described as "the greatest civilizing influence in the West." Fred Harvey hotels and restaurants played an important role in improving the quality and service of food along the Atchison Topeka and Santa Fe railroad. Prior to the founding of the first Harvey House restaurant, rail passengers often had to endure poor quality food and rushed service at the few eating-places available at railroad stops. The custom was to hold the train for a few minutes while passengers bolted for the nearest restaurant.

The original 1885 depot in Barstow consisted of a wooden depot, restaurant, and a hotel that later burned in 1908. The present, rather grander, structure was designed by Los Angeles architect Francis Wilson and built between 1910 and 1911. The building conveys a regional influence in its design, a hybridization of Santa Fe sixteenth century Spanish and Southwest American Indian architecture. The Harvey House in Barstow also includes Moorish elements and motifs worked into an interesting combination of towers and archways.

Unlike many towns on Route 66, Barstow's future of growth was assured with the construction of the modern highway system, as Interstates 40, 58, and 15 converged at Barstow's city limits, making the town the transportation hub of the western Mojave Desert.

Barstow is an extraordinary place where several trails meet. The Old Mormon Trail, Route 66, and Interstate 40 come together here in the high desert. In 1886 a depot for the Atlantic and Pacific Railroad was built here and the town of Barstow was officially founded. The town was named after William Barstow Strong, the president of the railroad at that time. The beautiful Railroad Depot was built in 1910 and also served as a Harvey House. Today it has been restored by the city of Barstow and is the site of the Route 66 Mother Road Museum.

Barstow takes pride in its Route 66 heritage, including the famous El Rancho Motel and the El Rancho Café. Both are Mother Road landmarks. Lodging can be had at the Route 66 Motel on Main Street.

Opposite: The Harvey House Hotel was built in a unique hybrid style with many different architectural influences.

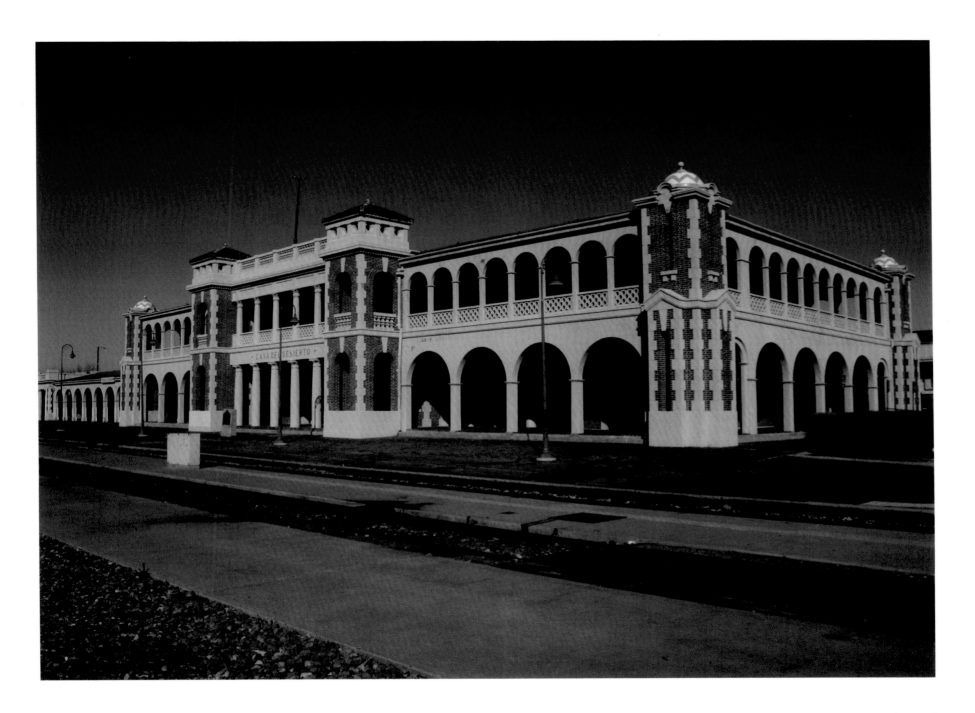

LENWOOD, CALIFORNIA

LENWOOD, CALIFORNIA IS THREE MILES WEST of the town of Barstow and is located on old Route 66. During the Dustbowl era, many travelers left the road before the town as they made their way to grape-picking jobs in the fertile fields of Bakersfield. Those that continued along Route 66 came through Lenwood.

The abandoned Dunes Motel lies just outside the desert town. The hostelry dates from the 1940s. Located in the dramatic hot and arid landscape of the Mojave, the motel had four guest bungalows, each of which had four rooms. The relics of the motel seem to have escaped too much vandalism and are reasonably well preserved. Its ruins are still surrounded by enigmatic desert palms. Several other abandoned buildings line the route of the old road.

Right: The motel is a famous Route 66 icon.
Below: The empty swimming pool tells its own story.

Above: The Dunes Motel opened in the 1940s.
Below: A dilapidated building at Lenwood, California.

SAN BERNADINO, CALIFORNIA

THE CALIFORNIAN TOWN OF SAN BERNADINO was responsible for two great innovations in American food history. In 1940, Route 66 in San Bernadino became the location for the first McDonald's restaurant. Brothers Richard and Maurice McDonald opened a barbecue drive-in, but discovered that most of their profits came from hamburgers. In 1948, they closed their restaurant for three months, reopening it in December as a walk-up hamburger stand that sold hamburgers, potato chips, and orange juice. The following year, they added French fries and Coca-Cola to the menu. This simple menu and food prepared using assembly line principles, allowed the McDonalds to sell hamburgers for 15 cents, or about half as much as at a sit-down restaurant. The restaurant was very successful, and the brothers started to franchise the concept in 1953. Their revolutionary thinking changed the restaurant industry forever.

In small, dusty, heavily segregated, Route 66 towns like San Bernardino, people felt the need to gather. On the west side of the city, where the Mexican families were allowed to live, that meeting point became Mitla Cafe on Mount Vernon Avenue.

Glen Bell was a visitor to the Mitla Cafe. Bell would go on to found Taco Bell but began by selling hamburgers and hot dogs across the street from Mitla Cafe. Bell watched lines form for the Mitla's signature ten cent tacos dorados. This was a thinly fried tortilla shell containing simple meats, shredded cheese and diced tomatoes. The entrepreneur befriended the Mitla's staff and even worked his way into the kitchen to decipher the secrets behind the beguiling taco that was proving so popular. Bell recognized that even non-Mexicans would bite on the concept of toned down tacos. The original Mitla cafe still stands, in the same location, with a historic designation sign. Framed photographs on the inside walls show generations of Mexican American history. More than just a simple all day eatery, the Mitla still stands as the voice of a quiet revolution that helped expand Mexican food throughout the world.

Below: The Mitla Café was the inspiration behind the Taco Bell chain.

FONTANA, CALIFORNIA

FONTANA IS SITUATED IN SAN BERNARDINO COUNTY, California. Founded by Azariel Blanchard Miller in 1913, the town was at the heart of citrus orchards, vineyards, and chicken ranches. Route 66 came through Fontana in the 1920s and during World War II, entrepreneur Henry J. Kaiser built a large steel mill in the area. Fontana is now a regional hub of the trucking industry, and has preserved much of its route 66 heritage. The famous Bono's Restaurant and the last remaining Orange Juice Stand can both be found in Fontana. These orange juice stands were once a common site along this stretch of Route 66, refreshing stops for travelers on the old highway. Bono's Restaurant is now closed.

Above: This is the only surviving Bono's orange juice stand.

Above: The Moana Motel still serves travelers.

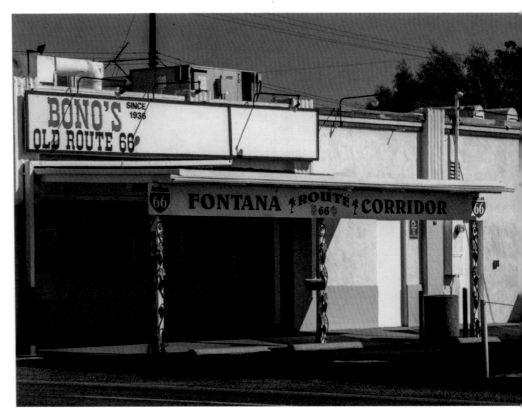

Above: Bono's Restaurant is now closed.

SANTA MONICA, CALIFORNIA

THE ICONIC SIGN AT THE END of the Santa Monica Pier marks the official end of legendary American highway Route 66. The pier was opened on September 9, 1909 and contains the charming Pacific Park. This family amusement park has a solar powered Ferris wheel and a lovely old Looff carousel. Near where Santa Monica Boulevard dead-ends at Ocean Avenue, a brass plaque marks the official end of Route 66, the Main Street of America, also remembered as the Will Rogers Highway. Just another of the many names the old road earned in its half century of existence. The plaque remembers Rogers as a "Humorist, World Traveler, Good Neighbor." A great epitaph for an Okie from the middle of nowhere, much of whose fame was achieved by travelling the length and breadth of America.

The road itself brought a huge wave of change to the West Coast, opening up the area to generations of travelers and tourists.

Above: The end of the road on Santa Monica Pier.

Right: The road ends at the sparkling ocean lights.